50 Works of Irish Art You Need to Know

50 WORKS OF IRISH ART YOU NEED TO KNOW

Síghle Bhreathnach-Lynch

GILL & MACMILLAN

Gill & Macmillan
Hume Avenue
Park West
Dublin 12
www.gillmacmillanbooks.ie

978 07171 6655 8

Design by Fidelma Slattery
Printed by Printer Trento Srl, Italy

This book is typeset in Perpetua and Lulo.

The paper used in this book comes from the wood pulp of managed forests. For every tree felled, at least one tree is planted, thereby renewing natural resources.

A CIP catalogue record for this book is available from the British Library.

5 4 3 2 1

For my grandchildren, Eva, Sonya, Adam, Charlie and Lucy

ACKNOWLEDGEMENTS

I would like to begin by thanking Gill & Macmillan for providing me with an opportunity to write a history of Irish art for the general public. Throughout my long career as an art historian and curator, I have had the pleasure of giving lectures and talks not only to those interested in gaining a qualification in the subject but also to the many who simply enjoy visiting museums and galleries and who are eager to know more about what they were looking at. Their enthusiasm, invariably infectious, has continuously inspired me to present and re-present the subject in ways that open up a deeper understanding and appreciation of Irish art. This book has been written specially with all those art lovers in mind.

My commissioning editor at Gill & Macmillan, Deirdre Nolan, offered guidance throughout the project, encouraging me to be always guided by my own experience and instincts when writing. Thanks too to other members of staff: Teresa Daly, Catherine Gough, Emma Lynam, Paul Neilan, Jen Patton, and my editors Aoife Carrigy and Síne Quinn, who were involved in other aspects of the publication.

Over half the selection of the works is from the National Galley of Ireland, whose Irish collection I know intimately, having spent eleven years as Curator of Irish Paintings and Sculpture. I want to thank my colleague and friend, Adrian Leharivel, Curator of British Art, for being a perfect sounding board from time to time. Lydia Furlong, manager of the NGI bookshop, offered enlightening advice on the behind the scenes world of publishing. In my many dealings with the NGI Library, Archives and the Centre for the Study of Irish Art, I want to thank Andrew Moore in particular. His keenness to dig out relatively unknown archival material was only matched by my own. I am grateful to Marie McFeely and Louise Morgan from the Rights and Reproductions department for their help in supplying the images.

I am also appreciative of all the other institutions whose work is included in the book: the National Museum of Ireland; Irish Museum of Modern Art; Dublin City Gallery, The Hugh Lane; Crawford Art Gallery, Cork; the Ulster Museum, Belfast; Trinity College Dublin; St Patrick's Cathedral and the Carmelite Friary, Clarendon Street, Dublin. Jacquie Moore and Avril Percival from the Office of Public Works were unfailingly prompt in supplying me with precise measurements for all the sculpted works in public spaces throughout the country and the Evie Hone window in Government Buildings. I also want to acknowledge some valuable advice offered by Dr John Bowman, RTÉ.

A special thanks to the artists who granted me permission to include examples of their work: Robert Ballagh, John Behan, James Hanley, Alice Maher, Maria Simonds-Gooding and Sean Scully. Patrick Coghill kindly allowed me to reproduce Edith Somerville's *The Goose Girl*.

50 Works of Irish Art You Need to Know was a labour of love, and my family and friends provided lots of encouragement whenever needed. The book is unsurprisingly dedicated to my five grandchildren. Finally, last but never least, I was enabled at every turn in producing this manuscript by my husband, Brian Lynch.

Contents

Contents

Ancient Irish Art (*c.*3700 BC–*c.*AD 430)

Neolithic Age (*c.*3700 BC–*c.*2000 BC)

The story of Irish art and architecture has its roots in the Neolithic Age (literally 'New Stone' Age). From *c.*3700 BC, a wave of settlers from the Continent gradually displaced earlier migrants on the island. The first incomers had arrived *c.*7000 BC, coming via Scotland from Scandinavia and the North European Plain. These people did not settle in specific locations but rather moved from place to place, building campsites, hunting and fishing. Today the only evidence we have of their existence are archaeological remains such as tools they made from flint to fish, hunt and prepare leather.

This second wave of settlers were farmers who brought seeds and livestock with them. They built houses from wood and cleared forests with stone axes to make way for tillage and pasture. Most of their settlements were permanent, although there were some seasonal camps for activities such as fishing. They were also impressive architects and engineers, as evidenced by the great megalithic tombs they built.

The word 'megalith', derived from the Greek for 'big stone', is apt as large pillars and blocks of stone marked these tombs in the landscape. Personal items were deposited together with the remains of those cremated, including pendants made of bone, beaded jewellery and, very occasionally, pottery.

Besides serving as places of burial, these sites had other uses which reveal much about the Neolithic belief system around death and the afterlife and their interest in celestial movements. Many tombs acted as territorial markers, while others measured Earth's cycle around the sun as well as lunar or other stellar actions. This interest in the sun is unsurprising given that, as farmers, their knowledge of terrestrial movement and the seasons afforded them greater success in the cycle of food production. About 1,500

megalithic tombs are known in Ireland. They are not unique to this country, also being found in Spain, Portugal, western France, Denmark and parts of Wales and Scotland.

Four distinct types of tomb exist, classified by shape: court tombs, dolmen tombs, wedge tombs and passage tombs. The earliest type is the court tomb, of which about 400 can be found north of a line from Galway on the west coast to Dundalk on the north-east coast. These court tombs comprise a rectangular burial chamber, usually covered by an earthen mound. The entrances to the graves are marked by a court of large stones laid out in a roughly semi-circular manner facing east. It is believed that some kind of funerary rite may have taken place in this outdoor area before the cremated remains were disposed in the chamber.

Difficult to date, the dolmen (or portal) tombs comprise one or two capstones resting on three or more upright stones. The capstone (or portal stone) always leans to one side, leaving a large opening at the high end. Human remains would have been entombed within and the entrance sealed with smaller stones. Dolmen tombs are mainly found in the northern half of the country, although some have been located in the southern counties of Wicklow, Wexford and Waterford.

Dating from the end of the Neolithic Age, wedge tombs are the largest and most prevalent of the four groups. Their name derives from the wedge-shaped burial chambers built for the remains and they can be found in the south and south-west of Ireland.

Although few in number, it is the passage tombs that invoke the most awe due to the skill necessary to construct them. About 330 passage tombs can be found mainly north of Wicklow on the east coast and across to Sligo in the west. Built on a high vantage point, they consist of a roughly circular earthwork of soil and stone known as a 'cairn'. Underneath are several burial chambers, which can be reached from the opening at the edge of the cairn via a passageway constructed from large vertical stones laid across with flat ones.

It is believed that *c.* 2500 BC, art was first applied to architecture in the construction of passage tombs. The most famous of these are at Newgrange **(Pl. 1)** and nearby Knowth and Dowth, which together form a cemetery group at a bend of the River Boyne. A number of boulders both inside and outside the tombs are decorated with

carved patterns, including spirals, zigzags, arcs, swirls, lozenges, chevrons, eye motifs and dots. It is unknown what these marks signify, but the general belief is that they had symbolic significance rather than being purely aesthetic. This complex use of architecture and decoration reveals an intelligent people. The passage tombs, specifically those in the Boyne Valley, are regarded as one of Europe's most important ancient cemeteries.

Further evidence of the impressive skills of this society lies in the discovery of the Céide Fields in Co. Mayo, the oldest known field systems in the world. They provide proof of a unique farmed landscape from Neolithic times. Beneath the vast bogland is a network of massively long stone walls that run from the cliff edge and are linked by transverse walls. There are five court tombs within the area of the fields.

Bronze Age (*c.* 2000 BC–*c.* 500 BC)

The Bronze Age gets its name from the materials used to make tools, such as axe heads and weapons. The warm climate enabled Stone Age farmers to grow crops but farming declined in the Bronze Age due to the spread of *Sphagnum* moss, commonly known as peat moss, in farming land. This led to the spread of bogs in parts of the country, such as the Céide Fields. Driven off their land, the settlers were forced to seek out more fertile ground, but these areas were increasingly inhabited by fresh arrivals to the island. This demand for land created a new tension and necessitated an increase in weapon production and stone fortifications.

The term 'Bronze Age' is somewhat misleading, as the era is more associated with the dazzling range of gold ornaments that can be seen today in the National Museum in Dublin and the Ulster Museum. Early prospectors were attracted by the country's natural resources of copper and gold, and a plentiful supply of tin was imported from Cornwall.

Overseas trade was a feature of the early Bronze Age. Irish metalworkers supplied axe heads to markets in Britain and the Continent. Many of these were decorated with simple but elegant linear designs: triangles, chevrons, herringbones, and hatched and unhatched patterns. These designs also appear on beakers, food vessels and jewellery.

The most outstanding objects from this early period are its gold discs and lunulae. This trade began on a small scale with the production of small discs, including those designed as earrings. Made from thin sheets of gold, they had two small holes in the centre through which hooks could be thread. Their design took the shape of a cruciform hammered out from behind (a technique known as *repoussé*). The beaten shape was enclosed in concentric circles with chevrons or dot motifs. Lunulae, on the other hand, were crescent-shaped ornaments worn as necklaces and decorated with skilfully chiselled geometric patterns.

The wedge tombs associated with the late Stone Age continued to be constructed, as were stone circles, which can be found in Cork, Kerry and throughout Ulster. While the circles in Britain, such as those at Stonehenge, were made from massive stones, the Irish circles used smaller stones. The remains of the dead were buried at the centre of the circle. The wedge tomb was also a ritualistic place used for worshipping the sun, the shape of which is echoed by the placement of the stones in a round.

Around the seventh and eighth centuries BC, the counties bordering the lower Shannon were at the heart of an important gold industry. Advanced techniques were often used to make some of the most popular items. For instance, gold-ribboned torques were found many centuries later on the Hill of Tara. Used as neck decorations, these torques were made by beating out a ribbon of gold that was then twisted along its length, curved around into a circle and fastened at the free end. Elegant bracelets, sleeve fasteners, sunflower pins and hair-rings were also popular – all of them works of extraordinary finesse.

Of the larger items produced, gold gorgets **(Pl. 2)** are striking for their elaborate decoration. Although most of the ornamental metalwork is in gold, some of the same motifs can be found on large bronze objects such as circular shields and cauldrons as well as some weapons.

The art of this period reflects a society whose craftsmen were superbly gifted. The buyers of this ornate jewellery were clearly a people of wealth and taste. On the other hand, the need for weapons is indicative of a growing warrior class determined to seize and maintain power.

Iron Age (*c.* 500 BC–*c.* AD 430)

The prevalent use of iron marks the beginning of what is known as the Iron Age. More durable than bronze, iron offered an advantage in weaponry and engineering. The first wave of iron-using Celts arrived in Britain and Ireland *c.* 500 BC, with a second wave following about 200 years later. They came from the loosely knit Celtic people who had settled across Europe as far east as Slovakia and Hungary. Although they never came together as an empire, their culture was highly influential; it effectively wiped out the existing culture of Ireland's Bronze Age within a few hundred years.

The Celts were a warlike people, and during the Iron Age they extended their territories and kingdoms throughout the island. Most kingdoms were fortified, often on hilltops where the enemy could be more easily spotted. These fortifications also provided refuge for local communities when necessary. Today the most significant of the larger sites, consisting of burial mounds and enclosures, is to be found on the Hill of Tara, Co. Meath – an important location from Neolithic times onward. Tara was a royal enclosure and the seat of the high kings of Ireland. Not surprisingly, the location held great mythological and symbolic significance.

Given the warlike culture of the early Celts, weapons, shields, spears and swords abounded, fashioned mostly from iron. But decorative metalwork continued to be made from bronze and many personal ornaments were made from gold.

From *c.* 300 BC, there is evidence of a new style of decoration, brought to Ireland by the second wave of Celts. Known as the La Tène style, it is named after a Celtic site in Switzerland. It employs a highly organic, curvilinear design with flowing curves and abstract leaf-like patterns. While influenced by natural forms, these were transformed by artists into attractive semi-abstract motifs. Unlike the Classical art of Greece and Rome where realism was paramount, Celtic artists had a preference for pattern, symbol and stylised forms. The Celtic warrior ornamented not only his weapons, but equipment for his horse and personal items as well. The decoration of these princely objects reached an apex by the first century AD with objects like the Petrie Crown **(Pl. 3)**.

La Tène art was not solely confined to metalwork. The style can also be found on carved stones, such as the Turoe stone in Co. Galway. An early Iron Age work, this curved stone is 1.68 metres high and is highly decorated with spirals, circles, curves and other motifs. The patterns are in relief, the stone having been expertly picked back from the surface. It is thought to have affinities with other carved stones in Britain.

Rock fragments, known as Ogham stones dating from the fourth century, were probably erected as symbols of status or territory. They are also proof of a distinctive Celtic script made up of a series of strokes at the angle of the stone, starting at the bottom left side, working its way upward and downward on the right angle, with no word separation. These marked stones were used as evidence in legal proceedings and for the inheritance and ownership of land.

Early Christian and Later Medieval Art (*c.* AD 430–*c.*1640)

Early Christian Art (*c.* AD 430–*c.*1200)

The Christian faith came to Ireland via the Roman Empire (Britain and Gaul). The first to arrive was St Palladius (known as Bishop of Ireland), sent by Pope Celestine in AD 431. Other bishops followed, the most important being Ireland's patron saint, St Patrick, who was active during the second half of the fifth century. By the middle of the next century, Irish Christianity was thriving and Irish missionaries travelled to Britain, France, Switzerland and Italy where they established monasteries. This monastic movement affected the structure of life in Ireland as monasteries were gradually built in carefully considered locations throughout the country. The monasteries served as villages, with the dwellings of the local people housed within their enclosures. Under the patronage of these institutions and a wealthy elite, the talents of artists, sculptors and craftsmen were applied to supplying the needs of the settlements. Some of the finest early medieval art, including decorated manuscripts and artefacts of gold, silver and stone, were produced during this period.

Metalwork

Early medieval metalwork showed a virtuosity of design and technique, both in objects for personal and religious use. One of the most impressive personal objects is the Tara Brooch (*c.*700, National Museum of Ireland). Made for a wealthy patron as a visible expression of status, it is composed of cast and gilt silver and elaborately decorated on both faces. Extremely fine gold filigree panels embellish the front, depicting animal and abstract motifs separated by glass, enamel and amber. The back consists of scrolls and

triple spirals recalling La Tène decoration. Many of the same designs can be seen on the magnificent Ardagh Chalice from around the same time **(Pl. 4)**.

Among the wealth of medieval metalwork on view in Ireland are some exceptional reliquaries or shrines. The practice of worshipping relics, ongoing since the coming of Christianity to Ireland, required these shrines to be carried from place to place. The containers protected and honoured the bodily remains or objects associated with a saintly person. Their symbolism was a powerful one: not only were they used in processions, for healing purposes and as battle talismans, but their mere presence sanctified and legitimised oath-taking, collecting taxes and formulizing treaties.

The largest surviving reliquary is the shrine of St Manchán, now preserved in the Catholic church at Boher, Co. Offaly. The shrine was created in 1130 at the monastic settlement at Clonmacnoise and contains some of the saint's remains. It is considered a masterpiece of Irish Christian Art.

The Cross of Cong (National Museum of Ireland), also from the same period, was made to enshrine a relic of the purported True Cross sent from Rome *c.*1123. The Cross of Cong is considered to be one of the great treasures of Irish medieval metalwork. It was used for processions but may have been employed as an altar cross. It has a core made of oak that is covered in plates of cast bronze decorated with interlacing animals in the Norse style. A rock crystal is set at the junction of the cross. The crystal is semi-transparent to allow the relic to be partially seen by the worshipper.

Manuscripts

Books were another essential church item and the original missionaries undoubtedly brought some religious manuscripts with them to Ireland. These were not only copies of biblical texts but also transcripts needed for use in the Mass and other liturgical ceremonies. By the sixth century, however, Irish monks had developed a distinctive script in the copying of religious texts and began to decorate the initials in an individualistic style.

The earliest known Irish manuscript is the *Cathach of Columba*, a copy of the psalms from the late sixth century (Royal Irish Academy). The script is drawn in red and brown

ink and the enlarged initials are adorned with simple spirals and trumpet scrolls, similar to those decorating hand-pins and brooches of the same period.

The *Book of Durrow* (*c.*700, Trinity College Dublin) shows the development of a more sumptuous style of decoration. This small manuscript of the gospels is lavish in its illumination. It was preserved for centuries at the Columban monastery at Durrow, hence its name. Each gospel begins with a page designed like an elaborately patterned carpet with a full-page symbol of each evangelist. There are extravagantly designed initials throughout the book.

However, an even more spectacular illumination is to be found in the *Book of Kells*, produced *c.* AD 800 **(Pl. 5)**. This was completed at the Columban monastery of Iona in Scotland where the first Viking raids occurred *c.* AD 795. The book was then brought to its sister monastery at Kells, Co. Meath. Sadly, the destruction and plundering of the early raiding parties resulted in the gradual decline of the art of illumination. By the time of the dissolution of monasteries under Henry VIII after 1530, this form of art had ceased.

Sculpture

Yet another vital visual testament of Christianity in Ireland is the stone cross. This form of religious art outlasted the Viking invasions (which themselves lasted until the turn of the tenth century). A cross was regarded as a status symbol of either a monastery or a patron or sponsor. Located in sacred places, it was a focal point for religious rituals of all kinds. The earliest crosses in Ireland were made of wood and metal and were in slab form. A seventh-century cross in the graveyard in Carndonagh, Co. Donegal, is representative of the transition from the slab form to those carved out in a shape resembling that of a cross. It also epitomises the continual stylistic crossover of early Irish art in paint, sculpture and metalwork. The Carndonagh cross has a braid pattern closely resembling the interlace on the *Book of Durrow.*

From the beginning of the ninth century, the free-standing cross had supplanted earlier forms. Carved from one or more blocks of stone, this kind of cross can be distinguished by the ring that encircles the arms and upper shaft. Increasingly, the cross contained figure sculptures denoting biblical scenes. These were carved alongside abstract

patterning, the latter derived from metalwork decoration. The Old and New Testament depictions were chosen for their symbolic meaning as well as to aid the teachings of Christianity for the many who could not read.

As the century advanced, Irish sculptors were increasingly influenced by Carolingian ivories and frescoes observed by Irish monks who had visited Continental Europe. These designs were transferred to monumental carvings on granite and sandstone. Crosses at Kells in Co. Meath, Durrow in Co. Laois and Clonmacnoise in Co. Offaly display significant narratives from the Old and New Testaments sculpted on each facet. The crosses are perfectly architecturally proportioned. However, it is the Cross of Muiredach in Monasterboice, Co. Louth, that is the most spectacular example of the free-standing type **(Pl. 6)**.

In the eleventh century, religious reform started to replace the age-old monastic organisation and bishops became more powerful. Reforming kings in Ulster and Munster supported the efforts to establish episcopal dioceses with fixed borders and sees. Interestingly, this shift is reflected in the decoration of crosses from the late eleventh century onward.

The cross was now treated as a crucifix with the figure of Christ in high relief. Representations of bishops complete with crozier were carved in prominent places. These new features can be seen on the twelfth-century Dysert O'Dea Cross near Corofin, Co. Clare. Underneath the figure of the crucified Christ is an imposing depiction of a bishop (or abbot) holding a pointed mitre. Large panels of ribbon-shaped intertwined animals in the Viking style add a stylistic richness to the carved object. During the Viking occupation of Ireland from the eighth to the late tenth century, their style of art enriched existing design features in Irish art.

The Normans arrived from England and Wales c.1169 and by the end of the century much of the country was under their control, with only small areas remaining in Gaelic hands. During the second half of the thirteenth century, the Irish fought back. The result of this constant warring meant that less money and leisure were available for fostering artistic projects. However, like the Vikings before them, the Normans put down roots in Ireland and eventually both elements of society co-existed, the Anglo-Normans and the Gaelic chieftains side by side.

Later Medieval art (c.1200–c.1640)

Metalwork continued to be produced in the later Middle Ages. In Limerick, Bishop Cornelius O'Dea was responsible for the creation of two more of the finest ecclesiastical works of art to survive from late medieval Ireland, the Limerick crozier and mitre (c.1418), both of which are on display in the Hunt Museum in Limerick. The end of the fifteenth century also saw the production of more fine metalwork. A splendid example is the great processional cross from Ballylongford, Co. Kerry dating from 1479 (National Museum of Ireland). Made of gilt silver, it depicts an elongated figure of the crucified Christ enclosed by the symbols of the four evangelists. Figures of Franciscan friars decorate the base. A nobleman and his wife Avellino, daughter of the Knight of Kerry, gave it to the Franciscan friary at Lislaughtin, Co. Kerry. This joint act of generosity marked a new importance for women of noble birth, as they emerged as patrons of monasteries and abbeys.

What distinguishes the later medieval period is the building of large numbers of castles and churches. The arrival of new orders such as the Franciscans and Cistercians resulted in an increase of abbeys and churches. The fifteenth-century abbey at Holy Cross near Thurles, Co. Tipperary, is noteworthy because it contains one of the country's few late medieval frescoes in the north transept. The hunting scene theme was quite usual in the decoration of monasteries and churches at this time. Tomb sculpture enjoyed a revival from c.1450 onward, with the best representative collection in St Canice's Cathedral, Kilkenny.

A break in the production of Irish art

By 1500 most of Ireland lay outside the ambit of English royal power. The rest of the country was run more or less by the Catholic Anglo-Normans and Gaelic chieftains. But within a century the influence of the former had been broken and Tudor forces had overcome the Gaelic strongholds. The seventeenth century saw almost continuous land confiscation, plantations, religious revivals and repression. These disturbances left their mark on the production of art, particularly in the first five decades, so much so that the scarcity of extant painting and sculpture from this period has meant that the history of Irish art cannot be narrated as a coherent, unbroken story from the ancient past to the present day. In fact, its history is one in which political, social and religious events at times directly or indirectly affected its production and changed its course.

Art for a New Age (1660–1799)

Art for an aristocracy

After the restoration of King Charles II in 1660, the next 25 peaceful years in Ireland resulted in the promotion of the arts once again. The arrival of James Butler, Duke of Ormond, as Viceroy of Ireland in 1662 was instrumental to this revival. He and his wife Elizabeth Preston were great patrons of the arts. They built up collections both in their English and Irish houses, eventually owning about 500 pictures.

The Butlers are key figures in the establishment of a taste for French, Flemish and Dutch art in Ireland. The couple were in touch with the big names in English art, commissioning painters Peter Lely and John Michael Wright and the sculptor Grinling Gibbons to do works for their home in Kilkenny Castle. Surviving inventories and descriptions reveal that these decorations were lavish, including tapestries, hangings, pictures, furniture and plates. The Butlers' artistic activities triggered interest by other wealthy people, who emulated this 'taste' in their own town and country houses.

In 1690 the outcome of the Battle of the Boyne resulted in the overthrow of Catholic King James II and the establishment of the Protestant William of Orange on the English throne. This series of events vanquished any remaining traces of Catholic influence in Ireland and England until political independence in 1922. From this time on, the Protestant Ascendancy controlled political power in Ireland. The parliament met regularly in Dublin, although legislation was subject to approval in Westminster parliament in London. Incongruously, the passing of the Penal Laws that denied Catholic civil and religious rights was to introduce a long period of relative peace. The new century saw the rich minority express their wealth through patronage of the arts as well as keeping up to date with the styles and fashions of London.

By the mid-eighteenth century, Dublin, Cork, Waterford, Limerick and smaller towns reflected a new elegance not only in the design of their Georgian buildings, but also in

their well-appointed interiors. Dublin was now regarded as the second city in the British Isles, with its own parliament and a glittering viceregal court. Fortunately, artist James Malton recorded many of the new public buildings of the age in coloured prints between 1792 and 1799. These views remain popular today, with copies of the original prints now adorning placemats and dishcloths aimed at the tourist market.

Establishment of Dublin Society Schools

The establishment of the Royal Dublin Society in 1731 contributed much to the flowering of the arts. It aimed to foster 'Husbandry, Manufactures and other Useful Arts' as well as encourage industries of all kinds and sponsor research. It also awarded premiums for exceptional talent. In 1750 the Society took over the running of Robert West's private school of art, renaming it the Dublin Drawing Schools. West stressed the importance of good draughtsmanship and trained his students in crayons and chalks. The Dublin Schools offered free tuition to pupils in architectural, figure, landscape and ornamental drawing as well as sculpture. Every year the students' work was publicly exhibited. The Schools also provided an important stream of patronage for the visual arts. It went on to serve as the foundation of the Dublin Metropolitan School of Art, which today is known as the National College of Art and Design.

The Schools encouraged Irish talent and strongly influenced the next generation of artists, although they did not teach oil painting and students had to apprentice themselves to established artists to become proficient in this medium. Among the early students associated with the Dublin Society is Susanna Drury **(Pl. 7)**. She was awarded a premium in 1740 for her remarkably detailed views of the Giant's Causeway in Co. Antrim. Another prizewinner seven years later was George Barret, who was to become a major force in the development of landscape painting **(Pl. 8)**.

Early developments in landscape painting

Landscape painting was much sought after from the 1750s on and remains hugely popular today. Initially, topographical landscapes were much in demand, including views of Irish towns, forts and garrisons. These early works show the influence of Dutch landscape painters working in England. The depiction of grand Irish houses with their

carefully manicured parks and demesnes were also popular among wealthy landowners. They liked the painted landscapes to reflect their skill at having single-handedly tamed nature and turned their land into an agrarian utopia. There was little or no reference to the many workers who had toiled to realise the landowners' ambitions.

Another hugely important inspiration in the development of landscape art was the orator and philosopher, Edmund Burke. His seminal work, *Philosophical Enquiry into the Origin of our Ideas of the Sublime and Beautiful* (1757), defines 'the Sublime' as the moment when the imagination is moved to awe or horror by dramatic elements of nature. Conversely, 'the Beautiful' is anything well-formed and pleasing in nature. These concepts introduced a new way of seeing art and literature that would carry well into the next century and beyond.

Sculpture

Since medieval times, sculpture has been used as a decorative feature for architectural, religious and commemorative purposes. It flourished in this century of urban development. However, at a time when there were fewer commissions for devotional sculpture, the portrait bust became extremely popular.

The way in which the male sitter was portrayed might signify his professional or aristocratic status. For instance, ancient Roman dress could imply a role in public life (reflecting the huge revival of interest in the classical past of ancient Greece and Rome). Women, less often depicted, were usually shown in their role as the wife of an aristocratic husband. The sculptor Patrick Cunningham, another award-winning student of the Dublin Schools, is best-remembered for his arresting bust of Dean Jonathan Swift **(Pl. 9)**.

Historical themes

Paintings or sculptures that alluded to important historical events, classical literature or the Bible were regarded by art academies across Europe as the highest and most worthwhile kind of art. Consequently, reputations and the highest fees were to be

obtained by securing a historically themed commission. In spite of this, landscape and portraiture remained more popular than any other artistic category as most patrons were far more interested in having pictures of themselves, their families and their lands hanging in their hallways and reception rooms. They had greater personal meaning and were less expensive to purchase. One Irish artist above all was passionate about promoting historical painting as a category in Britain and Ireland. This was James Barry of Cork, who had been a pupil at the Dublin Schools and spent much of his career in London, often mired in controversy **(Pl. 10)**.

Later developments in landscape painting

Paintings that evoked the atmosphere of a landscape rather than detailing the topographical minutiae were also popular in Ireland. These views relied on the imagination of the artist coupled with sketches made while on trips to picturesque places. In their studio, the artist would contrive an 'artful' view where time seemed to have stood still, resulting in a dominant mood of tranquility or nostalgia. Tiny figures and animals in various guises were included to add a human dimension to the scene. Besides producing superb topographical landscapes, Thomas Roberts was the greatest exponent of the imaginative landscape **(Pl. 11)**.

Artists working in England and Ireland

There was a great deal of contact between English and Irish artists, both painters and sculptors. Many Irish artists travelled to London and had successful careers there. Equally, English artists came to Ireland in search of commissions or to settle in the country. However, the prospect of greater distinction in London and elsewhere tended to encourage emigration. Artists in Ireland regularly sought work through newspaper advertisements, often announcing they had returned to Dublin having painted elsewhere in the country or in London. One Irish artist who made a name for himself in London was Nathaniel Hone **(Pl. 12)**. One of the founding members of the Royal Academy of Arts (1768), Hone exhibited his work there every year until his death.

Portraiture

The development of portraiture in Ireland took a different route to that of landscape painting. As in other countries, portraits up to the second half of the eighteenth century were not simply intended to convey a likeness, but more importantly emphasised the status, power and wealth of the male sitters. Portraits of married women of this class concentrated on their looks and fine clothes (no doubt reflecting their husband's good taste in both) or they were depicted as female characters in mythology.

One of the early portrait painters working in the early eighteenth century was Charles Jervas of Irish Protestant gentry stock. His career was principally in London where he trained under the leading portrait painter Godfrey Kneller. After the latter's death, Jervas was appointed principal portrait painter to King George I (1723). He returned to Ireland on occasion, where members of the Irish parliament and other powerful figures were among his sitters. A number of these portraits can be seen in the National Gallery of Ireland.

James Latham was the most gifted portraitist in the first half of the eighteenth century, showing an ability to capture the characteristics of the sitter. As in landscape art, the Dublin Society Schools produced some fine portraitists in the second half of the century, among them Hugh Douglas Hamilton, James Barry and Thomas Hickey **(Pl. 13)**. The painting of portraits in miniature was also very popular with patrons, and was chiefly carried out in Dublin, Cork and other prosperous cities throughout Ireland.

The Grand Tour

From the 1760s onward, wealthy young men of means from Ireland and Britain travelled to the Continent on what was known as the 'Grand Tour'. This event was intended to complete the classical education they had received at home. (However, it would be the following century before it became part of the education of women from this privileged class.) Trekking through France to Italy with a guide, the men gained first-hand experience of ancient and renaissance works of art and architecture. With their unlimited funds they were able to buy art, books, pictures and sculptures, which were then shipped back to their homes and displayed proudly.

By the mid-century the Royal Dublin Society had understood the importance of exposing their students to Continental art. Among them was Hugh Douglas Hamilton. He spent time in Rome and became a highly successful Grand Tour portraitist **(Pl. 14)**. The work of those who had attended the Dublin Society School of Landscape and Ornament was also in great demand from patrons anxious to own views of places visited on the artists' tours, such as Tivoli near Rome.

Towards a Distinctive
Irish Art (1800–1899)

Art following the Act of Union

In 1800 the Act of Union united England, Scotland, Ireland and Wales, creating the United Kingdom of Great Britain. All regional parliaments were abolished, and the entire United Kingdom was ruled from a centralised London parliament. This meant that Irish representatives now had to travel to the Palace of Westminster during parliamentary sessions. With this came a change of patronage for artists, shifting from a mainly aristocratic to an emerging mercantile class.

This group was largely made up from the Protestant professional classes (Catholic patronage would be more gradual). The new patrons did not own vast estates or big houses, and their education differed from the classical education of aristocratic buyers and collectors. While historical paintings and portraiture continued to be supported by aristocratic patrons, these new buyers of art preferred everyday subject matter and still life. Landscape continued to be very popular with all classes of patron.

Whereas painting and sculpture continued in Ireland after the Act of Union, there was some fallout from its implementation. The Dublin Society experienced financial problems and suffered from a lack of state support. Portraiture became less popular and many artists had to take up teaching. A number of Ireland's best artists sought to make careers for themselves abroad. Some achieved success, such as the sculptor John Hogan who worked in Rome from 1824 to 1849. Hogan was assured his international reputation in 1829 with his superb carving of a recumbent dead Christ **(Pl. 15)**.

Later in the nineteenth century, no less than four Irish sculptors would work on the Albert Memorial in London. The painter Francis Danby gained a reputation in Britain for his imaginative, dramatic landscapes. Others, including his two friends James Arthur O'Connor and George Petrie who had spent time in England, were obliged to return home having failed to attract enough patrons overseas.

Establishment of new Irish art institutions

From the 1820s better facilities were created for Irish artists. The Royal Hibernian Academy was inaugurated in 1823 and its annual exhibitions proved to be, and still are, an important venue for Irish art. The Schools of the Royal Dublin Society continued to produce talented fine artists, especially watercolourists. In 1849 the Schools were reorganised as a Government School of Design. Its emphasis on design, rather than on painting and sculpture, aimed to raise the quality of design for manufacture. Meanwhile, training for fine artists was to be found at the Royal Hibernian Academy Schools. Later in the century the Government School of Design became the Metropolitan School of Art, where the arts and crafts flourished well into the twentieth century. Schools of Design also opened in Cork and Belfast in 1850.

The National Gallery of Ireland opened its doors to the public in 1864, where it was hoped that artists would learn from the great art on display (both originals and copies) and that this interaction would help them to create an art of superior quality. Equally, the general public was encouraged to visit the gallery and appreciate the paintings and sculptures on view. This sentiment was in keeping with the fervent Victorian belief that the moral well-being and improvement of the masses would be enhanced by contact with the fine arts.

In the same spirit, the National Museum opened in Kildare Street in 1890. The new museum housed coins, medals and significant Irish antiquities from the national collection of the Royal Irish Academy, including the Tara Brooch and the Ardagh Chalice. The collections of the Geological Survey of Ireland were also transferred to the new museum, as was material from the decorative arts and ethnographical collections of the Royal Dublin Society, including antiquities, minerals and plants.

Cultural nationalism and the visual arts

Stylistically, Irish painting and sculpture followed developments in England. Training in both countries was identical, as was the taste of many of the patrons. In fact, the only way to distinguish between Irish and British art was by subject matter. In 1843 three important essays on producing a distinctive Irish art appeared in *The Nation*, the weekly nationalist newspaper, penned by its editor, Thomas Davis. Davis was a founding member of the Young Ireland movement, an association that sought the repeal of the Act of Union and wished to promote an Irish ethnic and cultural nationalism. The newspaper provided a platform for its editor to outline the role of art in the cultural life of the nation.

As part of a series of articles on history, art, music and literature, Davis argued for a distinctive national art. He wanted to transform painting and sculpture and make it central to the project of nationalism. He focused on subject matter and listed Irish historical themes, past and present, that he considered suitable for consideration.

However, historical painting as the basis for a national art was taken up by very few artists in the decades that followed. There was little appetite in the art market in Britain and Ireland for that type of subject matter, with everyday scenes and landscapes being firm favourites. As a result, no distinctive Irish school of art emerged in the mid-nineteenth century. These efforts would meet with much greater success in the early years of the twentieth century, in the periods before and after political independence.

Some artists did heed Davis's writings, most notably George Petrie. Through his illustrations for Irish travel books, drawings of ancient ruins and collection of folk music, Petrie helped to strengthen a Gaelic identity for Ireland. Above all, his detailed research and writings on Irish archaeology and antiquities, together with the bringing to light of important early Irish manuscripts and Celtic metal work, helped to form a distinct link between the historical past and present **(Pl. 16)**.

Another artist who followed Davis's advice on subject matter was Joseph Patrick Haverty. He depicted a number of paintings with nationalist overtones, including several portraits of the contemporary Catholic politician Daniel O'Connell **(Pl. 17)**.

O'Connell had successfully campaigned for Catholic emancipation, including the right for Catholics to sit in the Westminster parliament, which had been denied for over a hundred years. In the early 1840s he fought to have the Act of Union repealed.

The best-known Irish history painting of that period was by Cork-born Daniel Maclise in London. It depicts the twelfth-century story of the marriage of the daughter of the King of Leinster to the Earl of Pembroke, an event popularly believed to have changed the course of Irish history **(Pl. 18)**.

It was George Petrie who introduced his friend, painter Frederick William Burton, to the study of antiquarian remains and Irish landscape. In his capacity as Director of Topography (antiquities division) for the Ordnance Survey, Petrie brought Burton on sketching trips around the west coast (1833–43). Burton completed a number of Western paintings depicting romantic scenes of peasant life. Like Petrie, he was on both the Council and the Committee of Antiquities in the Royal Irish Academy. Thomas Davis had hoped that Burton would lead the way to the creation of a distinctive Irish art but he left Ireland in 1851, spending several years in Germany before settling permanently in London. Nowadays it is Burton's painting inspired by a medieval Danish ballad, rather than one of his Irish subjects, that is best remembered **(Pl. 19)**.

Irish Impressionism

Although Irish artists continued to look to England for extra training and work, the course of Irish art underwent yet another change of direction. From the mid-nineteenth century, following their training at home, students began travelling to the Continent to continue their art education and to familiarise themselves with the great art of the past. Increasing numbers travelled to Paris and Antwerp, sometimes via London. This movement was not confined to Ireland. Students from Britain, the United States, Russia and other European countries converged increasingly on the French capital.

Rome had been the capital of the art world in the eighteenth century. Now Paris supplanted it and attracted artists from across the western world, who arrived to educate themselves and seek inspiration from its artistic resources and galleries. A collection of antique sculptures and Old Master paintings in the Louvre were available

to students for copying. Tuition was offered either at the official École des Beaux-Arts or in the many private academies (*ateliers*) across Paris. The art salons and other exhibition venues provided ideal places to attract new buyers and make a reputation. Moreover, the exciting new trends in style and subject matter explored by avant-garde French artists throughout the century enticed the foreigners in their midst to investigate these ideas for themselves.

Painting directly from nature and in natural light rather than in the evenly controlled light of the studio was one of the exciting concepts championed by a group of artists known as the Barbizon. From 1830 these artists chose to settle in the area of Barbizon, a rural retreat from the urban busyness of Paris. By the 1870s a younger group of artists, later called the French Impressionists, were advocating an accurate description of light and its changing qualities by means of a high tonal range to replicate the colours of the rainbow. Historical paintings gave way to the celebration of ordinary, everyday life.

Irish artists travelling to the Continent generally tended to spend time in artists' colonies in the countryside as well as study in Paris or Antwerp. The forest of Fontainebleau and the area along the river Loing were both close to Paris by train. Picturesque Brittany and Normandy also appealed. Among the first to arrive in Paris in the 1850s was landscape artist Nathaniel Hone. He attended the studio run by painter Thomas Couture, an early exponent of realism. Couture encouraged his students to paint what they saw, rather than idealise or classicise the landscape. This, along with visits to the Barbizon colony, would influence Hone's interpretation of the Irish landscape when he returned to Dublin.

The Académie Julian was run by Rodolphe Julian, an artist who did not favour the long introductory studies required for entrance into the École des Beaux-Arts. Attending his life-drawing classes were Harry Thaddeus, Frank O'Meara, Sarah Purser and Sir John Lavery. This tuition in nude studies provided a sounder base for students than classes offered in the British and Irish art schools. Thaddeus visited Brittany where he sketched scenes of peasant life **(Pl. 20)**, while Purser would go on to be a successful portrait painter in Dublin. O'Meara and Lavery visited the unspoiled region of Grez-sur-Loing in the 1870s, the latter remaining there for eleven years. Their pictures, which involve a detailed study of nature, light and local village life, are especially evocative of that period.

Interestingly, this eagerness to extend one's artistic horizons was not confined to male artists. By the second half of the nineteenth century, women from the wealthy classes across Europe and the United States were beginning to break the barriers that had previously confined them to the domestic arena. Few women had made it as professional artists in the previous century and those who did almost always came from a family of artists.

In Ireland, as elsewhere, women lacked the same opportunities as men for training, exhibiting and patronage. The study of art for girls was limited to being considered an accomplishment, as was the rest of their education. It was 1893 before women were allowed to enter the Royal Hibernian Academy Schools and, even so, they were barred from anatomy classes on the grounds of sexual decorum. This greatly limited their chances of making a successful career in the art world, given that success in academic art hinged on the painting and sculpting of figures in a convincing three-dimensional style.

The Irish women who travelled to Paris to study art, especially life drawing, came from similar Protestant and well-off backgrounds. A degree of financial independence enabled them to further pursue art, but in so doing they were obliged to turn their backs on contemporary social conventions and lead independent lives. They almost never married and few became mothers. Thanks to the widespread belief that only men possessed innate artistic genius, female artists rarely received serious critical attention during their lifetime (the critics being invariably male).

Dubliner Sarah Purser, who studied at the Metropolitan School of Art, wished to become a portrait painter. She went to Paris and joined the Académie Julian, which had a separate top-floor studio where female artists could practise life drawing. Some of Purser's early portraits show an awareness of contemporary French painters **(Pl. 21)**.

The novelist Edith Somerville, also a fine artist and illustrator, studied in Paris. Her painting *The Goose Girl* demonstrates an absorption of French Peasant Realism **(Pl. 22)**. Harriet Osborne became a student at the studio of Thomas Couture. Although primarily a portraitist she showed a sensitivity to landscape. Osborne became an art teacher and is believed to have opened the first academy for women artists in Paris.

Helen Mabel Trevor, a student of the portraitist Carolus-Duran, produced many sensitive portraits and appealing domestic scenes of Brittany.

Antwerp was the second location that attracted Irish artists. The Académie Royale gave tuition in figure and landscape, sculpture and architecture, as well as the crafts. The emphasis was on careful drawing and a realistic style. Students were encouraged to travel around Belgium and paint outdoors. Walter Osborne registered at the Académie in 1881. Within two years he was sending nine Flemish pictures – canal and farmyard scenes from around Antwerp and Bruges – to the annual exhibition at the Royal Hibernian Exhibition. Later in his career, he would paint the everyday world of Dublin in a way that was directly influenced by Impressionism **(Pl. 23)**.

Interestingly, Irish artists who incorporated French avant-garde ideas did not necessarily interpret the Irish countryside as a metaphor for nation and nationhood. Their primary motive was a study of nature and the effects of light, yet this was a country that increasingly sought a distinctive national identity for itself. As part of that identity, the land, especially the West, had become a symbol of tangible difference from the rest of the United Kingdom. In post-famine Ireland, land agitation increased between tenants and landlords, especially those landowners who were largely absent from their estates. However, few artists directly depicted the harsher realities of life or the increasing political tensions over land. Buyers and patrons wanted appealing subject matter, not pictures that stirred up negative emotions or made them feel uncomfortable.

Among those who did tackle a more realistic subject matter was Harry Thaddeus, who painted a dramatic painting of an eviction (private collection). Aloysius O'Kelly, who studied at the École des Beaux-Arts, came from a radical nationalist background and some of his work depicts the life of the peasant in post-famine Ireland **(Pl. 24)**. James Brenan, who had trained in London, mainly confined himself to everyday subjects and depicted empathetic pictures of cottage interiors that alluded to the reality of Irish peasant life **(Pl. 25)**.

Meanwhile, artists like Nathaniel Hone (the Younger) were entirely aesthetically motivated, with Hone's depictions of locations in north county Dublin and elsewhere being pure studies in light **(Pl. 26)**. Likewise, the vividly painted French and Welsh landscapes of Roderic O'Conor are defined by a strong expressive aesthetic **(Pl. 27)**.

The Modern Age (1900–2000)

Continuity and change

In 1900 art dealer and collector Hugh Lane, a nephew of dramatist and folklorist Lady Augusta Gregory, visited an exhibition in Dublin. It displayed works by two important nineteenth-century artists, Nathaniel Hone the Younger and the portraitist John Butler Yeats (father of Jack B. Yeats). The painter Sarah Purser had spearheaded the show in the hopes that the beginnings of a distinct Irish school of painting might emerge from an admiration of their work.

This exhibition was to prove pivotal in the advance of Modernism in Ireland. The critics were impressed by Hone's fresh naturalist landscapes and by Yeats's ability to depict the character and personality of his sitters. Hugh Lane was so captivated that he commissioned Yeats to paint a series of distinguished Irish contemporaries in order to provide the basis for an Irish national portrait collection (later completed by portraitist Sir William Orpen).

Lane developed a great interest in Irish art and, in order to demonstrate that Ireland had a strong visual tradition as well as a literary one, he set up a large exhibition in London's Guildhall. Among the works on display were examples by Nathaniel Hone, Walter Osborne, John Lavery, William Orpen and Jack B. Yeats. Lane then lobbied for a modern art gallery in Dublin to house the Continental, British and Irish works in his collection. He hoped these would influence the next generation of Irish artists and critics. Lane was also to the forefront of an exhibition of modern art in Belfast in 1906, where there was a growing hope that the city would soon establish its own modern art gallery.

The Dublin gallery opened in 1908 in a temporary site in Harcourt Street, but Lane wanted a permanent site in a building to be run by Dublin Corporation. When the Corporation rejected two proposed sites, Lane withdrew his 'conditional gift' of

thirty-nine French paintings and decided instead to present them to the National Gallery in London.

However, during his short but energetic term as Director of the National Gallery of Ireland (1914–15) he changed his mind and added a codicil to his will, leaving the works to Dublin. Unfortunately, the codicil was not witnessed and, before this could be rectified, Lane drowned while returning from America on the passenger ship *Lusitania*. It was torpedoed in May 1915 off the Old Head of Kinsale, Co. Cork.

Among the most successful artists at the turn of the twentieth century was the portraitist and landscapist John Lavery. He had trained in Paris in the 1880s and spent time in Grez-sur-Loing, painting some major pictures including the magnificent *Bridge at Grez* in 1901 (Ulster Museum, Belfast). Lavery's professional progress spans both London and Dublin. Of the large portraits he painted, *The Artist's Studio*, in which he portrays his family, is visually impressive in the satisfactory arrangement of figures in an immense picture space **(Pl. 28)**.

That connection with the near past continued with the sculptor Oliver Sheppard, who studied at the Dublin Metropolitan School in the late 1880s and joined the Académie Julian in 1891. He spent time teaching in England but returned to live in Dublin in 1902, where he became the leading teacher of sculpture. A number of his sculpted subjects are directly inspired by themes charged with romantic and national feeling **(Pl. 29)**.

William Leech had been a pupil of Walter Osborne at the Royal Hibernian Academy Schools in 1900. His masterly skill at handling colour and depicting the effects of strong light and shade are captured sensitively in many of his paintings **(Pl. 30)**. He later declared that it was Osborne who taught him all he needed to know about painting.

The painting of 'the West' and a nationalist art

Pivotal to the history of establishing a distinctive school of Irish art was Belfast landscape painter Paul Henry. His abiding interest in depicting the west coast of Ireland would

be continued by other major northern artists, such as James Hubert Craig, Maurice Wilks and, later, Gerard Dillon, as well as painters from the south.

Henry was undoubtedly the most influential landscape artist of the twentieth century. His 'way of seeing' determined for decades how others would interpret Ireland and, in particular, 'the West', which he believed represented 'the real soul of Ireland'. Initially, his paintings concentrated on the activities of the hard-working men and women living in this semi-remote place. But gradually the landscape itself preoccupied him, and he painted compositions in which the different forms of terrain and the many transitory light effects became dominant themes **(Pl. 31)**. On the other hand, the paintings of his artist wife Grace show a more contemporary awareness with her highly coloured scenes of the everyday life of local women.

Other artists who travelled to the West include Seán Keating, William Orpen and Jack B. Yeats. Seán Keating's representations of the West are instilled with nationalist fervor, as are his paintings relating to the War of Independence (1919–21) and the Civil War (1922–23) **(Pl. 32)**. Orpen's reputation rests on the quality of his British and Irish portraits **(Pl. 33)**, but he did paint a number of important 'Irish' canvases, such as *The Holy Well* (1916, National Gallery of Ireland).

Charles Lamb set about creating a new cast of modern rural Irish folk from about 1920 and his love affair with Connemara resulted in him settling in the area. Maurice MacGonigal, who had taken an active part in the War of Independence, had a deep-rooted sense of his own national identity. This determined the character of his western paintings. Up to 1920 western subjects were a dominant theme in the work of Jack B. Yeats.

During the 1920s after gaining independence for twenty-six out of the thirty-two counties in Ireland, the West became an even more significant theme within the wider context of nationalistic aspirations. Seemingly far-removed from the urban bustle of towns and cities, this location coincided with the new concept of Irish identity. Ireland was officially promoted as a rural utopia, where a sturdy, pious people lived simple lives and spoke Irish. Simply put, it was the antithesis of everything Britain was: urban, cosmopolitan, English-speaking and Protestant.

The advent of Modernism

Many of the developments in Irish art occurred thanks to the zeal and wholehearted commitment of artists such as Sarah Purser, Mary Swanzy, Mainie Jellett, Evie Hone and Norah McGuinness amongst a host of other talented women. While artists in their own right, these women were also active and influential as organisers and crusaders for the various artistic causes of that time.

Because of the conservative nature of the Royal Hibernian Academy (RHA), young artists and those interested in exploring avant-garde styles found it difficult to have their work accepted for its annual exhibitions. To combat this, the Society of Dublin Painters was founded in 1920 to provide a venue where the general public could view Modernist works. Paul Henry was its founder and among its supporters were Grace Henry, Mainie Jellett, Mary Swanzy, Harry Clarke, Evie Hone and Jack B. Yeats. Their involvement did not preclude exhibiting at the RHA, but rather provided artists with a second viewing space in which the rigid artistic boundaries set by the academy could be largely ignored.

From the beginning, the new Society became synonymous with the best of avant-garde painting in Ireland. It proved to be particularly radical and influential during that first decade. In 1923 Mainie Jellett exhibited two of her paintings at the autumn show. She had developed an abstract style in which shapes are juxtaposed to echo the shape and proportions of the canvas **(Pl. 34)**. On show, too, were the innovative paintings of Mary Swanzy **(Pl. 35)**.

While these painters were using the Society exhibitions in the hope of interesting the public in this 'new' art, other Society members already enjoyed public acclaim. Harry Clarke had achieved considerable recognition for his set of spectacular windows for the Honan Chapel in Cork city (1915–18). Although best remembered for his religious windows, Clarke also made some enchanting small glass panels for exhibition and private patrons **(Pl. 36)**. Evie Hone would also establish a successful career as a stained glass artist a decade later **(Pl. 37)**.

In the 1930s more artists joined the Society, and among the most gifted were Nano Reid and Norah McGuinness. Other talented women, such as Hilda Roberts, Moyra Barry, Lilian Davidson and Beatrice Glenavy, were also members.

After the partition of the thirty-two counties, the short-lived Ulster Unit was formed in 1934 to stimulate the development of painting north of the border. Many of these artists were landscapists. It is notable that the Ulster Unit created a set of artistic principles that reflected the thinking of the entire group, unlike the individualistic attitude towards an aesthetic on the part of the Society of Dublin Painters.

Further developments in modern art

The attitude of most Irish people in the 1930s and 1940s, especially towards the arts, was reflected in the strict censorship imposed on publications. Although there was no censorship as such of the visual arts, outlets for exhibitions remained limited and the public at large continued to be unreceptive to modern art.

This changed in 1940 when a Modernist group of artists known as The White Stag held their first exhibition in Dublin. Escaping the Second World War, this group from Britain also included Irish painters. The White Stag took up the mantle of promoting modern art through their public shows. However, the Royal Hibernian Academy remained the most prestigious institution for the visual arts.

Meanwhile, many artists who had studied abroad were keen to demonstrate how new ideas had inspired and enriched their own creativity. Founded in 1943, The Irish Exhibition of Living Art (IELA) established itself as an annual forum for artists whose work had been consistently excluded from RHA exhibitions. The IELA was conceived as a show organised and curated by artists, who sought to reflect the various trends and concerns of Modernism rather than promote it as a homogeneous movement. Interestingly, the IELA didn't prevent academic artists from showing their work. President of the Royal Hibernian Academy, Dermod O'Brien, showed paintings, as did Seán Keating, a stalwart member of the Academy.

Not surprisingly, these IELA exhibitions proved to be aesthetically exciting due to the heady mix of artistic style and content. Mary Swanzy was praised for her most recent work, and the colourful lively folk scenes by the largely self-taught Gerard Dillon were critically acclaimed **(Pl. 38)**. Dillon became an active member of the committee, serving it for the best part of twenty years.

Jack B. Yeats exhibited with the IELA from 1943 but was to have little influence on the development of Modernism in Ireland. Instead, he went on to develop a unique expressionist style that remains his lasting legacy in Irish art **(Pl. 39)**. Critics singled out the work of Louis le Brocquy, who had helped establish the IELA along with Mainie Jellett and Norah McGuinness. Le Brocquy would go on to portray the theme of human isolation in many unusual forms **(Pl. 40)**.

An important figure in promoting Modernism in this period was the art dealer Victor Waddington, who had a gallery in Dublin from 1943 to 1957 where he supported progressive artists. Realising how difficult it was for them to earn a living from their work, Waddington offered some artists a monthly allowance and a number of solo exhibitions. Among those he supported were Jack B. Yeats and Gerard Dillon.

Exciting new directions

The second half of the twentieth century is remarkable for many noteworthy changes. In the aftermath of the Second World War, an advisory committee was formed by the government to focus on cultural relations. This was the first official body in support of art of the recently independent Irish State. The Arts Council was established in 1951 to promote all forms of Irish art outside Ireland. During the 1950s it sent artists representing Ireland to the Venice Biennale, Norah McGuinness, Nano Read, Louis le Brocquy and Patrick Scott among them.

A decisive contribution to the development of contemporary art in Ireland was the opening of the David Hendriks Gallery in 1956. He held an exhibition of Picasso etchings, alongside work by academic artists Seán Keating and Maurice MacGonigal. The exhibition also included paintings by more idiosyncratic artists such as Patrick Collins **(Pl. 41)**. That intersection of the traditional with the modern also extended to artists' careers. Oisín Kelly, for instance, became a member of the committee for the IELA in 1951, but went on to be an elected member of the RHA in 1965 **(Pl. 42)**. Later, in spite of earlier rejections of his work by the RHA, Louis le Brocquy became a member of the Academy's Honorary Council.

The 1960s saw the onset of energetic administrators and curators. James White became curator of the The Hugh Lane Gallery in 1960. He was instrumental in securing the Beit Collection of Old Masters for the National Gallery during his directorship (1964–80). Meanwhile, the first History of Art Department was inaugurated at University College Dublin in 1965, followed shortly by another in Trinity College Dublin. This has resulted in an ever-growing scholarly interest in researching and publishing the history of Irish art.

That same decade saw a generation of artists reaching their prime, le Brocquy and Collins among them. Undoubtedly the launch of the ROSC Poetry of Vision series of exhibitions from 1967 to 1988 proved to have an enormous impact, although paradoxically no Irish artists were chosen for the first two shows. It marked the internationalisation of the Irish art world with its inclusion of major international contemporary art.

The vitality of Irish artists continued in the 1970s and 1980s. Among those creating a new way of interpreting the Irish landscape was Maria Simonds-Gooding **(Pl. 43)**. The final three ROSC shows included a strong Irish presence with the work of Robert Ballagh **(Pl. 44)** and Patrick Scott **(Pl. 45)**. By the early 1980s it was officially noted that a number of Irish artists deserved state recognition for their exceptional contributions to the arts in Ireland. In 1981 an initiative taken by a group of writers and supported by the Arts Council resulted in the establishment of Aosdána (affiliation of creative artists in Ireland). Recognising the financial difficulties facing artists, a *cnuas* (stipend) is available to members of Aosdána to enable them to focus more fully on their work. Patrick Scott was one of the founding members. Among the artists who have been honoured over the years are painters Maria Simonds-Gooding, Dorothy Cross and Alice Maher **(Pl. 46)**, and sculptors Eilis O'Connell and John Behan **(Pl. 47)**.

The Troubles and Irish art

Lasting for three decades from 1968 onward, the Troubles in Northern Ireland produced a new subject matter. Many northern artists responded to what was happening, albeit in diverse ways. Rita Duffy revealed the divisions of different

communities in her paintings, as did Jack Pakenham. Willie Doherty superimposed text over photographic images in his politically charged work. The sculptor F. E. McWilliam's series of figurative sculpture, depicting shoppers caught at the moment of explosion, captured the horrific impact of bombings in Belfast (F. E. McWilliam Gallery, Banbridge, Co. Down).

South of the border, there were few who explored these experiences. However, Michael Farrell proved to be a radical for his time, with his art taking the form of a political commentary on the state of Ireland. Robert Ballagh, Shane Cullen and Brian O'Doherty also responded to the Troubles, the latter changing his name to Patrick Ireland in reaction to the Bloody Sunday killings in Derry in 1972.

Towards the twenty-first century

The final decade of the twentieth century brought about the establishment of the Irish Museum of Modern Art (IMMA). Founded by the state, it is Ireland's first national institution for the presentation and collection of modern and contemporary art. Its significant presence in the Irish and international arts arena enhances the existing public collections of modern art throughout Ireland.

Meanwhile, the National Gallery houses a comprehensive Old Master collection of European art, as well as the most comprehensive collection of Irish art in the world, and continues to enrich its Irish collection with gifts, bequests and purchases. Its National Portrait Collection honours not only those who contributed to Ireland's political, social and cultural past, but recent additions have included portrayals of broadcaster Gay Byrne, writers Brian Friel and Maeve Binchy, rock star Bono and sportsmen Brian O'Driscoll and Ronnie Delany **(Pl. 48)**.

Equally, Dublin City Gallery The Hugh Lane (to give the gallery its full title) has kept abreast with the many diverse developments marking the history of Modernism. The internationally renowned abstract artist Sean Scully gifted some of his work to the Gallery in 2006. Much of it is on display in a dedicated gallery in the new wing **(Pl. 49)**. After the death of painter Francis Bacon, his studio in London was donated

to The Hugh Lane in 1998. Its team moved the studio and its entire contents from London to Dublin, an astonishing feat given the chaotic working environment in which Bacon thrived **(Pl. 50)**.

While in the mid-twentieth century the Royal Hibernian Academy was seen as a reactionary force that hindered the development of Modernism in Ireland, this is no longer so. This repositioning of the RHA in relation to contemporary art was led by architect Arthur Gibney (then the RHA President) and sculptor Conor Fallon (then the RHA Secretary) in 1989. Its range of exhibitions embraces both modern and academic art in its many varied programmes. Today the academy's own mission statement says that it is dedicated to developing, affirming and challenging the public's appreciation and understanding of traditional and innovative approaches to the visual arts.

The contemporary art scene in Ireland – with its underpinning of national and city galleries, the RHA, the Arts Council, Aosdána and other public and private cultural institutions – remains in good shape. This is in spite of many difficulties, especially financial, faced in the first decade of this century. The stature of Irish art remains consistently high and its reputation continues to be secure both at home and abroad.

50 Works of Irish Art

. 1 .

Entrance Stone, *c.*2500 BC

Sandstone; length 3.2 m / Newgrange, Co. Meath

When the people who settled in the Boyne Valley, Co. Meath, looked for a suitable site on which to build a burial place, they chose an elevated one, commanding a panoramic view of the valley. It overlooks a stunning stretch of the River Boyne. The hill had already been used for several hundred years as a sacred place and a mound existed on the spot. It is believed that the location was chosen because it would bestow an extra significance on the ancestral dead. It also afforded a visible impact on the landscape, a demonstration of the importance and power of its builders.

Built *c.*2500 BC, its construction required careful planning and a large committed labour force. Work such as clearing the site, carrying earth, and quarrying, dressing and transporting the large heavy stones was all done without the assistance of wheeled transport. In line with the orientation of other passage tombs, the tomb was built to allow the rays of the sun to light up the back of the chamber in the days around the Winter Solstice (21 December). The building of a roof box directly over the entrance made this possible.

There is a close harmony between art and architecture at Newgrange. The kerbstones and innermost stones of the chamber are all highly decorated. This mainly abstract art, known as megalithic, almost certainly symbolises beliefs about life, death and the universe. The fact that this visual language cannot be interpreted adds to the sense of mystery at Newgrange.

The kerbstone outside the entrance to the passage tomb is a splendid example of megalithic pattern and motif. Measuring 3.2 m in length, the decorated greywacke sandstone is divided into two unequal parts. A groove running down from its top is thought to be an indication of where the entrance to the tomb lay. On one side of this divide is a large, perfectly carved triple spiral (a motif repeated only once, within the passage way itself), bordered by three lozenge shapes. In the larger area on the other side of the divide is a series of double spirals. Beneath them a lower pair of arched, wavy lines unite the overall composition. Near the end of the stone more spirals and a further lozenge are visible.

The shallow grooves forming the patterns were carved with stone chisels. Several techniques were used, the most common being picking and incision. To incise, a tool like a piece of flint or quartz was needed. This would have been drawn along the surface of the stone to make a line, either straight or angular. Picking required punch-like tools with rounded points of varying sizes. A stone was used to hammer the punch. This kerbstone is rightly considered to be one of the finest feats of European prehistoric art.

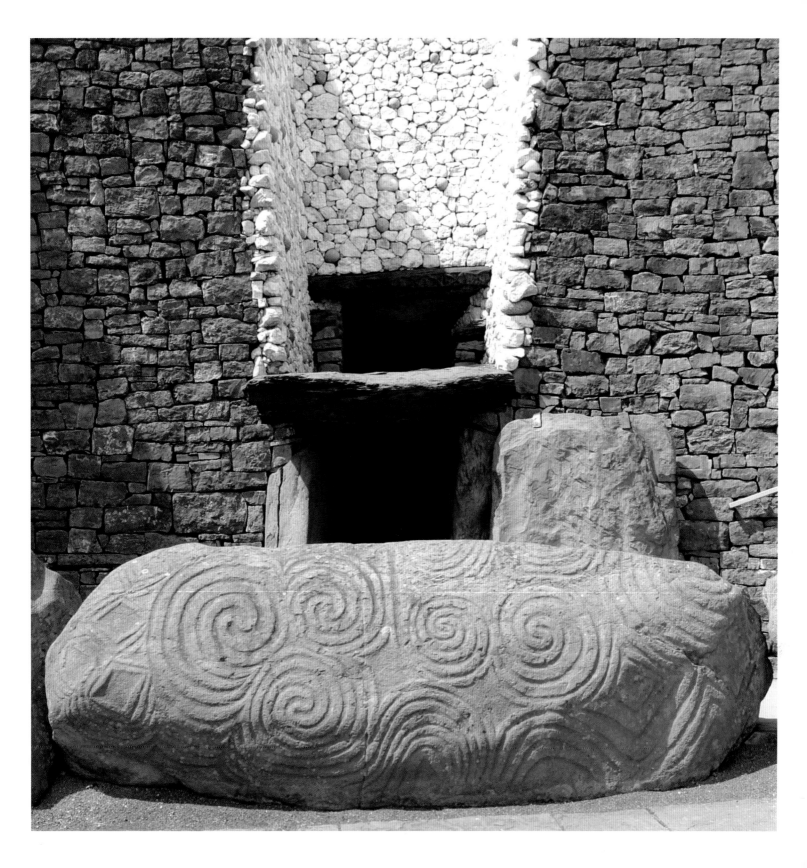

.2.

Gold Collar, *c.*700 BC

Gold; diameter 31 cm / National Museum of Ireland

Ireland's goldsmiths reached the zenith of their craft between 800 BC and 700 BC, as revealed in this spectacular neck collar or gorget. It was found in a rock fissure in 1932 in Glenisheen, Co. Clare, by a boy hunting for rabbits. It had been folded over before being placed there, as were another eight remaining examples. This act of 'vandalism' took place because the original owners wished it; they wanted to ensure that the collars would not be worn by anyone else in the future because they carried the status of supreme individuality. Interestingly, when discovered, the collar was taken to be an old coffin fitting.

The gorget recalls the lunulae of the early Bronze Age, both in shape and by the inclusion of decorative features. The front section is semi-circular and is set off by discs at either end. This semi-circular section is decorated with a number of ribbed lines in relief, every second one being decorated with a cord decoration. The discs, on the other hand, contain eleven small spiral patterns encircling a larger one, with tiny conical bosses at the centre of each motif. The sheer variety of design features in this collar surpasses the simple linear patterns of earlier lunulae. Advanced techniques were used, including *repoussé*, stamping, twisting, stitching and chasing.

The collar was a unique Irish expression of a contemporary and fashionable European style of armour. On the Continent, bronze cuirasses were worn. These had protective front and back plates to cover the body. They tended to be highly decorated and signified high status: that of an exalted warrior class. This type of armour was not found in Ireland where leather protection was favoured. The raised lines in the collar match the lines on a cuirass that would indicate the wearer's ribs. The terminal discs imitate the man's breast and nipples. Accordingly, the Irish version actively transforms the details of the body of the wearer into an abstracted form, and in a metal more precious than bronze. The donning of this collar would have reinforced a fervent sense of superiority and sent an impression to the viewer of a person of wealth, power and discrimination.

This spectacular collar could only have been produced by a sophisticated, settled society with a population large enough to encourage and support high-quality artists and artisans. Its ingenious transformation of the everyday cuirass into something beautiful suggests a people with a strong aesthetic taste.

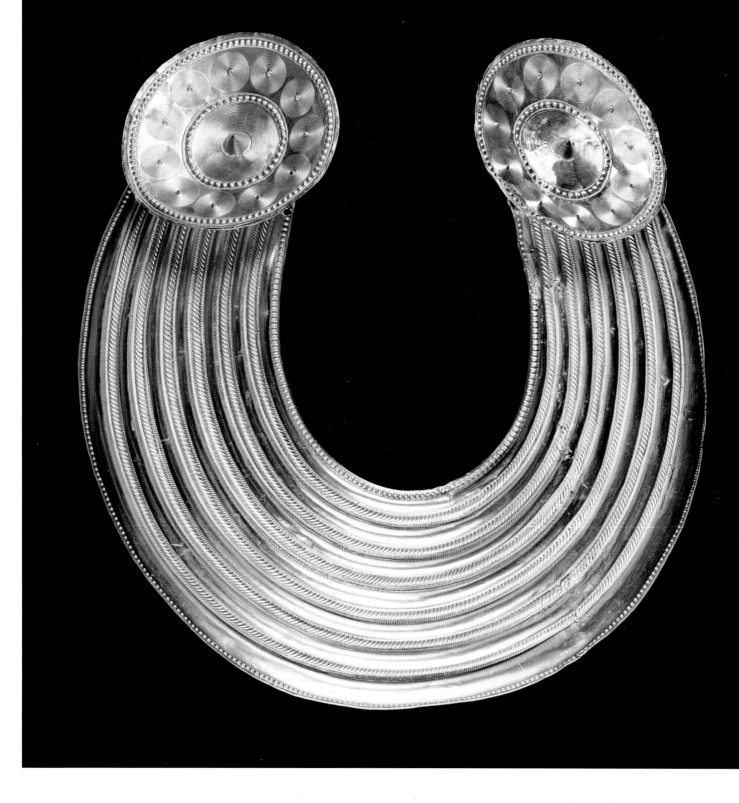

.3.

Petrie Crown, *c.*100 BC–*c.* AD 200

Bronze; height 15 cm / National Museum of Ireland

Discovered in Co. Cork in the nineteenth century, the Petrie Crown is a masterpiece of Iron Age goldsmithing and La Tène design. It is a section of a horned headdress, but it has also been argued that it may be a fragment of a candelabra rather than a crown. It consists of a circular bronze band to which a number of concave circular discs have been attached. These are decorated with elegant spirals and some beadwork. The design is a highly stylised depiction of a boat in which the sun is being carried across the skies. Its prow and stern are adorned with a bird's head.

Also attached are a series of goblet-shaped discs, which have been riveted on a single conical horn. There are marks that suggest there may have been a second horn. More spiral shapes ending in stylised birds' heads adorn the cone. Originally, the heads were filled with red enamel, as were the bosses on the discs. One stud remains providing a clue of what the completed 'crown' would have looked like. When completed, a leather or textile band to form a headdress would have been sewn on. Given the quality of its decoration, it was probably owned by a powerful member of the community.

The 'crown' has a connection with Roman Britain, where this kind of horned headdress was worn. Although they never conquered Ireland, the Romans traded with the island. There was much commercial toing and froing between the ports, which can be proved by the Roman objects found at the royal site at Tara. It was perhaps through these connections that the crown found its way to Ireland.

It was discovered by the famous nineteenth-century Irish archaeologist, antiquarian and painter George Petrie (*qv*) in Co. Cork, but there is no record of where the object was originally found. In the late 1820s and 1830s, Petrie injected new enthusiasm into the Royal Irish Academy's antiquities committee and he is responsible for their acquisition of metalwork.

Happily, other superb examples of La Tène art can still be seen today. A magnificently decorated bronze sword-scabbard with engraved spirals filled in with basketry pattern motifs, found on the site of a *crannóg* in Co. Antrim, is on display in the Ulster Museum. A gold collar from Broighter, Co. Derry, can be viewed in the National Museum in Dublin.

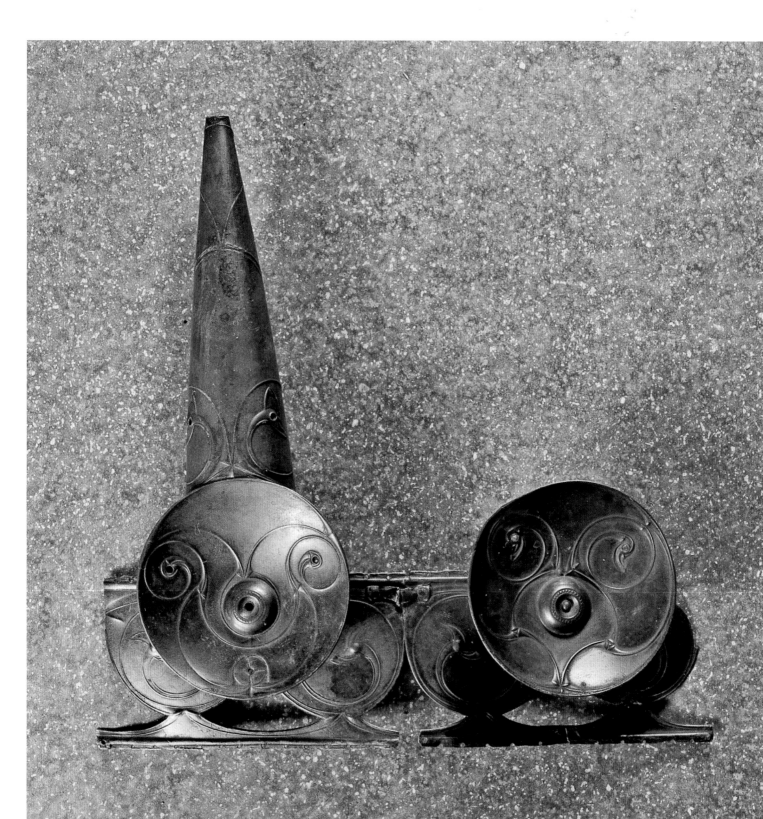

.4.

Ardagh Chalice, *c.* AD 750

Silver decorated with gold, gilt-bronze, brass, lead pewter, enamel; height 18 cm, diameter 19.5 cm
National Museum of Ireland

The Ardagh Chalice is part of a hoard found in 1868 by two young men who were digging for potatoes at a ringfort in Reerasta near Ardagh in Co. Limerick. A second bronze chalice, four gilt-silver brooches and a wooden cross were also discovered. The cross is dated to 1727 during a time when Ireland was under Penal Law and the saying of Mass was one of the many prohibitions Roman Catholics in Ireland were expected to endure. Perhaps the Ardagh hoard, possibly buried in the tenth century, had been hastily re-hidden during Penal times along with the cross.

The chalice itself is a silver cup linked with a gilded collar to a silver base. Chalices of this kind were used for holding wine in the Christian ceremony of communion. Its shape recalls late Roman tableware in the stubby two-handled bowl, but otherwise it is quintessentially Irish in its design. Irish craftsmen enjoyed using a complexity of decoration and a wide range of materials were used in the making of this chalice: silver, gold, gilt-copper alloy, enamel, glass, crystal, amber and malachite. The techniques involved included engraving, stippling, lost-wax casting, filigree, *cloisonné* and enamelling. In all, over three hundred individual pieces were put together to create this sumptuous object.

Encircling the bowl is a girdle of ten panels of finely wrought gold interlace, depicting stylised birds and beasts interspersed with enamel studs. Below this the names of the Apostles are engraved in the shining metal (not surprisingly the apostle Judas has been replaced by St Paul). The names are set against a delicately stippled background. Beneath are medallions, one on each side of the bowl. These are of cast bronze frames in the shape of a cross within a circle and are decorated with gold filigree scrolls and studs. The handles, too, are decorated in a similar manner with glass studs and filigree panels.

The main bulk of the chalice is formed from two hemispheres of sheet sliver connected by a rivet hidden behind a gilt-bronze band. The latter is embellished with La Tène spirals, fret patterns and an intricate honeycomb interlace. Even the underside of the chalice is decorated. Three gold friezes of animal, spiral and interlace adorned with small enamel and glass studs surround a large rock crystal.

The object is similar to the only other major early Irish example to survive, the Derrynaflan Chalice, found in the neighbouring Co. Tipperary (National Museum of Ireland). It is believed to date from the eighth century and was found with a paten and liturgical strainer. While made from more valuable metals, this chalice is not as lavishly decorated as the Ardagh one, although it does display more gold filigree ornamentation.

The Ardagh Chalice is undoubtedly one of the most prized examples of eighth-century metalwork in existence today. The combination of artistic and technical expertise evident in its design are, quite literally, centuries ahead of their time and they ensure that it remains one of the most celebrated of Ireland's historical artefacts.

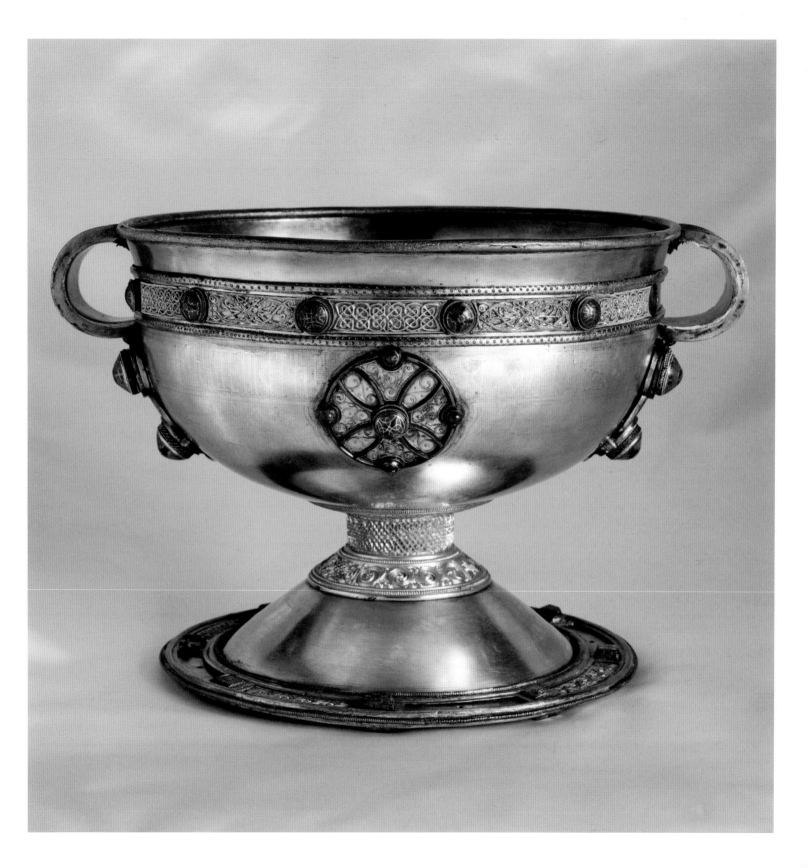

.5.

Chi Rho Page, *Book of Kells, c.* AD 800

Coloured ink on vellum; 32 x 25 cm / Trinity College Dublin

The *Book of Kells* is regarded as the greatest surviving manuscript of the Hiberno-Saxon period. Lavishly illustrated, it is written in Latin and contains the four gospels of the New Testament, along with a number of introductory texts and tables. It originated in a Columban monastery, probably that of Iona, Scotland, which was founded by the Irish missionary, St Columba (AD 521–597). Following Viking raids, the monks moved back to Ireland and built a new monastery in Kells, Co. Meath, where the book was completed. There are 340 folios in all. These are not made of paper but from vellum (calf-skin leaves). About 150 calves were used to supply the material for the manuscript.

Each scribe wrote with a pen made out of feathers or reeds and the inks used were produced from the juices of plants, leaves and roots. The text is clearly written with a variety of small artful motifs distributed throughout the script. The first letter of each section of the manuscript transforms into an imaginatively shaped animal, human form, plant or flower. Astonishingly, there are over two thousand capital letters in the book, each one different in shape and colour.

The Chi Rho page is one of two full-page illustrations depicting the birth of Christ (folio 34r). The glory of the occasion is celebrated by decorating the page in truly dazzling form. It is filled with the Greek letters XPI, a monogram meaning 'of Christ'. This symbol was often seen on the walls of churches or on carved crosses. Written in the lower right-hand corner is the single Latin word '*generatio*', meaning 'the birth'. The monogram's letters have a wealth of decoration both without and within them.

The X (Chi) dominates the page and is clearly outlined in purple. Within the shape are panels of interlacing, recalling those of the Ardagh Chalice. Some are abstract designs, while others are animal, insect or human interwoven forms. Where the X intersects, a panel of wriggling surreal forms are visible. There are men's heads in the four corners, their expressions bemusedly staring at their elongated limbs, which seem to weave in and out of four animals, twelve birds and some mythical serpents. It is a delightfully amusing motif that relieves the page of too much solemnity.

Again, humour is to the fore in the way in which P (the Greek 'r') is rounded off with a human head. Wit and religious symbolism combine again in the space on the lower left where the X ends in swirling form. Here two kittens share the Sacred Host, while elder cats look on. Nearby a plump otter gleefully holds a fish (yet another symbol of Christ). A delicately patterned butterfly with outstretched wings is tucked away near the top left-hand corner, snuggly fitting the painted shape. Close by stand three angels, two of them in close harmony. The longer you examine the page, the more details emerge. The sheer wealth of spirals on the page adds its own richness. It is believed that three scribes were involved in the designing of the manuscript. Yet the mass of intricate details come effortlessly together to form a unified splendour.

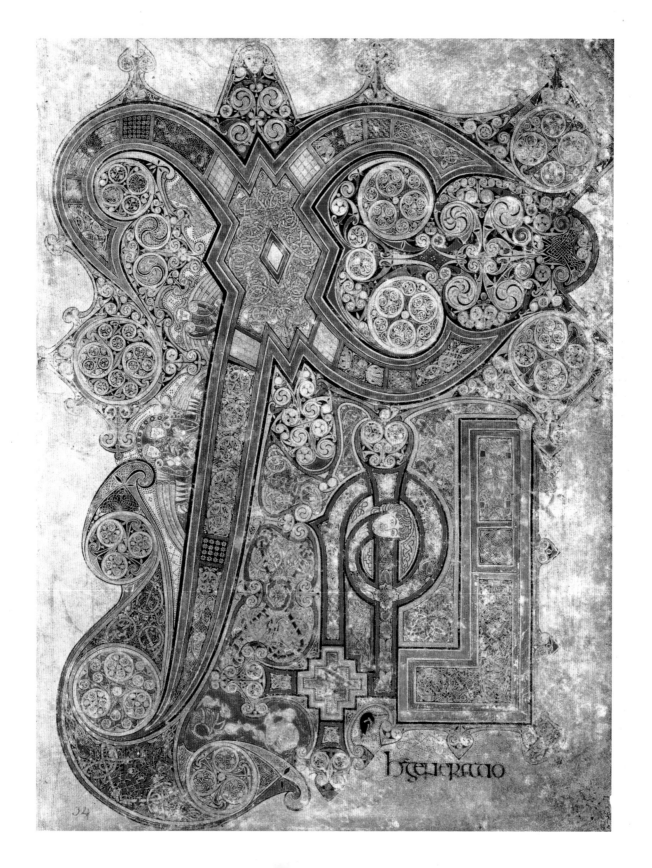

generatio

.6.

Muiredach's Cross, *c*. AD 950

Sandstone; height 5.2 m / Monasterboice, Co. Louth

The ornately sculpted Muiredach's Cross is regarded as one of the finest examples of the Irish high cross. The shaft is divided into a number of panels, each of which depicts scenes from the Old and New Testaments. It is possible that originally these scenes were painted, rendering them even more striking than they are to the viewer today. The shaft is sufficiently broad and deep to allow plenty of space for the portrayal of each scene. As a result, there is no sense of crowding and each panel can be easily read. Additionally, the depth of the relief carving makes the figures appear to be in the round.

The cross derives its name from the Irish inscription on the west face of the base. It asks for prayers for Muiredach who erected it. It is believed that this may be Abbot Muiredach Mac Domhnaill, who died in AD 923. Carved in front of the inscription are two cats holding mice in their paws, vividly recalling the cats near the bottom of the Chi Rho page of the *Book of Kells*.

The east face depicts scenes from both the Old and New Testaments. Starting with the temptation of Adam on the lowest panel of the shaft, it continues with the murder of Abel by Cain, Goliath kneeling after being vanquished by David, Saul forgiving Jonathan and Moses supplying water for his followers during the escape from Egypt. The Adoration of the Magi introduces a New Testament theme.

The centre of the cross is dominated by an extravagant Christ in Judgement scene, thought to be the earliest and most elaborate representations of this subject. The blessed are on Christ's right and the damned on the left. In the small space underneath is an amusing version of the weighing of souls by Michael the Archangel: a devil lying on the ground attempts to alter the balance of the scales in his own favour by using a long pole, in spite of the fact that the archangel's staff is being rammed down its throat. The cross is capped by a shingle roof, very much in the style of roofs in Irish churches of the period. The panel beneath it shows the monastic hermits St Anthony and St Paul.

The west face focuses on a few events from the story of the crucifixion and its aftermath. At the base is a depiction of the second mocking of Christ. Above it, St Peter is presented with the key of the new church, while St Paul is presented with the book of the new law. The centre space is dominated by the crucifixion, while the arms depict the denial of St Peter and the resurrection. Christ ascends into heaven at the top of the shaft. Other biblical scenes adorn the north and south faces, all a reminder to the faithful of Christ's sacrifice to redeem the sins of mankind. Intermingled with the narrative scenes are panels of pure ornament set along the short sides of the shaft, including an amusing scene of men pulling each other's beards.

Like the metalwork and manuscript painting of the period, this astonishing feat of carving so many narratives into a coherent whole confirms a golden age in early Irish art.

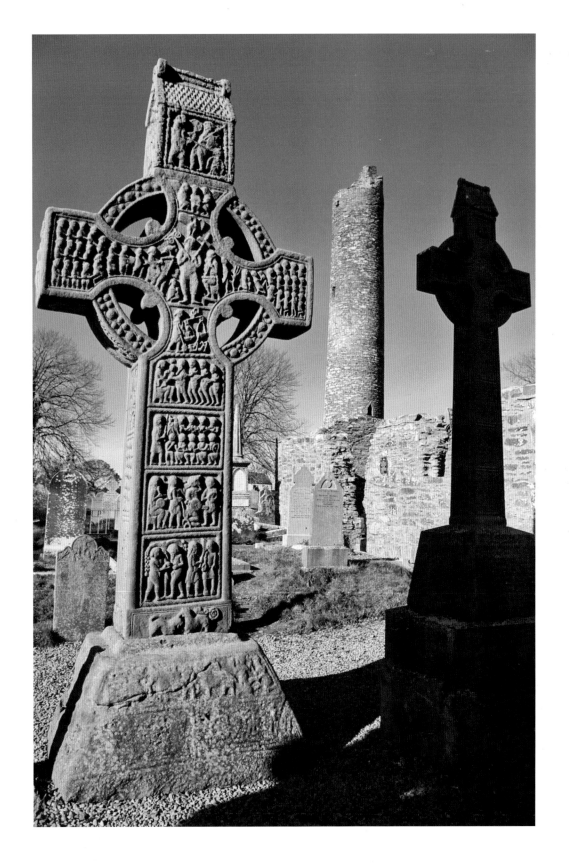

.7.

East Prospect, Giant's Causeway, c.1739

Susanna Drury (c.1698–c.1770) / Gouache on vellum; 34 x 67.6 cm / Ulster Museum Belfast

This painting is one of two views of the Giant's Causeway, Co. Antrim, unusual in that they were depicted on vellum rather than canvas. The medium used by Drury is gouache, which is watercolour made opaque by the addition of white pigment. Its use was to become very popular a century later. Apparently the artist spent more than three months living in the area in her pursuit to create convincing views, both east and west, of the rock formations.

This depiction of the East Prospect meticulously captures the layered polygonal columns of basalt that seem to have spewed out mysteriously from the ground. The formation was the result of a volcanic eruption more than sixty million years ago.

In order to add life and movement to the view, Drury depicts more than twenty people engaging in different activities: looking at the site, walking, hiking, fishing, picnicking and laying out kelp for drying. The fashionably dressed ladies and gentlemen reveal that this area was already a tourist destination in 1739–40. Today it is a World Heritage site attracting many thousands of visitors from all over the world.

Susanna Drury's views are the first accurate delineations of the Causeway, reflecting her own understanding of geology. She had them published in print form in 1743–4 and they proved to be so popular that they were reprinted in 1777 and again in 1837. Not only did the Giant's Causeway inspire artists, it also stimulated European scientific interest. Drury's prints were used by the French geologist Nicholas Desmarest to support the Vulcanist argument regarding the origins of the Causeway's geological features. The Vulcanists believed these features had occurred over millions of years as a natural result of volcanic activity. However, the location was already steeped in local legend, which asserted that the mythical hunter-warrior Fionn Mac Cumhaill had built the Causeway as stepping-stones to Scotland so as not to get his feet wet!

The incredible detail of Drury's painting attests to an artist of quality. Unfortunately, little is known about her. She was born in Dublin into an artistic family, her brother being the miniaturist Franklin Drury. It is thought that she possibly trained in London, where the technique of painting on vellum was taught by a fan painter, Joseph Goupy.

She is the earliest premium-winning landscape painter in Ireland, having won a £25 premium from the Royal Dublin Society for her views of the Causeway in 1740. Happily, being born into an artistic background freed her from the usual obstacles that could deter women from pursuing art as a career. Eighteenth-century women, with the exception of the urban and rural poor, were expected to put marriage before any kind of professional career. Art was taught as an accomplishment in their meagre education. Presumably Susanna Drury was taught within the confines of the family studio and her talent was treated seriously.

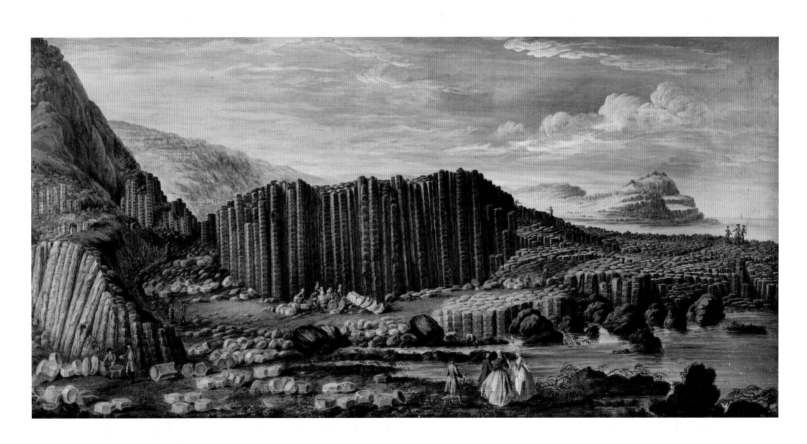

.8.

View of Powerscourt Waterfall, c.1760

George Barret (c.1730–1784) / Oil on canvas; 101.5 x 127.5 cm / National Gallery of Ireland

George Barret was born in the Liberties in Dublin *c.*1730. Before becoming an artist, he was apprenticed as a stay-maker in the production of women's corsets! However, choosing a more interesting way to make a living, he attended the Dublin Society School of Landscape and Ornament and was awarded his first prize in 1747. In the 1750s and early 1760s, he painted topographical views of demesnes in the counties of Meath, Louth and Kildare.

Barret became acquainted with the philosopher Edmund Burke, a student in Trinity College, who had begun work on his *Philosophical Enquiry into the Origins of our Ideas of the Sublime and the Beautiful* (1757). Burke encouraged the artist to paint directly from nature. As early as the 1760s, visual artists throughout Europe were exploring the sublime elements of nature in their landscape scenes. Under the influence of Burke, Barret became fascinated by the grand and breathtaking aspects of the natural world. This led him to north Wales, which was then an unknown location for artists. He also spent time on the estate of the 2nd Viscount Powerscourt in Co. Wicklow, the scenery there being described in a contemporary topographical dictionary of Ireland as 'unequalled for its variety of beautiful and sublime views, in which the most pleasingly picturesque is combined with the most strikingly romantic'.

This depiction of the waterfall at Powerscourt demesne is one of several by the artist. It was one of his favourite subjects and he painted it from various angles and distances. The waterfall (121 m) is in the deer park of the demesne and is one of the tallest in Britain and Ireland. The River Glenislorane (or Dargle) cascades down a precipice near the summits of Djouce Mountain and War Hill.

The canvas concentrates on the awe-inspiring height of the waterfall. The torrent of water dramatically plunging down the mountainside towards the rocks below is perfectly captured by the artist in his choice of brilliant whites and creams. The energetic, jagged brush strokes convey the gushing water. The inclusion of tiny figures in the left foreground emphasises its awesome scale, as do the seemingly diminutive trees decorously dotting the top of the hill, which contrast radically with the tall trees at ground level. While all of this suggests the notion of 'the Sublime', Barret's golden evening light conveys the idea of 'the Beautiful'.

Barret moved to London in 1763 with his wife, Frances Percy, whom he had married in 1757. His *View of the Waterfall at Powerscourt* was one of two paintings successfully shown at the Society of Artists in Dublin. His career was secured with the establishment of the Royal Academy in 1768, in which he played a prominent role as a founding member. He received a large number of topographical commissions, including ten views of the house and grounds of Welbeck Abbey, Nottinghamshire, for the 3rd Duke of Portland. He also painted views of England, Scotland, Wales and the Isle of Wight. Although he earned considerable sums of money, he spent more than he earned. Thanks to his friend Edmund Burke, he secured a well-paid job as Master Painter to Chelsea Hospital in 1782. In spite of this, he died in penury two years later.

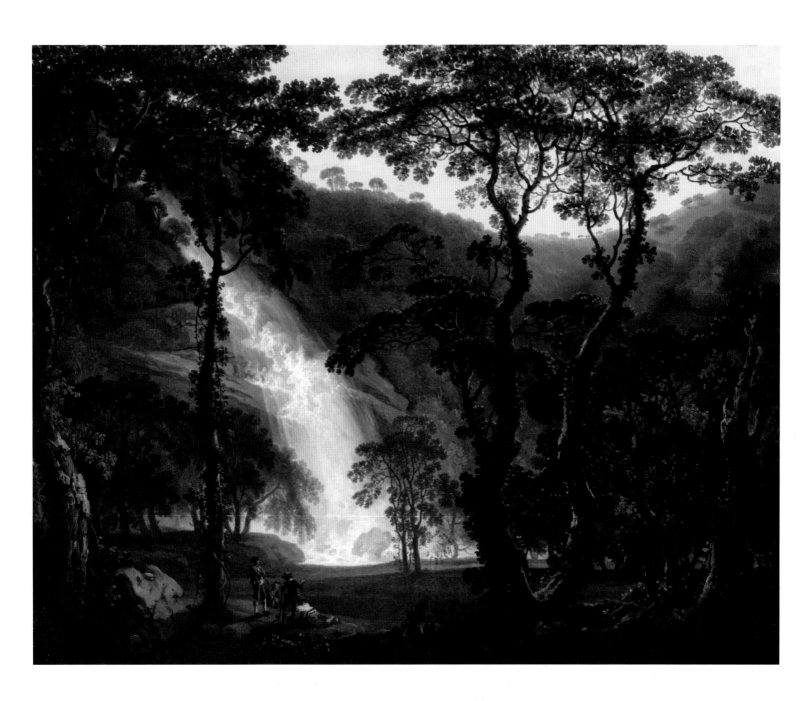

.9.

Jonathan Swift (1667–1745), c.1766

Patrick Cunningham (d.1774) / Marble; Height, 0.64 cm / St Patrick's Cathedral, Dublin

The writer, satirist and poet Jonathan Swift died on 19 October 1745 aged 78 years, having served as Dean of St Patrick's Cathedral since his election in 1713. He held very controversial views on Irish issues that he expressed by means of pamphlets. These included advocating a boycott of English goods, the English misgoverning of Ireland and the issue of absentee landlords. His best-loved novel is *Gulliver's Travels*, a satire on contemporary politics, religion and literature.

A visit to St Patrick's Cathedral reveals many reminders of the huge esteem in which he was held. He had written his own epitaph in Latin and left instructions for it to be carved on black Kilkenny marble. It is on the wall opposite his grave, which is set into the floor at the west end of the cathedral. Nearly two centuries later W. B. Yeats poetically translated it as:

> Swift has sailed into his rest;
> Savage indignation there
> Cannot lacerate his breast.
> Imitate him if you dare,
> World-besotted traveller; he
> Served human liberty.

Nearby is the table he used to celebrate the Eucharist. However, it is the marble bust located close to the epitaph that, above all, exudes the sheer force of Swift's character and personality. The man who wished to be remembered for his fierce outrage at the many injustices he perceived is represented as someone of great physical and psychological presence. It is an informal representation in that he is un-wigged and his garments are arranged casually. The sculptor Patrick Cunningham, known for his realistic manner of portrayal, has vigorously carved a determined jaw, pouting mouth, dimpled chin and fierce bushy eyebrows over watchful eyes. The expression is sharp and observant.

This impressively life-like commemorative bust was commissioned by Swift's publisher, George Faulkner (owner of *Faulkner's Dublin Journal*). He had a premises in nearby Parliament Street where he stood the bust on a bracket in a bow window looking towards Essex Bridge. In 1776 the bust was presented by his nephew, Thomas Todd Faulkner, to the then Dean and Chapter of St Patrick's Cathedral. It is now in the south aisle of the cathedral within a heavy sculpted oval frame, with a message reminding the viewer of the gift and its generous patron.

Patrick Cunningham was a pupil in the Dublin Society's Schools and later apprenticed to the sculptor John Van Nost, an English artist who settled in Dublin in 1749. The bust of Swift was exhibited at Dublin's Society of Artists. In spite of his prowess as a realistic portraitist, Cunningham did not prosper and he turned to making small, low-relief portraits in wax. These had oval frames and convex crystal glasses and were very fashionable. He and his wife settled in London in 1772. He exhibited figures in wax and a bust in clay at the exhibition of the Society of Artists of Great Britain, the only occasion that he exhibited his work in London. He died in December 1774 at Paddington.

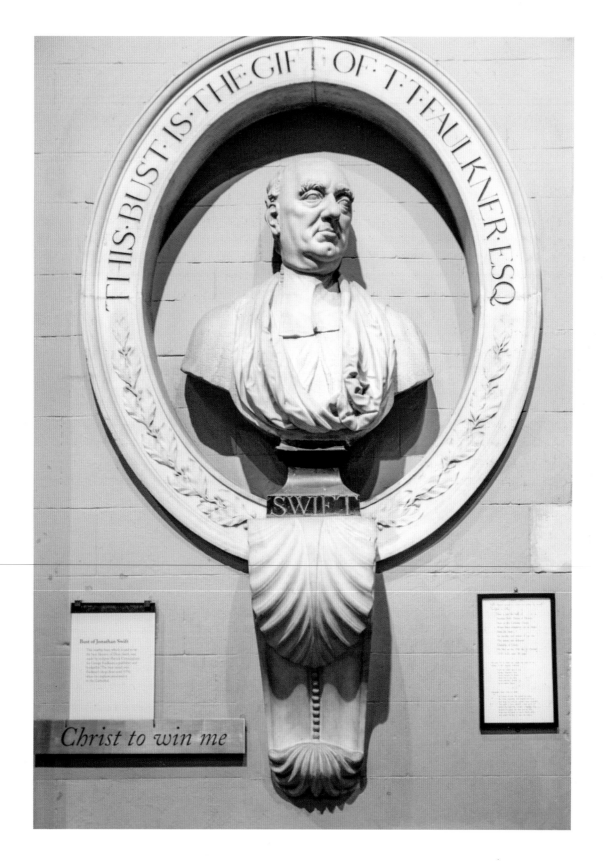

THIS·BUST·IS·THE·GIFT·OF·T·T·FAULKNER·ESQ

SWIFT

Bust of Jonathan Swift

Christ to win me

.10.

The Temptation of Adam, 1767–70

James Barry (1741–1806) / Oil on canvas; 199.8 x 152.9 cm / National Gallery of Ireland

James Barry was born in Cork and trained initially under a local artist, James Butts. He came to Dublin *c.* 1760 and joined the Dublin Society's Figure Drawing School under Robert West. In 1763 he was awarded a premium for a historical subject, *The Baptism of the King of Cashel by St Patrick*. The painting, the first of an Irish historical subject, was later acquired by the Irish House of Commons. It brought the artist to the attention of the writer and philosopher Edmund Burke, who was to be so influential in artists' interpretations of landscape.

Barry left for London and, having worked there as a draughtsman for a year, set off for the Continent under the patronage of Burke. He visited Paris and then travelled to Italy, where he stayed for three years visiting Rome, Florence, Bologna and returning home via Venice. It was during this trip abroad that he painted *The Temptation of Adam*. It would be exhibited twice in London, at the Royal Academy of Arts in 1771 and a year later at the International Exhibition.

The artist chooses a dramatic moment from John Milton's poem *Paradise Lost*. Eve has just confessed to Adam that she has eaten the apple and therefore sinned. He looks suitably dazed: his strong, manly body reeling in shock at the news. The bewildered expression, pose and gesture perfectly express the sheer horror of the situation. As befits the role of temptress, Eve leans seductively towards him, gazing into his eyes while her hand moves the apple in his hand towards his mouth.

Symbols are used to reinforce the contrast between good and evil. Joining Eve on the left side of the canvas are the serpent and the eaten fruit, while a lion prowling in the background implies danger. On the right are emblems of Christian hope: grapes above Adam's head, a symbol of the Eucharist and a gourd on the ground in reference to the Resurrection.

Barry's time in Italy was principally spent studying classical Hellenistic statuary in the form of available Roman copies and Renaissance sculpture. The figure of Adam is based on the antique sculpted torsos of the Laocoön and the Belvedere Torso, much studied by contemporary artists in this age of neo-classicism. Eve recalls antique Venus figures. The spiral twist of Adam's body (*contrapposto*) is influenced by the sculpture of Michelangelo, whose work was publicly on view in Florence.

James Barry's main aim was to promote historical painting. To this end, he went so far as to agree to paint a series of six large canvases for the Royal Society of Arts in London without a fee. The overall theme was the development of culture from barbarity to civilization. It was completed in 1784. However, going without a remuneration involved personal hardship and he was obliged to produce etchings after the paintings in order to yield enough income for the remainder of his life. Of a belligerent nature, his publications on art were controversial, so much so that he was expelled from his post at the Royal Academy as Professor of Painting in 1799, the first of only two artists expelled in the history of the Academy.

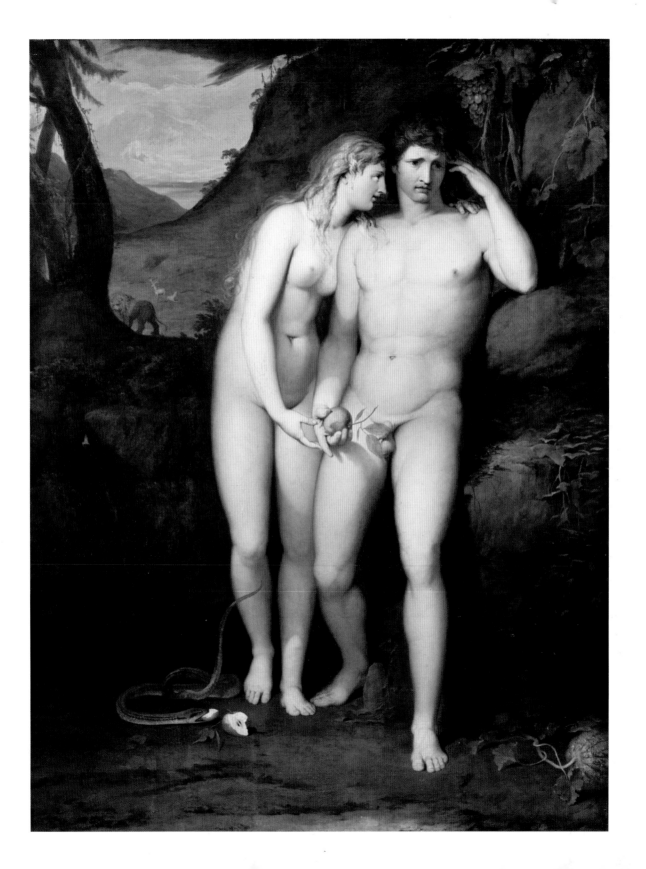

.11.

A Landscape, c.1775

Thomas Roberts (1748–1777) / Oil on canvas; 112 x 153 cm / National Gallery of Ireland

Thomas Roberts was an outstanding landscape artist of both topographical and imaginary views in the later part of the century. *A Landscape* is one of his finest imagined scenes in which the viewer is invited to enter into an idyllic place where nature is depicted in all its beauty and time seems to stand still. This feat is achieved by various artistic ruses in the tradition of Claude Lorrain, a French artist who worked in Rome in the seventeenth century. Of the pictures brought back to Ireland from the Grand Tour travels, Claude's paintings were among the most popular and resulted in a growing market for this kind of landscape. Roberts was undoubtedly one of its best champions, along with William Ashford, an English artist who settled in Ireland.

Following the rules of classical painting, the viewer is enticed into this arcadian world by means of the clumps of trees on either side of the foreground known as *coulisses* (from the word used to describe theatrical wings). The *coulisses* are deliberately painted in dark colours and contrast with the light tones in the centre and background of the picture. Roberts manipulates the eye of the viewer towards the lighter middle ground where a lake gleams like glass in the hot, hazy sunshine. The blue sky with its golden, fluffy clouds is mirrored in the still water below.

In the background, the horizon is rendered in even lighter tones which suggests distance within pictorial space. The tiny, well-drawn figures in the foreground, complete with horse and resting cattle, help establish the scale of the landscape. They also project a mood of quiet and calm, in keeping with the arcadian scenes by Claude.

Thomas Roberts was born in Waterford, son of architect John Roberts, who designed the Church of Ireland and Roman Catholic cathedrals in the city. In 1763 he joined the Dublin Society Schools under the artist John Mannin, and was later apprenticed respectively to the notable landscape painters George Mullins and John Butts. From 1766 until his untimely death in 1778, Roberts exhibited regularly at the Society of Artists in Ireland. In his final year he was awarded a premium for landscape painting.

His many topographical scenes attest to the fact that he travelled widely throughout Ireland. He also painted sets of views of different demesnes. Among these are four exquisite views of the Lucan Demesne in north county Dublin, which originally hung in the dining room of the estate's house. They are now in the National Gallery of Ireland.

Roberts' ability to capture detail and nuanced light effects are present in all his work. Sadly, this hugely talented artist did not have a long life. He suffered from tuberculosis and decided to spend time in a warmer climate for the sake of his health, but died in Lisbon.

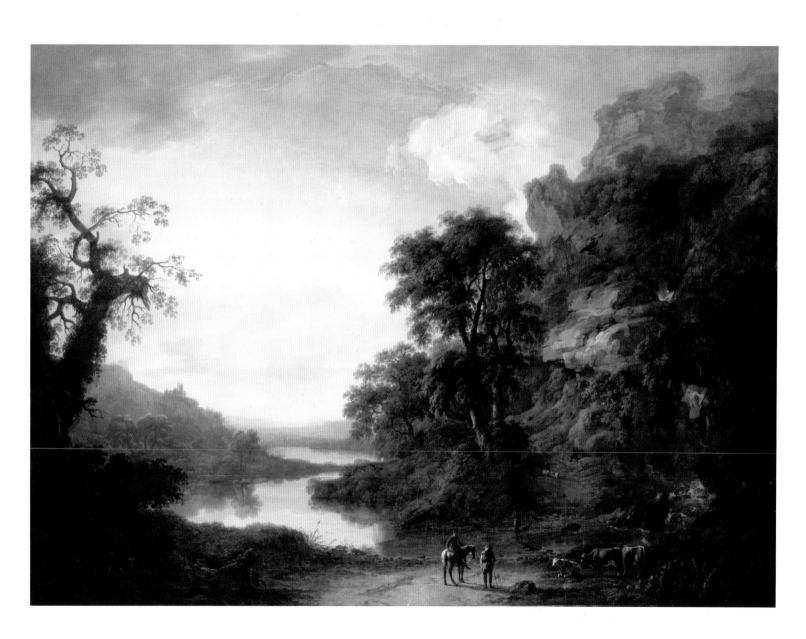

.12.

The Conjurer, 1775

Nathaniel Hone (1718–1784) / Oil on canvas; 145 x 173 cm / National Gallery of Gallery

The elder of two artists of the same name, Dublin-born Nathaniel Hone was an engraver and painter of portraits and general subjects in oil and miniature. His pastel drawings and prints suggest that he may have had early training in the city from artist Robert West. He worked as a portraitist in England from the early 1740s, becoming one of the most successful enamellists in this category of art. He also painted in watercolour on ivory.

He established a considerable clientele, many of them people of power and importance in London society. However, he is also remembered for some charming and sensitive informal portraits of his own children (the National Gallery of Ireland). In 1768 he became a foundation member of London's Royal Academy along with fellow Dubliner George Barret (*qv*). He exhibited there regularly until his death.

The Conjurer is Hone's best-known painting. A direct attack on then president of the Royal Academy, Sir Joshua Reynolds, the painting caused such a controversy at the Royal Academy in 1775 that it was withdrawn from the show. Reynolds had recently given his annual lecture at the Royal Academy prize-giving ceremony in which he stressed the necessity of copying from the Great Masters as well as from nature and ancient art. Hone profoundly disapproved this reliance, believing that it stunted artistic creativity. Moreover, he believed that Reynolds' work was far too dependent on Old Master prints and lacked originality.

The painting 'innocently' depicts an old magician in a darkened room, a small child leaning on his knee. Behind him is a large globe and an owl. A large book of classical prints is propped up in the lower right-hand corner. The conjurer has summoned up a selection of Old Master prints, delivered by a winged demon seen flying outside the smaller window above him. They flutter down towards a fire in the bottom left-hand corner, where a framed fake painting emerges from the flames. Meanwhile, the child gazes serenely at another print in the conjurer's hand. In the upper left-hand corner, a group of people is seated against the backdrop of St Paul's Cathedral, London.

Hone conveyed his derision in a number of ways. On seeing the work, Reynolds immediately recognised that he was being personally slighted. There were numerous clues in the scene, beginning with the choice of prints, all representative of his favourite Old Master paintings. In *The Conjuror*, they are treated as mere rubbish and only fit for the fire. Furthermore, the model for the conjurer is clearly George White, a favourite model of Reynolds'. The pendant around his neck depicts the sign of Libra, a zodiac sign symbolic of a balanced personality but also of laziness and dishonesty, a reference to Hone's view of Reynolds' character!

In the end the Academy refused to put the painting on public view, but Hone merely transferred his picture to an exhibition of his work in a nearby gallery where it was the hit of the show.

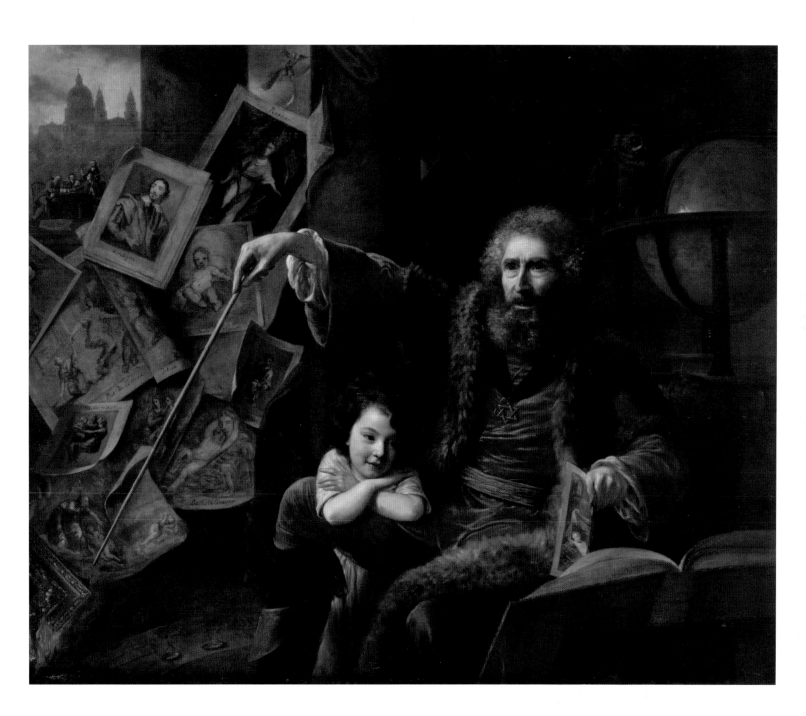

.13.

An Indian Lady, perhaps 'Jemdanee', Bibi of William Hickey, 1787

Thomas Hickey (1741–1824) / Oil on canvas; 102 x 127 cm / National Gallery of Ireland

This vibrant portrait was executed by the artist Thomas Hickey while on his first visit to India. His trip was not without adventure. Hickey had originally embarked on his journey in 1780, bearing a letter of introduction from the painter, Sir Joshua Reynolds, to the Governor General of Bengal, Warren Hastings. Unfortunately, the convoy of five ships was captured by enemy French and Spanish fleets, and Hickey was taken to Cadiz where he was given permission to return to England. He made his way to Lisbon to find a ship but, owing to various events, was not to travel back to London until 1791.

Thanks to many fortuitous portrait commissions, he was able to make a living in the Portuguese capital. After two years in the city, he continued on to India, arriving in Bengal in March 1784. He spent the next few years in Calcutta, and it was here that the portrait of an Indian lady was painted. It is believed that she was the mistress (*bibi*) of lawyer and diarist William Hickey, and not the wife of a high caste Indian as some supposed. The latter were always kept in seclusion and certainly not allowed to sit for a male foreign artist!

The young woman is seated cross-legged on a patterned Mughal-style carpet and holds in her hand an edible leaf, probably a *paan,* which was used to fold together a mixture of crushed betel nuts and spices. At her feet is a silver tray holding the various ingredients needed to make the *paan.* She wears a pink muslin sari fringed with gold thread over a pink bodice, a full skirt in a paler pink and loose green trousers. Indian jewellery decorates her hair, eyes, neck, wrist and ankle.

The picture reveals an interesting variety of brushwork. The figure is carefully delineated, as are the jewels decorating her body. In order to convey the abundance of muslin cloth used in the costume, Hickey changes his brush technique to a suitably sketchy one and strokes of white are painted over the pink to suggest the flimsy voluminous folds. The gold braid fringing is superbly captured in tiny strokes that show its herringbone design. Hickey delicately picks out the light falling on the young woman's hair, nose, necklace fringing and trousers, while evoking the lush vegetation of India in large feathery strokes of green paint.

As with all the major names of eighteenth-century Irish art, Hickey's training began in the Dublin Society's Drawing Schools, where he was one of the first pupils to train under artist Robert West. He went to Italy in 1762, enjoying its art and culture and learning Italian. Returning to Dublin six years later, he became disappointed that he was not gaining enough commissions. He set off for London in 1771 and was admitted as a painter to the Royal Academy Schools. Having travelled as far as China during his career, Hickey finally settled in Madras where he died in 1824.

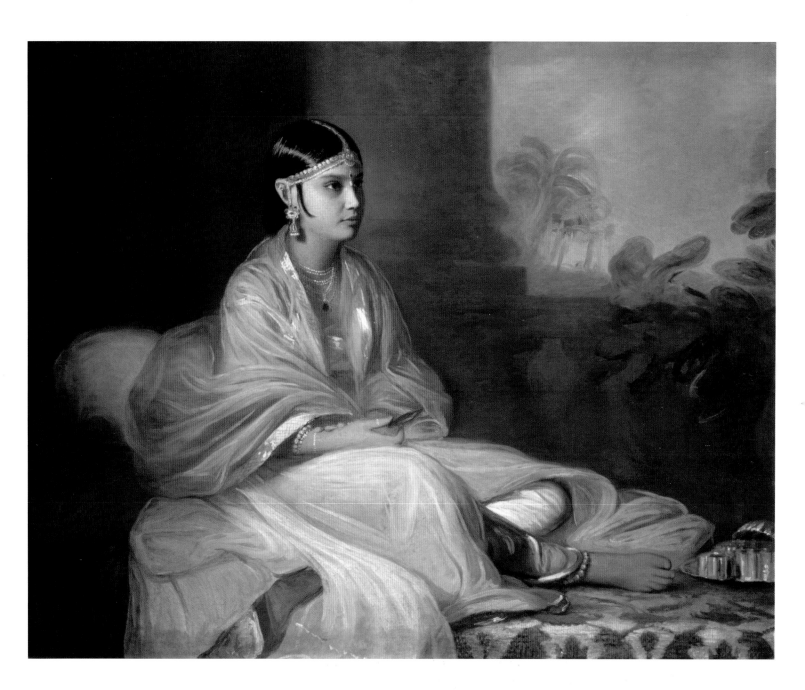

.14.

Frederick Hervey, Bishop of Derry and 4th Earl of Bristol, with his granddaughter, Lady Caroline Crichton, in the Gardens of the Villa Borghese, c.1790

Hugh Douglas Hamilton (1740–1808) / Oil on canvas; 224.4 x 199.5 cm / National Gallery of Ireland

This imposing portrait was painted in Rome where Hugh Douglas Hamilton had settled with his wife and daughter. He arrived in 1782 and spent four years in the city, quickly establishing a high reputation for portraiture in the delicate medium of pastel chalks. While in Rome he also did a number of large, full-length oil portraits of some of the Grand Tourists. Typically, the subjects of these portraits were posed against a background of ancient monuments and other tourist sights. At a time when cameras had not been invented, these inclusions served as personal souvenirs. They also signalled to viewers that the subject was a member of an elite who had been on that most fashionable of European tours.

This fine double portrait dates from c.1790. The Earl-Bishop was Bishop of Derry from 1768 and 4th Earl of Bristol from 1779. For an Englishman who held high office in Ireland, he was unusually sympathetic to the idea of Catholic emancipation and had built several Roman Catholic churches in his diocese. He was also opposed to the passing of the Act of Union between Britain and Ireland. He is pictured with his granddaughter, Caroline Crichton. She was the daughter of his eldest daughter, Lady Mary Erne, whose marriage to John Crichton, 1st Earl Erne, was over by the time this portrait was painted.

The Earl-Bishop was an enthusiastic traveller who spent long periods in Italy, even crossing the Alps on horseback.

He was an extravagant collector of art. In amassing his collection from Italy, he had several agents, buyers and artists to assist him. Hugh Douglas Hamilton was commissioned to do several works.

The two figures are painted as if in the gardens of the Villa Borghese. Dressed soberly in black with white shirt and gold-buckled shoes, the Earl-Bishop leans against a stout maple tree. His pose recalls the popular 'swagger pose' in contemporary portraiture, an informal one in which one leg is casually crossed over the other and the hands are joined together. His granddaughter wears a white frock in light cotton with matching pink satin sash and slippers.

She is depicted pointing towards an ancient work of art: the Altar of the Twelve Gods, shaped like the base of a three-cornered candelabrum, surmounted by a large vase (now in the Louvre, Paris). Carved in low-relief into the upper and lower register are gods and the female seasons. Lady Caroline's hand rests on the figure of Spring. The temple seen in the distance is a contemporary building, completed in 1787 in the style of the ancient Temple of Aesculapius.

The artist was obliged to leave Italy in 1791 because of the French Revolutionary Wars. Instead of settling back in London, he made his home in Dublin and continued painting until 1804, four years before his death.

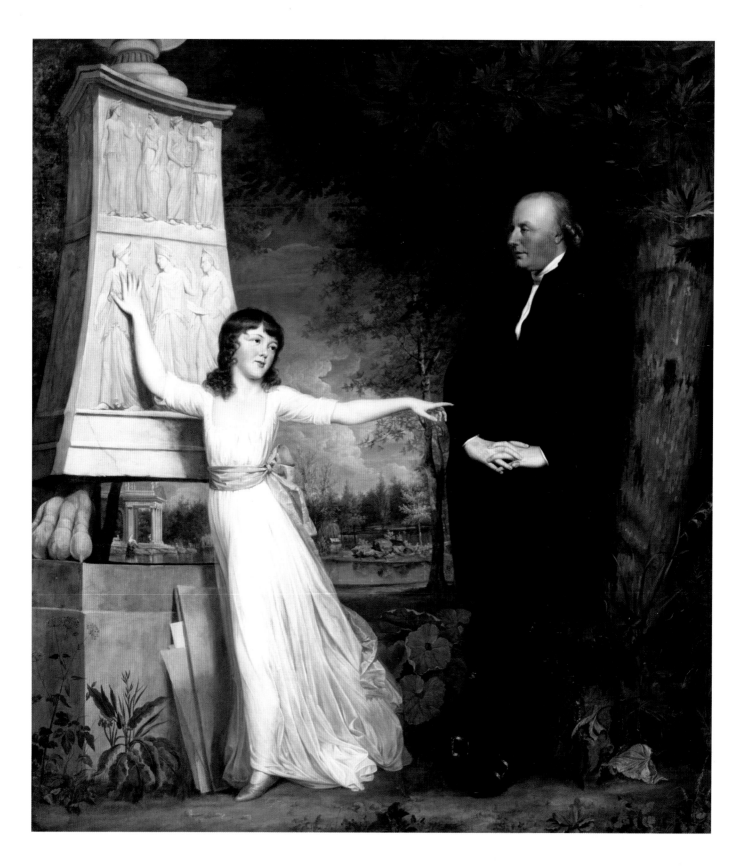

.15.

Dead Christ, 1829

John Hogan (1800–1858) / Marble; height 59 cm, length 225 cm, width 66 cm
Carmelite Friary, St Teresa's Church, Clarendon Street, Dublin

In the ornately decorated main altar of this busy city centre church is a superb sculpture of the Dead Christ. Laid out directly beneath the altar table, the head and torso gracefully recline on blocks of stone. What is immediately striking to the viewer is the sheer physical beauty of the carved marble figure. It seems the sculptor, John Hogan, has captured nature at its most ideal.

Artists from the Renaissance onward believed that all aspects of nature, especially the human form, must be improved upon in order to produce a perfect representation in art. Thus the dead body of Christ does not sag as it would normally in death. The many wounds he received from the crowning of thorns to the crucifixion are barely visible and the joints have been smoothed out. It is a superb example of 'ideal nature' in neo-classical sculpture of the late eighteenth and early nineteenth centuries.

Before going to Rome to complete his studies and set up his own studio, Hogan was fortunate to be able to study copies of 115 casts of the most celebrated marbles of Rome. They had arrived in Cork in 1818 and were exhibited with great ceremony. The casts were made by the Italian Antonio Canova, Europe's greatest exponent of neo-classical sculpture. A gift from Pope Pius VII to the Prince Regent (later George IV). Hogan soon set to work sketching and copying these examples of Greco-Roman art. The Catholic Bishop of Cork, Dr Murphy, who was a friend of Canova, soon put the young Hogan to work carving twenty-seven figures of saints and apostles for Cork's St Mary and St Anne (North) Cathedral.

On his first visit home from Rome in 1829, Hogan's talent as a sculptor was recognised by the Royal Dublin Society who presented him with a gold medal. The *Dead Christ* was exhibited at the Royal Irish Institution. Hogan had hoped it would be bought by Dr Murphy or some other ecclesiastic in Cork but no offers came. Instead, the Rev. Fr L'Estrange of Clarendon Street bought it for the Carmelite community of St Teresa for £400. A second version, carved in 1833, is in St Finbarr's (South) Cathedral in Cork. A third version (1854) is in the Basilica of St John the Baptist in Newfoundland, Canada. Aside from his ideal, religious and funerary work, Hogan made a number of portrait busts, including those of Bishop John Murphy of Cork (1834) and writer Francis Mahony (1848).

Hogan and his family returned to Ireland and settled in Dublin. After he showed busts of Daniel O'Connell and Father Matthew, the leader of the temperance movement, at the Royal Academy in London in 1850, the commissions began to flow. The Thomas Davis Memorial Committee commissioned him to carve a statue of their Young Irelander namesake, who had admired the sculptor's focus on national subjects. It was placed by Davis' grave in Mount Jerome, Dublin, before being moved to City Hall.

Hogan died in 1858. His patronage reflects the resurgent Catholic Church in Ireland and the rising nationalist movement in the mid-century.

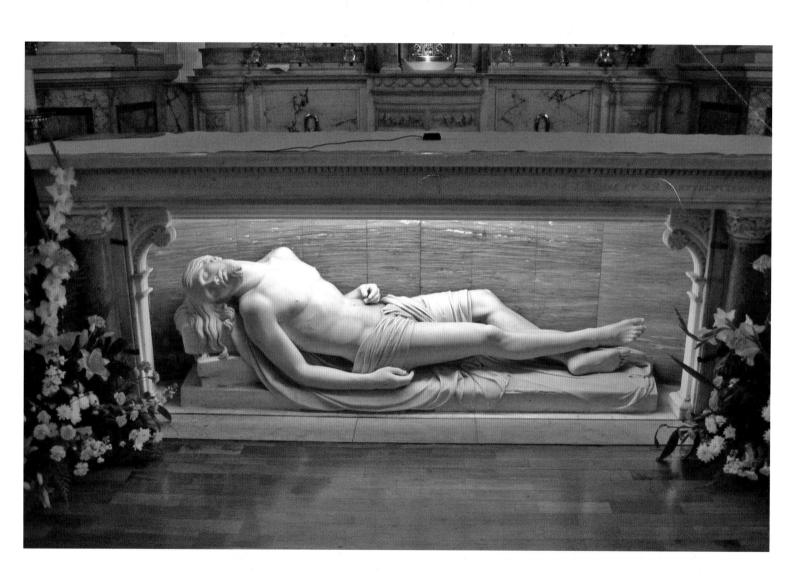

.16.

The Last Circuit of Pilgrims at Clonmacnoise, County Offaly, c.1843–6

George Petrie (1790–1866) / Graphite and watercolour; 67.2 x 98 cm / National Gallery of Ireland

The monastery of Clonmacnoise was founded in AD 546 by St Ciarán. By the ninth century, thanks to its strategic midlands location on the River Shannon, it had become a major centre of religion, learning, craftsmanship and trade. Many of the high kings of Tara and Connacht were buried here.

George Petrie visited Clonmacnoise in the early 1820s. An antiquarian as well as a writer and artist, he was drawn to the location because of its early Christian history and architecture, as well his interest in the folk custom of a 'pattern' or patron's day. Each year on 9 September, the feast of St Ciarán, people would come to the enclosure to pray to the saint, while making a circuit of the religious sites within its boundaries.

Petrie returned to Clonmacnoise in the early 1840s and painted this larger version of the watercolour, changing some of the details. Writing about his artistic intentions, Petrie declared that it was his wish to produce a landscape composed of several monuments from Ireland's great past, and to connect them to the present by including the 'pattern' day activities of the local people. This sentiment is very much in keeping with the growing desire to establish a distinctive cultural identity.

The artist was deeply concerned about the ruins at Clonmacnoise. They had deteriorated since his first visit in the 1820s, the east wall of the cathedral having collapsed in the intervening years. He believed that the important evidence of Ireland's heritage would be lost if nothing was done to rectify it. Clonmacnoise symbolised for Petrie the decline of the state under an indifferent English rule.

His watercolour is a romantic depiction of the ancient site. O'Rourke's Tower dominates the picturesque landscape bordering the Shannon as the sun sets. To the left is the north façade of the cathedral (Temple Ciarán) where Rory O'Connor, the last high king of Ireland, is buried. The four-metre high Cross of the Scripture stands close by, surrounded by praying pilgrims. In the background is the remains of a castle whose ruins are precariously balanced on the edge of a mound. The evening sky and the glowing light create a tranquil mood, in which the faithful move around the circuit saying their prayers.

The scene is made more dramatic by a woman outlined against the sky, praying on the hillock near the tower. In the foreground, a family of three pick their way through the burial slabs which have clearly been disturbed over time. In keeping with his archaeological interests, Petrie depicts the original decorative patterns on the upturned slabs. Interestingly, he also includes a reference to himself in depicting an artist's cloak and canvas lying across one of the memorials. The inscription asks that he, George Petrie, may be remembered in prayer.

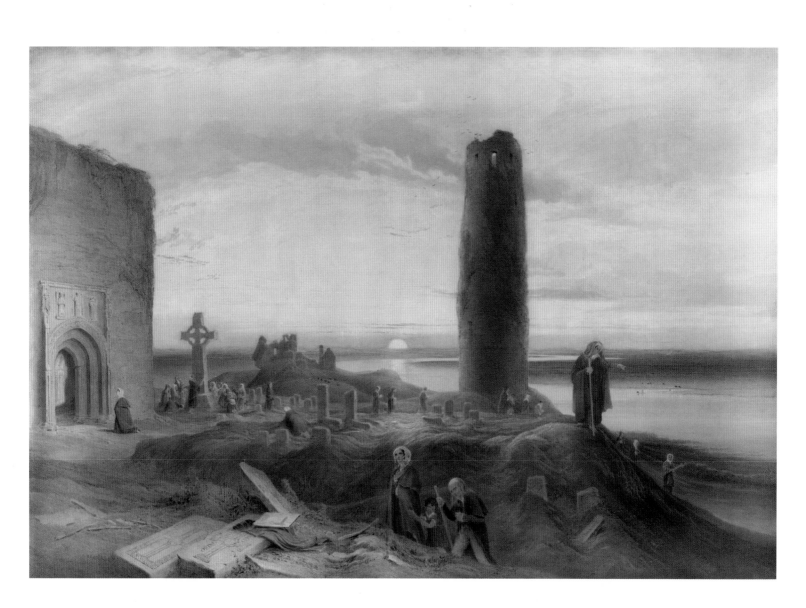

.17.

The 1843 Monster Meeting at Clifden, 1844

Joseph P. Haverty (1794–1864) / Oil on canvas; 110 x 183 cm / National Gallery of Ireland

Galway-born Joseph Haverty is thought to have received some artistic training in his home city before moving to Dublin. Like many artists, he had to travel in search of work and visited London on several occasions. When he returned to Dublin, he was made an associate member of the newly established Royal Hibernian Academy, becoming a full member in 1829 – a measure of how highly regarded he was by his fellow artists.

Haverty's speciality was portraiture and he painted several portraits of the politician, Daniel O'Connell. He also painted narrative pictures that are religious or nationalistic in tone. Their subject matter is in accord with Thomas Davis' dictates for an Irish art.

O'Connell, or 'the Liberator' as he had become known since gaining Catholic emancipation in 1829, amassed over 5,000 miles while travelling the length and breadth of Ireland in 1843. His intention, and that of his Repeal Association, was to have the Act of Union repealed. 1843 was a year of constant campaigning and he attended over thirty 'monster meetings' (a term coined by *The Times*). A superb orator, everybody wanted to see this famous man and, according to the contemporary press, virtually all of Co. Galway did so in that year, attending O'Connell Repeal rallies in Loughrea, Tuam and Clifden.

This painting is the artist's second representation of an O'Connell 'monster meeting'. The first one depicted the Clare by-election in 1828 (which O'Connell won).

Haverty sets this latter painting against the imposing backdrop of Clifden, Co. Galway. Daniel O'Connell dominates the crowded composition by being placed in the centre, dressed in his characteristic voluminous cloak and top hat.

The remainder of the figures are carefully balanced to his right and left. It is clear from the gentlemen's clothes that these are important 'worthies' in their own right. In fact, they are all political allies from different walks of life, including the local bishop of the county and a number of upper-class women. Included on either side of the immediate foreground are local peasants from the area. Representative of their 'class', Haverty depicts them pointing towards O'Connell, their poses and gestures implying that he is also their saviour.

For many years, the whereabouts of this painting were unknown. The mystery was solved in 1950 when then Taoiseach Éamon de Valera presented it to the National Gallery. A gilt tablet attached to the frame stated that it had been presented to him by a Mother Mary Alice, O. S. E., Superior of St Clare's Hospital in New York. The hospital was sited in the poor area of Hell's Kitchen, Manhattan. When de Valera became President of Ireland in 1959, he requested it be loaned to his presidential residence, Áras an Uachtaráin. When he died in 1975, the painting was loaned by the Gallery to O'Connell's ancestral home in Derrynane, Co. Kerry, but it is now back in Dublin.

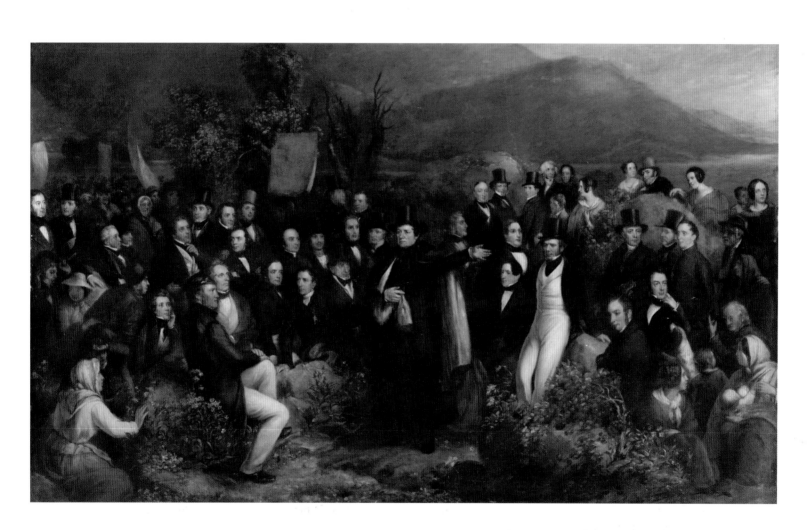

.18.

The Marriage of Strongbow and Aoife, c. 1854

Daniel Maclise (1806–1870) / Oil on canvas; 315 x 513 cm / National Gallery of Ireland

Cork-born Daniel Maclise is best remembered as a painter of historical and literary subjects. He began his career by drawing from plaster casts of the Vatican marbles housed in Cork. He went to London early in his career, moved in Irish cultural circles and is believed to have been a member of an Irish Society that was an extension of the Young Ireland movement.

The largest picture in the National Gallery is his *The Marriage of Strongbow and Aoife*. A *tour de force* in its dramatic representation, it depicts the marriage of Norman knight and Earl of Pembroke, Richard fitz Gilbert (Strongbow), to Aoife, daughter of the King of Leinster, Diarmait Mac Murchada. In return for his help in overthrowing Mac Murchada's enemies, Strongbow was given Aoife's hand in marriage. Consequently, Irish land was handed over to an 'outsider', paving the way for eventual English rule.

The painting was completed in 1854 and exhibited to much critical acclaim at the Royal Academy exhibition. However, its origins go back to 1847 when it was proposed that Britain's heritage be celebrated by the state in commissioning several frescoes (wall paintings) in the Houses of Parliament. The subjects included different aspects of the nation's history, including the taking over of other territories. Maclise was asked to depict this triumphant territorial acquisition.

Although supposedly a celebratory event, in the Irish painter's hands it is at once tragic and emotional. This marriage takes place on the battlefield where Mac Murchada's enemies were beaten. It is strewn with corpses of the dead, the captured, as well as the mourning onlookers. On the right are the beaten and now submissive Gaelic chiefs, who have laid down their arms. In contrast, and silhouetted against the sky, are the proud Anglo-Norman victors on horseback. Maclise's dramatic use of light and shade boosts empathy for the vanquished. They are bathed in a pure white light, while the Normans and their allies are in deep shadow.

Next to a woman in uncontrollable grief and with upraised arms is the dejected figure of a harpist. A copy of the so-called Brian Boru harp on display in the Long Room in Trinity College Dublin, his instrument and its broken strings symbolise the passing of the old Gaelic culture. It is possible that Maclise included it to illustrate his Romantic nationalist sympathies. His empathy with the conquered Irish is also expressed in Aoife's cowed pose. The inscription on the tombstone in the centre foreground reads 'Oraid do Mac', which can be translated as 'prayer for the son of'. However, there is no room for a name, and another interpretation is that it may be read as 'pray for Mac [lis]' in a reference to the artist's surname.

This work demonstrated the artist's careful research on his chosen theme to ensure that the scene appear to be a genuine visual historical document: the meticulous portrayal of the Celtic costumes, the ruined church, the armour, even the delicate wild flowers in the foreground. All this thoroughness was expected of Victorian artists to authenticate a historical subject.

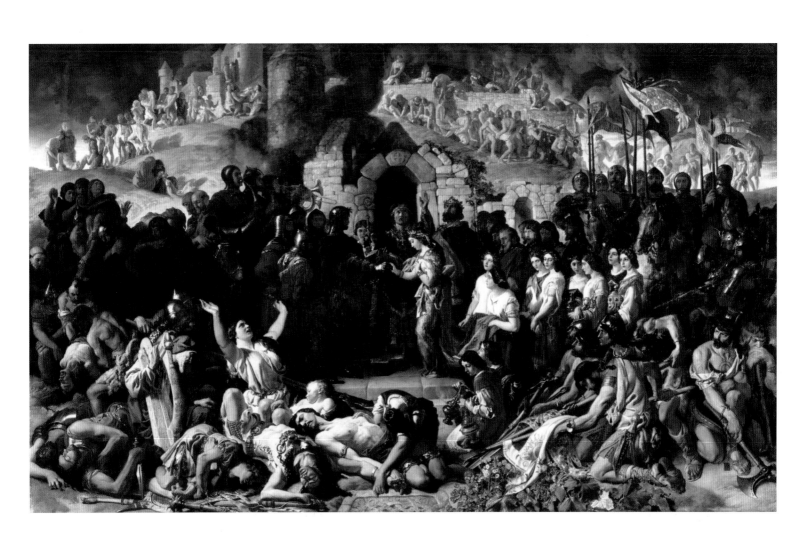

Hellelil and Hildebrand, The Meeting on the Turret Stairs, 1864

Frederick William Burton (1816–1900) / Watercolour and gouache on paper; 95.5 x 60.8 cm / National Gallery of Ireland

This work was voted by the Irish public as Ireland's favourite painting in 2012. Its theme of doomed love, like that of Romeo and Juliet, possesses an everlasting appeal. The story is taken from a medieval Danish ballad, translated into English and published in 1855. It tells the story of Hellelil, who falls in love with one of her personal guards, Hildebrand, Prince of Engelland. Her father is angered and sends his seven sons to kill the young prince. Hildebrand kills six of the brothers and their father. As Hellelil begs her lover to spare her remaining one brother, the latter kills Hildebrand and she, of course, dies of a broken heart.

Burton depicts the final meeting of the lovers on the turret stairs as Hildebrand goes to meet his fate. Both know that their love is doomed. The moment is exquisitely captured in their intense clandestine touch in the narrow confines of the turret. Hellelil, her body turned away and head bowed, extends one arm behind her. Hildebrand takes it and reverently places a kiss on it, closing his eyes as he does so. The strength of emotion passing between them is electric. The rose petals on the step next to Hellelil remind the viewer of the impermanence of beauty and love.

The magnificent range of colours, especially that of Hellelil's gown, looks jewel-like. Yet the medium chosen by Burton to paint his picture is that of watercolour. Instead of mixing the pigments with water for a translucent finish, he mixed them with chalk (gouache) to produce opaque, rich hues. It was a popular medium during the Victorian age. Burton never painted in oil preferring watercolour. The artist worked slowly and methodically on his picture. He produced numerous preparatory sketches before painting the final version, using fine brushstrokes to build up a depth of colour and using gouache to highlight individual details. His precision in building up the layers of colour resulted in a work that looks as if it was painted in oils. It was first exhibited at the Old Watercolour Society's Annual exhibition in London in 1864, and Burton sold it to art dealer Edward Fox White that same year. Interestingly, the artist retained the copyright, presumably aware of how popular the image might be if reproduced in print form.

Frederick William Burton's early career was as a miniaturist and illustrator of Irish subject paintings. Like his friend George Petrie (qv), he was interested in Ireland's ancient culture. Among his best-known Irish subjects is *The Fisherman of Aran's Drowned Child* (National Gallery of Ireland). He did not remain in Ireland but spent time in Germany, where he copied Old Master paintings and did many landscape and figure sketches.

In 1858 he settled in London, moving in the circle of the Pre-Raphaelite painters. On being appointed as Director of the National Gallery, London, in 1874, he gave up painting. During his directorship, he made a number of outstanding purchases for the Gallery. Knighted in 1884, he died in 1900 and is buried in Mount Jerome Cemetery in Dublin.

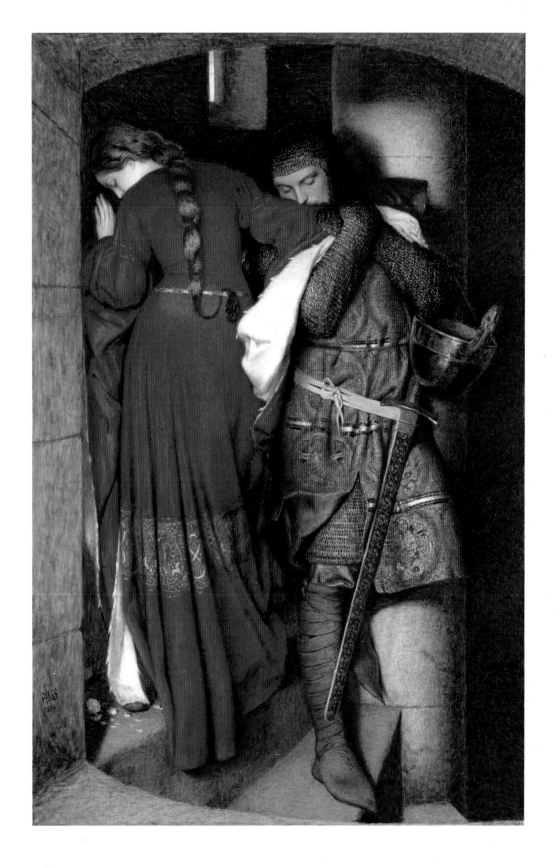

.20.

Market Day, Finistère, 1882

Harry Jones Thaddeus (1860–1929) / Oil on canvas; 201 x 132 cm / National Gallery of Ireland

Harry Thaddeus began his training in the Cork School of Art at the tender age of ten. Having won a Taylor Art Prize from the Royal Dublin Society in 1879, he spent time in London and then travelled to Paris. He spent the first month exploring the city, visiting museums and galleries before joining the Académie Julian. His autobiography, *Recollections of a Court Painter* (1912), gives an entertaining account of his student days and his visit to Brittany, the location for this painting.

In the early summer of 1881, Thaddeus spent two weeks in Pont-Aven, a popular place for visiting artists wishing to sketch and paint out of doors (*en plein air*). He then moved on to the town of Concarneau, one of the most important sardine fishing ports in France. Nevertheless, the town retained its distinctive cultural and picturesque qualities so beloved by painters, including their individualistic religious customs, costumes and the Breton language.

Thaddeus, able to support himself, established his studio in a small medieval chapel (today an art gallery). There he immersed himself in sketches and studies of the town and its people. Most artists stayed away from Paris for only the summer months, but Thaddeus stayed on in Concarneau for the winter of 1881, despite a small pox epidemic that wiped out half the town and most of its children.

He returned to the metropolis the following spring and submitted *Market Day, Finistère* to the Paris Salon. Accepted, it was favourably reviewed by the critics. It is an ambitious work in its vast scale and the complexity of the composition. The artist draws on many elements of interest. There is a detailed portrayal of the physical types of the region, their distinctive clothing and the ways in which their survival utterly depended on the sea.

The strong, well-built young woman in the foreground is holding a basket of leeks. In spite of it being a working day, the artist has her decked out in her Sunday best, as are the other female figures. In his *Recollections,* Thaddeus recalls how physically strong the women were and how it was they, not the men, who did all the work. The latter stayed at home to mind the children, while the women went out on Saturday nights and regularly got drunk!

This dominant figure looks towards a young boy (whose physique is also typical of the Breton type) holding out a basket of langoustines, recently caught in his shrimp net. Close by, an old peasant woman is roasting chestnuts on a brazier. In the background, people are engaged in other sea-related activities or merely chatting. Thaddeus' complete mastery of the brush is evident in the depiction of the different textures throughout the painting. These range from the precisely detailed headdress of the dominant figure through to looser 'impressionist' strokes suggesting small boats out at sea.

Thaddeus went on to achieve international fame as a portraitist, mainly of the rich and famous across Europe. These portraits include a striking portrayal of the Irish parliamentarian, John Redmond (1901, National Gallery of Ireland).

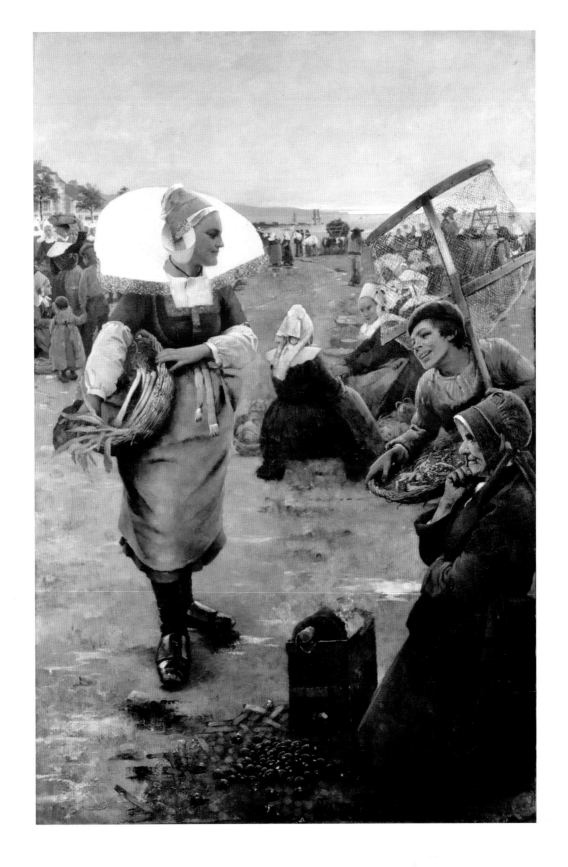

.21.

A Lady Holding a Doll's Rattle, 1885

Sarah Henrietta Purser (1848–1943) / Oil on canvas; 41 x 31 cm / National Gallery of Ireland

This delightful informal portrait depicts Mrs Mary Sturgis (née de la Poer Beresford) and is dedicated by the artist to Julian Sturgis, whom Mary had married in 1883. He was a prolific novelist, a librettist for several operas and a journalist. The portrait was painted in their home in Surrey, England.

Mary Sturgis is seated against a grey wall with ochre dado. Presented in three-quarter profile, one arm akimbo, she holds aloft a punch-like rattle. She is wearing a fashionable white dress emphasising her neat waist. It contrasts dramatically with her handsome black bonnet, decorated with green feathers.

Immediately striking about the portrait is its incredibly vigorous brushwork; it is as if Purser had painted it in minutes. Yet the face has been treated carefully, capturing both its physical features and the sitter's thoughtful expression. This combination of tight and loose brushwork reveals Purser's academic training at the Académie Julian, which emphasised a thorough knowledge of the human form. It is also informed by her personal interest in the work of Edgar Degas and Édouard Manet, who moved in Impressionist circles. The composition has the qualities of a snapshot, so prevalent in Degas' work, while the black hat painted in a fluid manner is reminiscent of Manet's brushwork.

Sarah Purser set out to establish herself as a painter mainly of portraits. In the 1870s the Irish art world was one in which a female artist had to battle against the odds to survive, let alone flourish. But Purser had tenacity and determination. Almost from the start of her exhibiting at the Royal Hibernian Academy in 1872, she received favourable notices for the vigour and freshness of her style of painting. Modern and imaginative, it was grounded in the fashionable newness of Paris rather than the mere conventional. Her success as a painter provided a role model for future female painters.

Purser involved herself in Irish artistic life and spearheaded an exhibition of British and Continental art, with a view to educating art students and the general public alike. It opened in April 1898 and showed eighty-eight works by artists of note, including those by the French artists Degas, Manet and Monet, and the British artist Constable. To encourage the emergence of a distinctive school of Irish art, Purser organised an exhibition of the work of Nathaniel Hone the Younger (qv) and John Butler Yeats. This was arranged at her own expense and the catalogue was written by her. She was also involved in the formation of the Hugh Lane Gallery in Dublin.

She set up the Friends of the National Collection and the Purser-Griffith Diploma in the History of European Art, jointly run by Trinity College Dublin and University College Dublin. Perhaps her greatest success is in the establishment of *An Túr Gloine* (Tower of Glass), which revived interest in stained glass. The studio was to produce stunning work by artists of the calibre of Evie Hone (qv), Michael Healy, Wilhelmina Geddes and others. In 1923 Purser became the first female member of the Royal Hibernian Academy.

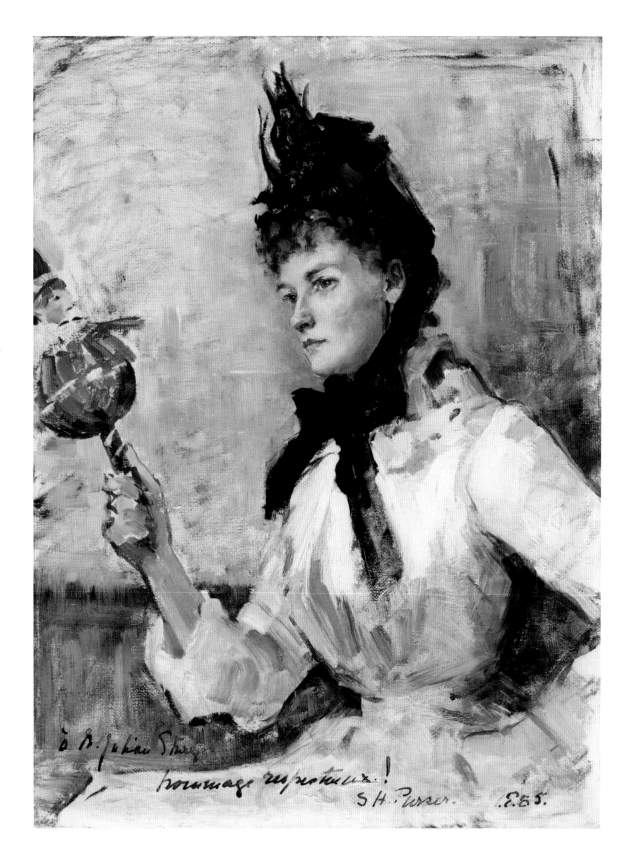

à B. Julian Story
hommage respectueux!
S.H. Purser. E85.

.22.

The Goose Girl, 1888

Edith Œnone Somerville (1858–1949) / Oil on canvas; 95 x 132 cm / Crawford Art Gallery, Cork

Edith Somerville is primarily celebrated as an illustrator and co-author with her second cousin, Violet Martin, of a string of successful books, essays and travelogues. Working together under the pseudonym of Somerville and Ross, both texts and illustrations provide a fascinating perspective of Anglo-Irish life in the late nineteenth and early twentieth centuries.

Somerville was to spend much of her life in the family home of Drishane in Castletownshend, Co. Cork. Her earliest passion was drawing but, like other girls of a similar background, her formal education including instruction in art was spasmodic. However, when she was about seventeen, her London-based godmother invited her to visit and to study for a term at the South Kensington School of Art. Her second term of apprenticeship was in Düsseldorf some years later where her cousin Egerton Coghill was studying fine art. When he moved to Paris in 1884, she was keen to follow him. While Somerville's family did not oppose the idea of her becoming an artist and, in fact, encouraged her initial training, it was an entirely different matter when she announced that she wanted to go to Paris.

The family's negative reaction is wonderfully captured in her later publication, *Irish Memories* (1917):

> Paris! They all said this at the top of their voices … They said that Paris was the Scarlet Woman embodied; they also said, 'The IDEA of letting a GIRL go to PARIS!' This they said incessantly in capital letters … and my mother was frightened. So a compromise was effected and I went to Paris with a bodyguard consisting of my mother, my eldest brother, a female cousin, and with us another girl, the friend with whom I had worked in Düsseldorf.

However, within weeks the rest of the family had returned to Ireland. With a chaperone to keep her company, Somerville remained in Paris where she studied life drawing at the studio of Filippo Colarossi.

The Goose Girl is one of the artist's finest paintings. The model was a local Cork girl, Mary Ann, and the goose was acquired for three shillings. Somerville recalls having to get the goose drunk with whiskey and laudanum in order to paint it! The two are depicted in apparent perfect harmony inside a cottage. The work has all the hallmarks of French Peasant Realism. The room is shabby and Mary Ann wears suitably tattered clothes, her hair unkempt and her feet dirty. Girl and goose are surrounded by an assortment of cooking utensils, cabbage and a string of onions. Some mashed food is in the container on the floor.

The strength of this work lies in the use of a dramatic light (*chiaroscuro*) to illuminate the dark interior and its inhabitants. The soft fluffy feathers of the goose, the gleaming utensils nearby, the face of the young girl with her dark, wide eyes and ruddy lips are all theatrically revealed in this stunning painting.

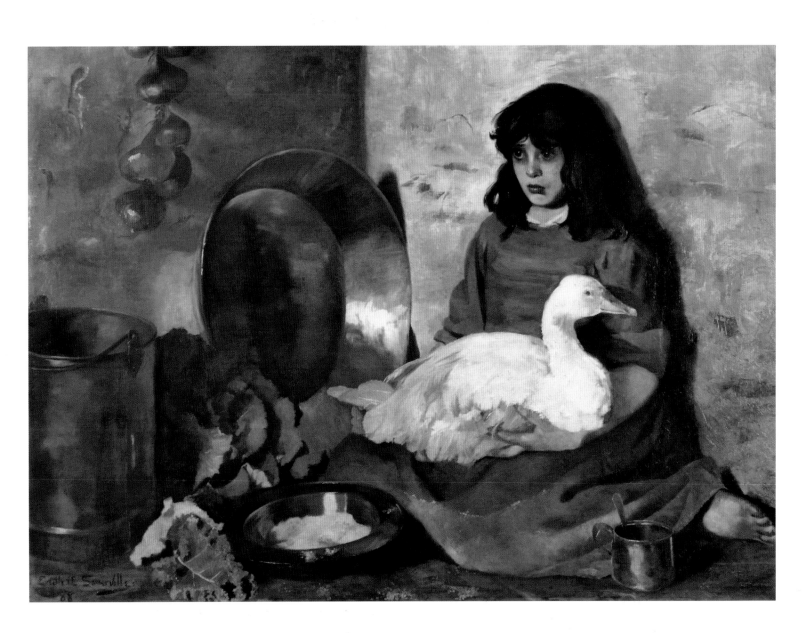

The Dublin Streets – A Vendor of Books, 1889

Walter Frederick Osborne (1859–1903) / Oil on canvas; 80 x 90 cm / National Gallery of Ireland

This is one of a series of Dublin scenes painted by Walter Osborne in the 1890s, each showing an aspect of life in the city's streets. They include market scenes, men at work on the quays, working people relaxing in the Phoenix Park and tenement life around St Patrick's Cathedral. This painting depicts a street bookseller's stall set up on Eden Quay, close to O'Connell Bridge. The view is eastwards towards the Custom House.

Several men are gathered around the stall, leisurely reading the books and other print media on offer. A small terrier is seated on the footpath patiently waiting for his owner to move on. Close by a little drama unfolds as a barefoot girl selling daffodils tries in vain to entice the men to buy. Nearby her mother, holding a sleeping infant, is looking on anxiously. At her feet is a basket full of flowers propped up against the quay wall, sadly suggesting few sales. Their personal plight remains unnoticed.

City life flows around this little drama. Horse-drawn cabs stand by waiting for customers. The newly rebuilt bridge (formerly Carlisle Bridge) is busy with traffic. Several men in kilts have congregated on the corner, although one of their number is now strolling up the quay. A barge is heading downriver, some seagulls circling around it, the remainder manoeuvring high up in the early evening sky.

Osborne's method in working up the Dublin genre scenes was to make dozens of pencil sketches on the spot as well as studies of individual figures. Photographs were also used, and the finished pictures were created from these *aides-mémoire* in his studio. Osborne's skill in this scene lies in the realistic modelling of the figures, bridge and river. These contrast with the sketchy atmospheric rendering of background buildings including the Custom House.

The artist's interest in ordinary everyday life is undoubtedly influenced by French Naturalism and Realism. Having completed his art studies in Dublin, he became a student of the Académie Royale des Beaux-Arts in Antwerp and then travelled to Brittany.

Osborne worked around Pont Aven, Dinan and Quimperlé in Brittany. In 1884 he successfully exhibited about twenty Breton scenes at the Royal Hibernian Academy. Already an associate of the RHA, he became a full member two years later. That same year he moved to England where he continued to paint attractive rural village scenes and cottage gardens.

He returned to Ireland in the early 1890s. From then until his untimely death from pneumonia, he developed a reputation as an impressive fine portraitist. The Dublin subject pictures show Osborne's genuine interest in ordinary people and their lives. Unfortunately, these paintings did not sell very well, necessitating his move to the more lucrative painting of portraits. A skilled watercolourist, his late interiors with children, such as *The Doll's School* (1900) and *The House Builders* (1902) in the National Gallery of Ireland's collection are especially appealing.

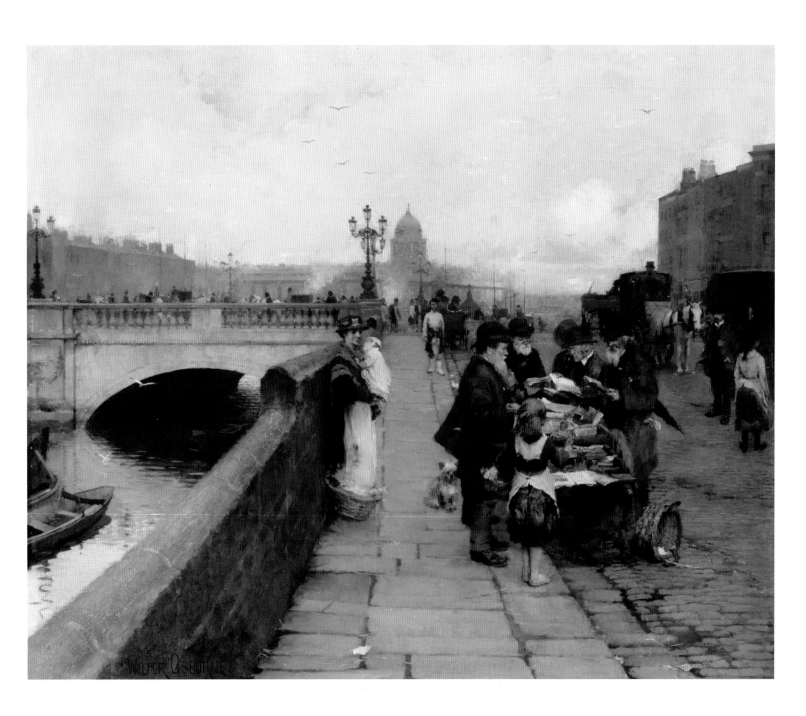

.24.

Mass in a Connemara Cabin, 1883

Aloysius O'Kelly (1853–1936) / Oil on canvas; Framed 171 x 217 x 13 cm / On loan, National Gallery of Ireland

Long thought to have been lost, *Mass in a Connemara Cabin* was found in November 2002 in the front room of the presbytery of St Patrick's Roman Catholic Church, Edinburgh. The painting had been hanging on the wall, but nobody recognised the artist or knew that it was a missing piece of work. Out of curiosity a member of the clergy decided to research the name of the artist, which was visible on the lower right of the canvas. It was then discovered that it was a significant work by Aloysious O'Kelly, exhibited to critical acclaim at the Paris Salon in 1884.

The artist had emigrated to the United States in 1895, after which the work appeared to vanish. It is thought to have ended up in Edinburgh because of O'Kelly's brother James, who was an MP for Westminster, a member of the Irish Republican Brotherhood and a campaigner for land reform in Ireland. He was an associate of the then parish priest in Edinburgh, Canon Hannan, who was also a supporter of the reform movement. O'Kelly's own views mirrored the political radicalism of his brother.

The picture represents the saying of Mass in a peasant home in the west of Ireland. Gathered are family, neighbours and others who have come from further afield, all kneeling reverently in front of the young priest. His hand is raised to give the final blessing at the end of the ceremony. A kitchen table acts as an altar and on it are the chalice covered with a pall, a missal, prayer leaflets and lit candles. A copy of the Sacred Heart, one of the most popular 'holy pictures' in many rural homes until well into the twentieth century, is pinned on the wall. This celebration of the Eucharist was known as the 'Station Mass' because a priest would travel around from house to house over a large rural area. The Station tradition not only involved the Mass preceded by Confession, but also included hospitality for everyone afterwards.

The visit of the priest was preceded by weeks of preparation that included repainting the exterior of the cottage, polishing and cleaning the interior and preparing food. It was often the only opportunity in a long time for people to hear Mass. The practice began to slowly wane as more churches were built across the countryside after the establishment of Catholic emancipation.

Aloysius O'Kelly came from an artistic family. He travelled to Paris and enrolled at the École des Beaux-Arts in 1874. Two years later he travelled to Brittany, painting *en plein air*. His many delightful scenes of the coastline, fishing ports and villages demonstrate his technical skills. He later travelled to Egypt and the United States.

In the early 1880s O'Kelly was posted in Connemara to cover the Land War as 'Special Correspondent' to the *Illustrated London News*. This painting would have been informed by his experiences as an illustrator for the newspaper, as well as his personal political convictions. In foregrounding the close bond between rural clergy and peasantry in the highly charged atmosphere of the period, the artist creates a new bond between high art and the complex problem of anti-colonial politics.

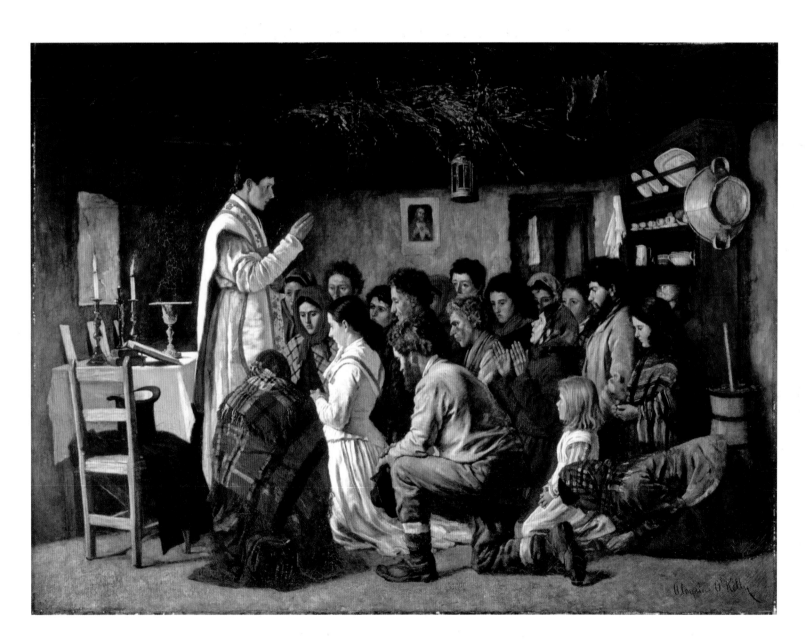

.25.

Patchwork, 1892

James Brenan (1837–1907) / Oil on canvas; 25 x 30.5 cm / Crawford Art Gallery, Cork

James Brenan is another artist whose sympathetic depictions of Irish provincial life are in line with Young Irelander Thomas Davis' aspirations for a distinctive Irish art. They record the ordinary and often difficult lives of farming or fishing families in their homes. The convincing realism conveyed by his careful observations and attention to detail in these scenes provide an authentic visual record of social life in Ireland in the latter quarter of the nineteenth century.

Born in Dublin, the artist studied at the Metropolitan School of Art, the Royal Hibernian Academy Schools and the Royal Dublin Society Drawing School. He then opted for further studies in painting in London and subsequently trained as an art teacher. He taught at the School of Art in Birmingham and elsewhere in England. In 1860 he became headmaster of the Crawford School of Art in Cork where he proved to be active and popular. In 1889 he became headmaster of the Dublin Metropolitan School of Art. There he played an important part in the development of the School and, in particular, the advancement of industrial art and crafts such as lace-making. His aim was to promote high-quality design wherever possible.

Patchwork demonstrates the artist's interest in even the most humble of occupations. The small intimate canvas depicts an old woman patching a garment. The custom was to use scraps of material to reinforce elbows and other parts of clothing to ensure they lasted longer. To emphasise this activity, the patch is depicted in a bright blue in the centre of the composition. Other garments are hanging from hooks and rails above the fire and from

a hanger on the bannister rail of the staircase. A realistic detailed depiction of the interior includes architectural details such as the masonry-arched fireplace and the wooden staircase. A metal bucket sits on a small wooden bench and a black kettle stands beside the fireplace where a turf fire is burning. The flagstone floor has been carefully delineated. Nearby, a large wicker basket with a strap holds more turf. The strap was used to carry a load on the back of a donkey or on a person's back.

While focusing on the everyday, Brenan's scenes touch on the bigger issues that affected Irish life in the post-famine period. For instance, *Letter from America* (1875, Crawford Art Gallery, Cork) shows a young girl reading a letter to her parents from a family member who has had to emigrate. Emigration was one of the major consequences of the Great Famine. However, the fact that she can read, while her parents cannot, is a reminder of the spread of universal education in Ireland since the mid-1850s. Literacy was vital in relation to political and social developments in Ireland in this century.

Although popular, the vogue for realistic genre painting was going out of fashion by the early 1890s. This scene and others of its kind were considered a bit old fashioned by critics. Up-and-coming artists were expected to appeal to the aesthetic rather than instruct or educate. Yet Brenan's pictures have stood the test of time. They are informative about life in the Munster region and, as such, serve as useful documentary evidence for the political and social historian.

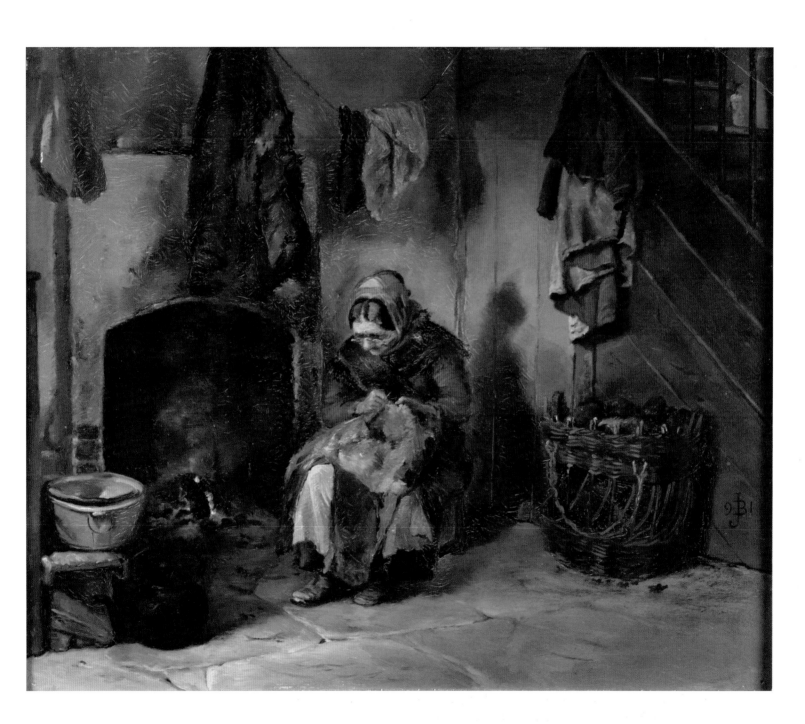

.26.

Pastures at Malahide, c.1894–6

Nathaniel Hone the Younger (1831–1917) / Oil on canvas; 82 x 124 cm / National Gallery of Ireland

Nathaniel Hone is a descendent of the eighteenth-century artist of the same name, hence the nomenclature 'Nathaniel Hone the Younger'. Although interested in painting, he initially studied engineering and science at Trinity College Dublin, graduating with two honours in 1850. Having started work with the Midland Great Western Railway, he quickly realised that art, not engineering, was his calling.

In 1853 Hone travelled to Paris where he registered as a student copyist in the Louvre. The following year he entered the studio of Thomas Couture. The latter not only gave students a strong grounding in technique but, unlike the École des Beaux-Arts, also taught painting. Couture was in favour of a careful mixing of colour in order to achieve freshness and clarity. He also emphasised the need for lots of preliminary sketches towards the final picture, a practice that Hone followed throughout his career. His finished works were always painted in his studio.

Interestingly, Nathaniel Hone, now regarded as one of Ireland's finest landscapists, had studied for three or more years before he turned to landscape painting. A fellow Irish student, Richard Hearn, introduced him to the Barbizon artists. The village of Barbizon, close to Fontainebleau, was still unspoiled and thus frequented by many artists. Hone settled there in 1857 for the best part of thirteen years. Fortunately, he was financially independent.

Pastures at Malahide, although painted late in his career, reflects the concerns of this group of artists: the use of tonal hues and light, and loose brushwork to create the compositions. Hone limits himself to greys, blues, browns and greens to build up this scene. The colours perfectly typify the countryside in north county Dublin, with its ever-changing weather.

The artist's great gift for capturing the complexities of light and shade is revealed in this work. While the rolling clouds overhead block out direct sunlight on part of the landscape, it is contrasted with the scattered shafts of sunlight that light up the tilled fields on the horizon line.

Having spent almost twenty years abroad, travelling extensively throughout France and the Mediterranean, Hone returned to Dublin in 1872. He and his wife settled at the family estate of Seafield in Malahide. *Pastures at Malahide* is one of several scenes of cattle in the meadows that he painted around the area. He continued to travel abroad from time to time. One trip was to Scheveningen in Holland, a popular venue for artists, where he painted pictures of the beach as well as the fishing fleet. He and his wife travelled to Corfu, Constantinople and Egypt where he painted many watercolours and oils.

Nathaniel Hone began to exhibit at the Royal Hibernian Academy in 1876. He became a full member of the academy in 1880 and was appointed Professor of Painting in 1894. He was also one of the artists who supported Hugh Lane in his attempt to establish a gallery of modern art in Dublin. Generally regarded as Nathaniel Hone's masterpiece, *Pastures at Malahide* was presented to the National Gallery in 1907.

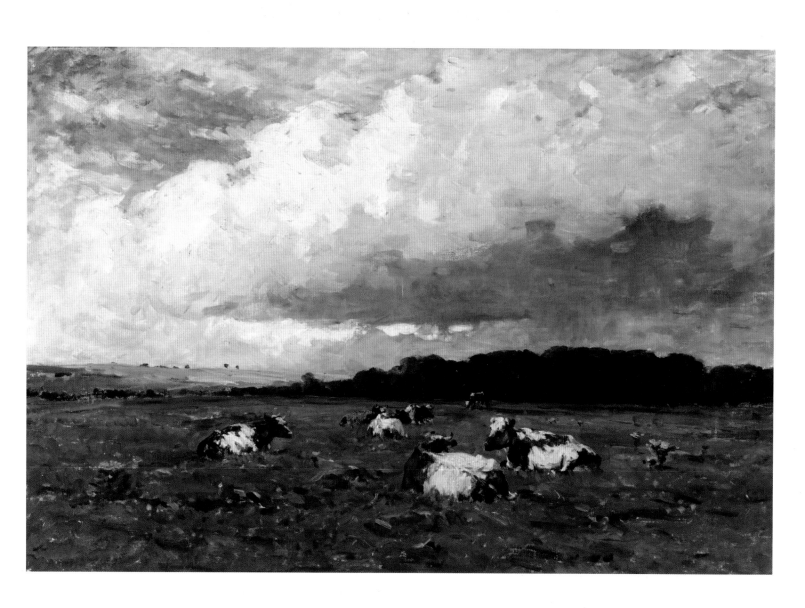

.27.

Still Life with Apples and Breton Pots, c.1896–7

Roderic O'Conor (1860–1940) / Oil on board; 49.5 x 55.5 cm / National Gallery of Ireland

Born in Milton, Co. Roscommon, Roderic O'Conor was connected to the O'Conor Don, an ancient Irish family. His parents were keen for him to attend the University of London but he wanted to be an artist. It is believed that their disapproval resulted in him getting no yearly income, although he did receive his share of the family estate. He enrolled at the Metropolitan School of Art in 1879 and by 1883 had exhibited two pictures at the Royal Hibernian Academy. In the autumn of that year he went to Antwerp and enrolled at the Académie Royale des Beaux-Arts. After two years he moved to Paris, but also returned to Dublin to attend a session at the Metropolitan School.

In Paris, he began to paint bold, colourful landscapes, some of which are close to the works of French Impressionists Camille Pissarro and Alfred Sisley. In 1890 O'Conor moved to Pont Aven, Brittany, where a number of artists, such as Gauguin, were pushing the limits of Impressionism towards what is now termed 'Post-Impressionism'. They still used vivid colours, thickly applied paint and realistic subject matter, but figures and objects were intentionally inclined to be geometric in form and unnatural hues and tones were expressively used by the artist.

O'Conor's deceptively simple still life depicts apples and Breton pots arranged on a dark tablecloth. It is full of interesting artistic techniques. The artist deliberately uses contrasting high-key colours, such as blue, orange, white and yellow, set against the rich wine-coloured cloth, their combined intensity almost dazzling the viewer. O'Conor

eschews the painting of shadows in the traditional brown used by academic painters. Instead, the shadows within the jugs and on the plates reflect the colours that make up the fruit or the blue of the crockery. These painterly ideas replicate those of Gauguin, who had become a close friend of his in Pont Aven.

The composition also lacks a clear horizon line, so that both the tableware and fruit appear to defy gravity, and the artist ignores the academic norm of creating compositions with single-point perspective. This play on perspective was an exciting avant-garde concept of the time. No longer was the composition organised so that the viewer might imagine they were looking through a window at the subject in the picture. Paul Cézanne enthusiastically explored this new concept and it was to be fully exploited by Pablo Picasso in the next century.

Another noteworthy feature is the use of local Breton pottery in the still life. This kind of pottery was freely available and the artist sought to bring its decorative features to the attention of viewers who were, in the main, middle and upper-middle class. He also deliberately uses apples as the fruit of choice, a fruit connected with this part of France, especially in the making of cider and *lambig*, a local form of *calvados*.

Having spent more than a decade in Brittany devoting his time to painting its landscape and its Breton people in traditional costume, O'Conor moved to Paris in 1904 where he lived and worked until his death in France in 1940.

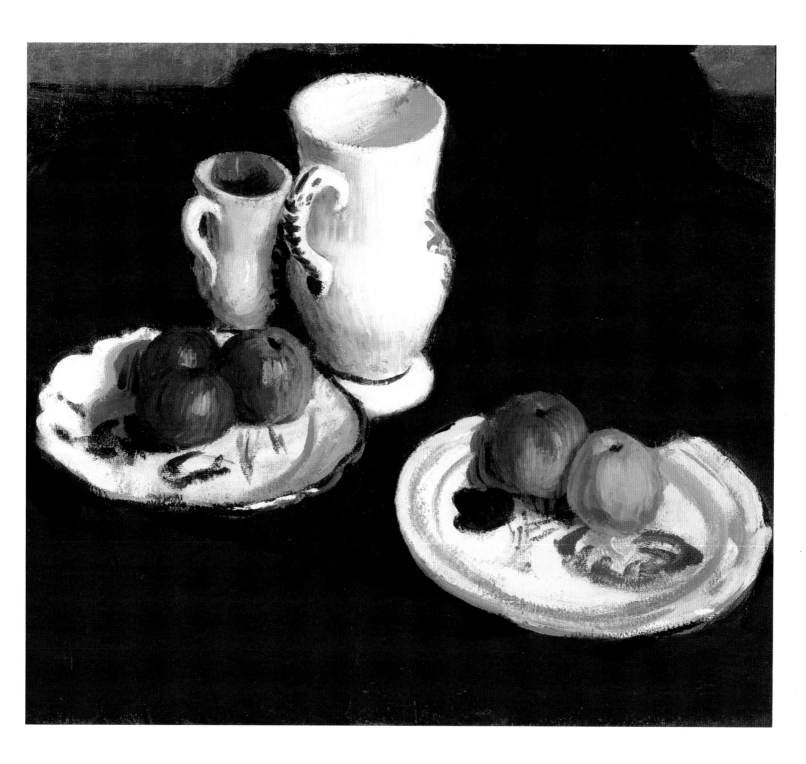

.28.

The Artist's Studio: Lady Hazel Lavery with her Daughter Alice and Stepdaughter Eileen, 1909–13

John Lavery (1856–1941) / Oil on canvas; 344 x 274 cm / National Gallery of Ireland

Born in Belfast, John Lavery initially trained in Glasgow and London. He first travelled to Paris in 1881 where he studied at the Académie Julian. During his second session there, he spent Sundays working out of doors by the River Seine. Back in Glasgow he became associated with a group of modern artists known as the Glasgow School. In 1888 he was commissioned to paint the state visit of Queen Victoria to the Glasgow International Exhibition. It launched his career as a society painter and he moved to London where he established himself as a successful society portraitist. He would become an official war artist at home in the First World War, painting the activities of British naval bases. After the war he was knighted and in 1921 he was elected to the Royal Academy, London.

Lavery first encountered Hazel Martyn in 1903 at the artist colony of Beg-Meil in Brittany. She was twenty-three years old and an art student. Later that year she married Edward Livingston Trudeau. He died four months after the wedding and their daughter, Alice, was born five months later. Lavery was already a widower with one daughter, Eileen. They met again and Hazel and he married in 1909, setting up home in London.

Their first visit to Ireland was in 1913, and it was Hazel who subsequently encouraged her husband to paint a collection of portraits of Irish Catholic and Protestant religious leaders, followed by the protagonists on both sides of the Treaty negotiations. Lavery also documented events in Irish politics, including the ratification of the Anglo-Irish Treaty in December 1921.

This impressively large portrait was begun in his London studio in 1909. Hazel Lavery is fashionably dressed in a feathered turban and richly coloured silk and satin Paisley coat. Alice is seated in a basket chair while Eileen leans elegantly across the grand piano. The family dog, Rodney Stone (named after the hero in a mystery story by Arthur Conan Doyle), lies at the feet of the two girls. In the background, Ayisha, the maid, is seen entering the room bearing a salver of fruits. Also visible in the portrait is the artist himself. Reflected in a mirror, his palette and brush clearly visible, Lavery paints himself studying the group of figures he is portraying.

The painting over the mantelpiece is one of his equestrian portraits, while to the right, resting on an easel, is a working sketch of Queen Mary. This reveals the fact that from 1910 he was engaged in painting a large portrait of King George V, Queen Mary, the Prince of Wales and Princess Mary (National Portrait Gallery, London). Both of the family portraits are alike in the setting of figures in an imposing interior.

The Artist's Studio is also an homage to Las Meninas by Velasquez (Prado Museum, Madrid), a painter much admired by Lavery. The grouping of the figures in the foreground, the reflection of the artist in the distant mirror, the position of the dog and, above all, the scale of the interior all recall Velasquez's famous painting of 1656.

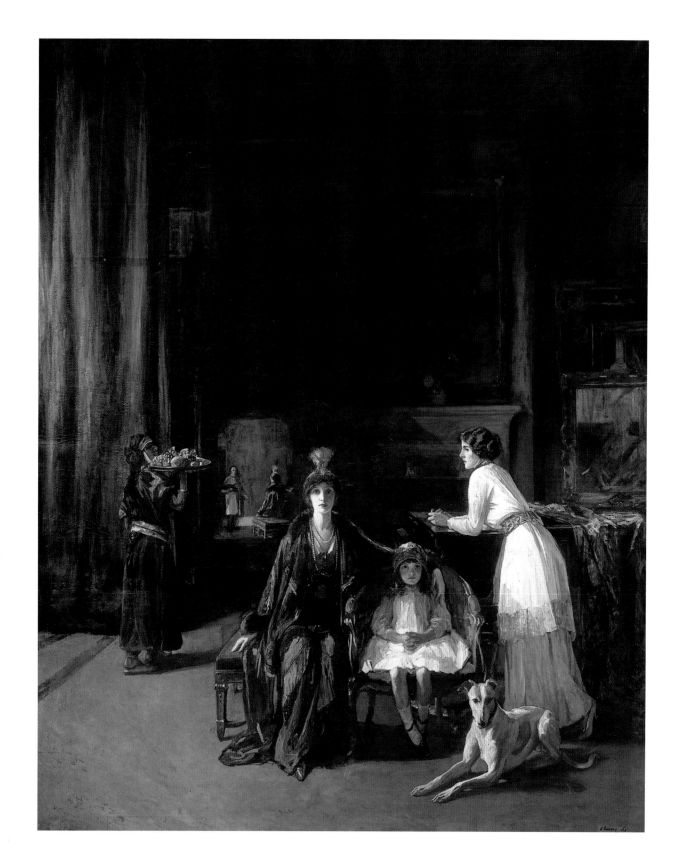

.29.

The Death of Cuchulainn, 1911–12

Oliver Sheppard (1865–1941) / Bronze; height 150 cm / General Post Office, Dublin

The story of Cuchulainn appealed to Irish cultural nationalists in the early twentieth century. Part of the Ulster cycle of Irish mythology, it told of the legendary hero bravely meeting his death. To fight his enemies to the last, he tied himself to a stone pillar. The bronze statue sits in the central window of Dublin's General Post Office. This was the principal site of the fighting during the Easter Rising, 1916, and was where Patrick Pearse read the Proclamation of the Irish Republic. After six days of fighting, he and fourteen other leaders surrendered, were court-martialled and executed by a firing squad.

The sculpture was chosen to be the official memorial to the Rising in time for the twentieth anniversary of the event by the then Taoiseach of the new Republic, Éamon de Valera. It had been modelled many years before by Oliver Sheppard, the hugely influential professor of sculpture at the Dublin Metropolitan School of Art, and exhibited as an independent work at the Royal Hibernian Academy in 1914.

The theme of the romantic heroic male nude from mythology had become especially popular towards the end of the previous century in France and Britain. Sculptors were keen to explore the nature of the hero and the heroic world through expressive form. The figure of Cuchulainn recalls *The Call to Arms* by French sculptor August Rodin (1878, Musée Rodin, Paris). This latter depicts a naked wounded soldier, who in turn vividly recalls the figure of Christ in Michelangelo's *Pietà* of three centuries before. It also echoes the pose of the *Dying Gaul* from Roman antiquity.

The body is flawlessly observed, the anatomy and muscles demonstrating Sheppard's skill in modelling with his hands rather than tools. Its expressive force is portrayed in the twisted pose, the bowed head and the noble bearing of the facial features. A raven, the symbol of death, is perched on his shoulder. Its strong quasi-religious disposition serves to unite the mythical hero with those of later Christian martyrs. This symbolism was clearly recognised by the public: down through the decades, one bronze foot has been rubbed as though it is a 'real' sacred relic.

The sculpture was unveiled in April 1935 amidst an elaborate military service. At the unveiling, the Taoiseach Éamon de Valera stressed the continuity of the executed signatories with the present-day elected representatives. Originally chosen because of the role assigned to the mythical hero by Patrick Pearse in his writings, a role in which chivalry and blood sacrifice on behalf of Ireland were paramount, it resonated with all those who had fought in the Rising and later conflicts.

At the time of its unveiling, the *United Irishman*, the voice of extreme republicanism, argued that Cuchulainn had not fought against foreigners as the other great mythical Irish hero Fionn Mac Cumhaill was reputed to have done. Later in the century the sculpture would be adopted by both sides during the Troubles. It appeared as a wall painting in the republican Bogside of Derry and was later used by loyalists in East Belfast.

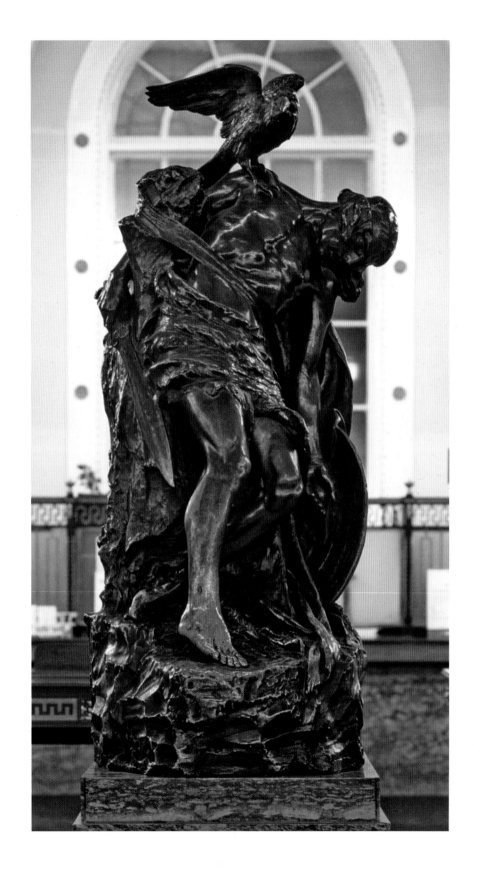

.30.

A Convent Garden, Brittany, c.1913

William Leech (1881–1968) / Oil on canvas; 132 x 106 cm / National Gallery of Ireland

William Leech was born in Dublin and attended the Dublin Metropolitan School before training in Paris at the Académie Julian. In 1903 he moved to Brittany where he encountered Impressionist and Post-Impressionist artists. Both styles were to have a lasting influence on his work. Leech exhibited regularly at the Royal Hibernian Academy and elsewhere. He was awarded a bronze medal at the Paris Salon in 1914. From 1916 he settled permanently in England, continuing to visit France for many years.

His earliest French scenes, harmonious in their gentle tonal shades, are influenced by the work of the nineteenth-century American artist James Whistler. But from 1910 onward, the bright summer light of Brittany began to affect his work. *A Convent Garden* is a stunning example of Leech's flair and skill in depicting strong sunlight as it strikes a small area within a walled convent garden. The painting was displayed at the Paris Salon in 1913 and was chosen in 1930 to represent the best of Irish painting and sculpture for an Exhibition of Irish Art in Brussels.

Using his first wife, the artist Elizabeth Kerlin, as his model, Leech depicts her as a contemplative novice about to make her final vows. As a bride of Christ, she is dressed in a traditional Breton lace wedding dress and starched lace *coiffe*, prayer book in hand. Having taken her vows she will wear the plain white cotton habit of the other nuns, who can be glimpsed behind her in the shadow of the trees.

Leech's canvas combines aspects of both Impressionism and Post-Impressionism. To suggest the sheer strength of the direct light, the novice's flimsy gown positively dazzles the eye, recalling work by Claude Monet in the 1870s. Although fully covered, her slim, graceful form can be seen beneath. The rippling grass is made up of bright yellow and acid greens, for all the world looking like a large bright, shaggy rug. The highly coloured palette and choppy brushwork implies a knowledge of Vincent van Gogh.

The creation of shadow throughout is masterly and, again, one developed by the Impressionists, who paid close attention to the reflection of colours from object to object. The garment's delicate shades of mauve and lilac, as well as white and green, reflect the colour of the flowers and grass close by. The shadow created by the novice includes an opaque pink suggestive of flesh tones.

Leech's composition is unusual in that he doesn't place the main figure in the centre but rather to the side. It is as if she will walk out of the picture space. This recalls the work of two artists connected with Impressionism and whose compositions are equally asymmetrical, Edgar Degas and Mary Cassat. The setting is Concarneau in Brittany. While there in 1904 Leech contracted typhoid and convalesced in a local hospital run by the Sisters of the Holy Ghost. The garden where he recuperated is most likely the garden in the picture and the sisters in the painting are wearing the habits of that order.

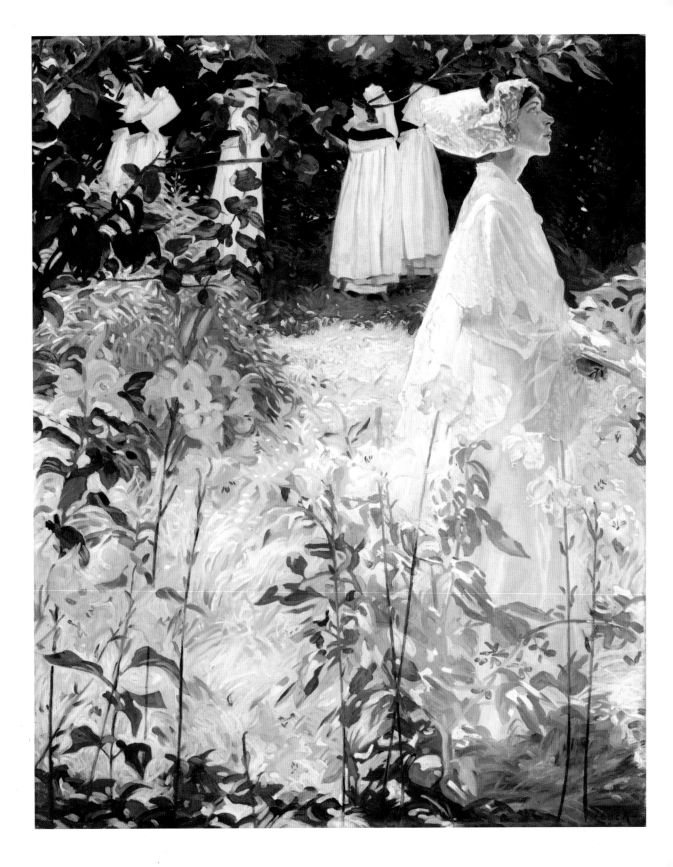

.31.

Dawn, Killary Harbour, 1921

Paul Henry (1876–1958) / Oil on canvas; 69.1 x 83.3 cm / Ulster Museum, Belfast

In 1910 Paul Henry and his wife, the painter Grace Henry, travelled to Achill Island, Co. Mayo. He was so spellbound by the location, he later recalled, that he tore up his return rail ticket to Dublin. He took a job with the Congested Districts Board. This allowed him to remain on the island to paint and sketch for the next nine years with brief forays to London and Dublin. His wife, however, did not settle and took as many opportunities to return to a more comfortable life in Dublin as possible. Eventually, they would separate acrimoniously. He later settled in Co. Wicklow with Mabel Young, whom he married after Grace's death in 1953.

Paul Henry's early western paintings such as *The Potato Diggers* or *Launching the Currach* (National Gallery of Ireland) were innovative in that they depicted for the first time the struggle against poverty on the part of the islanders. They recall the work of French Realist artist Jean-François Millet, as well as being informed by the writings of the Irish playwright, poet, writer and collector of folklore, John Millington Synge. Synge's western drama *Riders to the Sea* (1904) had made a deep impression on the artist. But above all, the paintings reflect Henry's sincere admiration for the plight of those who made a living in this beautiful but inhospitable spot.

Of his 'pure' landscapes, *Dawn, Killary Harbour* is undoubtedly one of the finest. Remarkable for their simplicity of concept and sense of timelessness, these scenes are devoid of people. They focus entirely on the terrain and record how the ever-changing weather patterns coming in from the Atlantic constantly change the quality of light. This view is one looking towards the sea, about three miles west of Leenane. It catches the early morning light of a spring or summer's day. The artist's red-green colour blindness caused him to prefer capturing the cool light of dawn or evening.

He did many sketches out of doors and then painted the oil on canvas in his studio. His choice of colour is monochromatic in keeping with the misty morning light. He has stripped back the actual forms of the landscape so that it is represented in a decorative, semi-abstract way. This kind of interpretation was influenced by the work of American artist, James McNeill Whistler. On arrival in Paris in 1898, Henry had enrolled at the Académie Julian, but when Whistler opened his *atelier* the artist was quick to enroll. He much admired Whistler's atmospheric compositions and from him he learned to observe everything in a simple, direct way and compose them in harmonious tones. *Dawn, Killary Harbour* combines the lessons learned from Whistler with Henry's own creative impulses. It is notable, too, that rather than encourage the eye to explore the pictorial space in depth, the composition encourages it to travel up and down the canvas.

Although depicting a particular place, this nuanced, evocative scene has a universal appeal. The usual naturalistic representations of the West of that period are dispensed by Henry in favour of a wonderfully poetic vision of landscape.

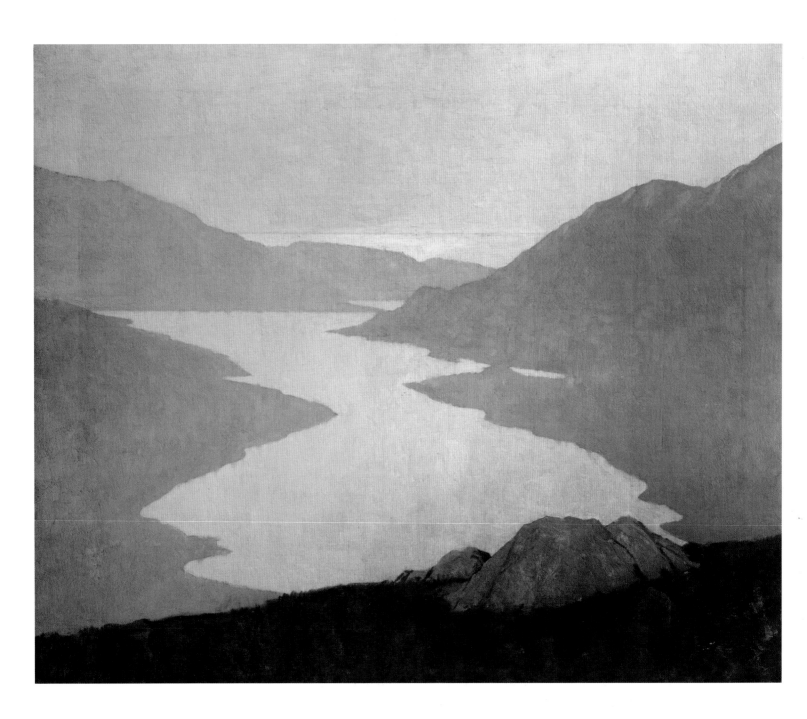

.32.

Men of the South, 1921–2

Seán Keating (1889–1977) / Oil on canvas; 127 x 203.4 cm / Crawford Gallery, Cork

By 1919 Ireland was in turmoil. The War of Independence between Britain and Ireland was one of continuous raids and ambushes. The armed guerrillas, known as 'flying columns' for the speed at which they carried out their actions against the forces of the Crown, were making their detection all the more difficult.

Several paintings document this increasingly ferocious war, the majority of which are by Seán Keating. Begun in late 1921, *Men of the South* depicts a flying column from the Second Battalion, Fourth (North) Cork Brigade of the Irish Republican Army. They are waiting impassively to carry out their ambush. Partly hidden in trees and bushes, they are placed against a backdrop of autumnal fields and hills.

The artist's preparations were thorough. He began by assembling a group of leading officers and photographing them in an arrangement that is almost identical to the painted composition. Several of them later travelled to Dublin, where they sat for Keating in his studio at the Metropolitan School of Art. Apparently the porters at the School were scared to encounter these men, who appeared with their rifles wrapped in brown paper!

Recalling the great heroes of antique classical friezes, the artist arranges the figures across the canvas and in profile. This visually establishes them as a new kind of Irish hero, one corresponding an idealised notion of Irishness. Their resolute expressions and alert poses, coupled with the accuracy of detail in their appearance and the arms they carry, create an image that demands to be valued for its historical authenticity.

Men of the South can be seen as an image of the struggle for independence. The artist glorifies the recent military struggle and its participants. His earlier *Men of the West* (1915, Dublin City Gallery The Hugh Lane) is nationalism at its most visionary. Yet Keating was no mere propagandist. He believed in and supported the nationalist cause and looked forward to an independent Ireland. This would change after the horrors of the Civil War (1922–23). His *Allegory* (1924, National Gallery of Ireland) expresses his abhorrence of the turn of events. When the Irish Free State came into being, Keating became its official artist.

Seán Keating's career had commenced with his study of drawing at the Limerick Technical School. He received a scholarship at the Metropolitan School in Dublin in 1911. There he came under the influence of William Orpen (*qv*), the leading portrait painter of the period. From 1911 onward, he took up a part-time teaching post at the School. In 1915 Keating became Orpen's assistant and model in his London studio. He returned to Ireland in 1916 and soon established his credentials as an artist of quality. He would become Professor of the School of Painting in its later reincarnation as the National College of Art in 1936. In 1950 Keating was elected President of the Royal Hibernian Academy, a post he held until 1962 when he resigned, believing that, as the bastion of tradition in art, the academy had become too open towards Modernism.

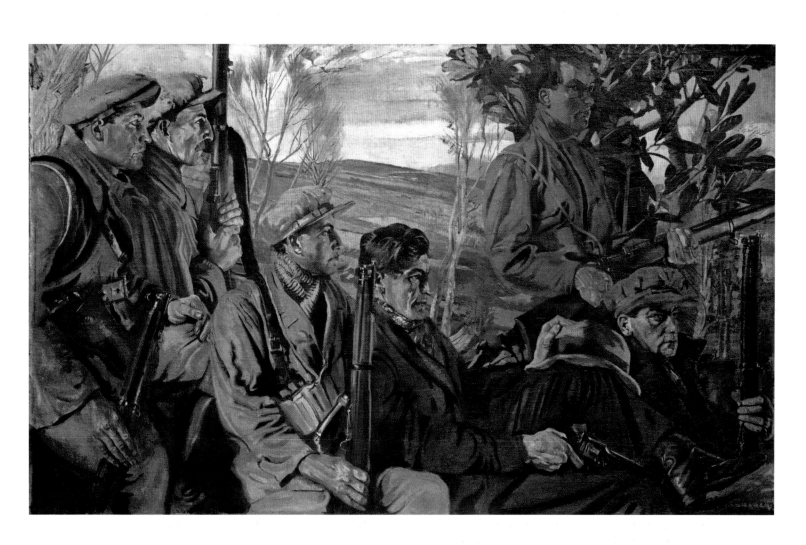

.33.

Portrait of Count John McCormack (1884–1945), Singer, 1923

William Orpen (1878–1931) / Oil on canvas; 104 x 86.4 cm / National Gallery of Ireland

John McCormack, born in Athlone, Co. Westmeath, is regarded as one of the world's finest lyric tenors. In 1903 he was awarded a gold medal at the Dublin *Feis Ceoil*. Two years later, thanks to fundraising activities, the singer was able to go to Milan to continue his studies. His first important operatic performance was at Covent Garden, London.

In 1909 he began a very successful career in the United States. He toured Australia in 1911 and was taken on by Dame Nellie Melba to sing the starring tenor roles at the Melbourne Grand Opera Season. He retired from opera performance in 1923 at Monte Carlo. McCormack made over 600 recordings. His best seller was the ballad 'I Hear You Calling Me' and he was the first to record 'It's a Long Way to Tipperary'. His 'Irish' repertoire of nationalist ballads and songs was especially popular. In 1928 he was made a Papal Count for his work with Irish charities.

Given the number of formal photographs of the maestro, this portrait by William Orpen is refreshingly informal. Painted in Paris, McCormack is seated holding a sheet of music. Although he looks out of the canvas, he seems preoccupied with his own thoughts. This air of introspection lends a vulnerability to the sitter's otherwise dynamic presence.

Originally, he was to have been portrayed in evening dress. Orpen stipulated that McCormack should wear a soft shirt because he was to be presented in a seated pose, but the plan was jettisoned. So, too, a further proposal that he wear an elaborate dressing gown was rejected on the grounds of being too intimate! The problem was solved when he appeared for tea from playing tennis and picked up a piece of music to give the cellist Laurie Kennedy. Orpen instantly decided that his loose sports suit would provide the ideal garment and the sheet of music would serve to remind the viewer of his illustrious career. The flash of red on his lapel was added in 1924, a reference to the *Légion d'honneur* he had recently received.

Although born in Dublin in 1878, Orpen spent much of his career in England where he became one of most fashionable and successful portraitists of the period. He was knighted in 1918 for his services as a war artist. A child prodigy, he entered the Dublin Metropolitan School of Art aged twelve, going on to spend time at the Slade School in London. From 1901 until 1915, he lived between Dublin and London. Every year he would spend time teaching life-drawing at the Dublin School where he was to influence the next generation of artists such as Seán Keating (*qv*), Patrick Tuohy, Leo Whelan, James Sleator and Beatrice Glenavy. He helped Hugh Lane to organise the Guildhall Exhibition of Irish Art in 1904 and supported his efforts to establish a gallery of modern art.

A life-sized bronze sculpture of Orpen in song, by Elizabeth O'Kane (2008), can be seen in the Iveagh Gardens, Dublin.

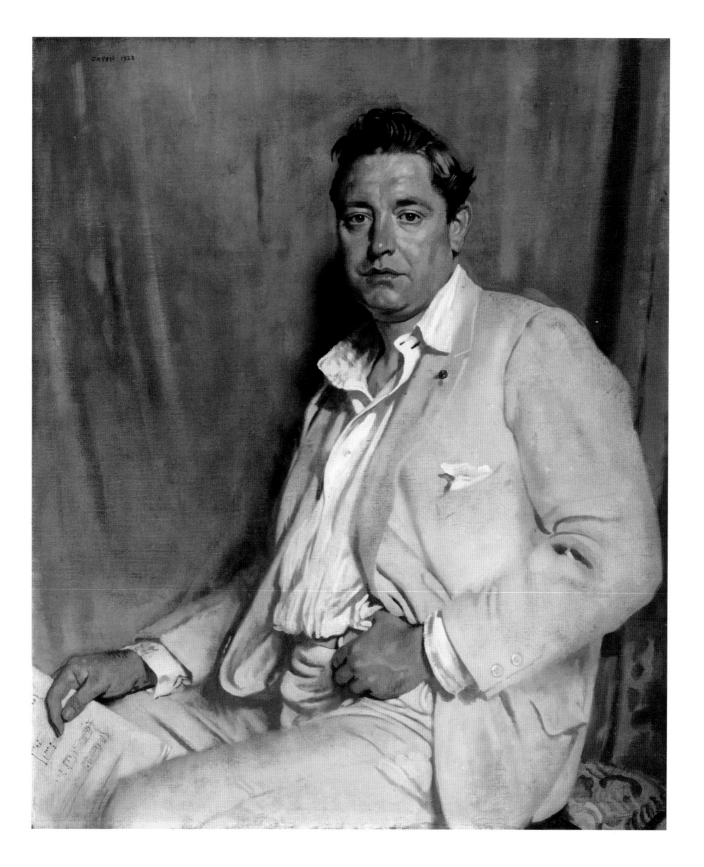

Decoration, 1923

Mainie Jellett (1897–1944) / Tempera on wood panel, 89 x 53 cm / National Gallery of Ireland

Decoration was one of the first abstract paintings seen publicly in Ireland. It was exhibited at the Society of Dublin Painters in October 1923. The critical response to the work was almost entirely negative. The nationalist writer, artist and critic George Russell (pseudonym Æ) declared that Jellett was a victim of 'artistic malaria'! The public, whose taste was influenced by the conservative artistic milieu of Dublin, was taken aback by the picture.

It is a panel painting with references to earlier European religious art. But, to the uninitiated, its abstract form and content were akin to trying to comprehend a strange visual language. The shapes with their vivid colours were radically different from popular devotional pictures. Yet, looking at it closely, the arrangement of geometric and irregular forms resemble the general outline of Madonna and Child figures in early Italian religious painting. Furthermore, the pentagonal framing of the panel is a reference to older altarpieces.

Jellett uses tempera (the mixing of colour pigments with egg yolk), yet another feature of altarpiece painting, as is her inclusion of blue, red and green hues. The fifteenth-century artist Fra Angelico employed these colours in his religious paintings. Finally, there is the addition of gold paint, which was customarily used to indicate sacred figures or imply a spiritual aura.

This progressive artist was born in Dublin. Her early talent for art was encouraged by her parents and in 1914 she entered the Dublin Metropolitan Schools. She studied under the influential life-drawing teacher William Orpen (*qv*) and then enrolled at the Westminster Art School in London. It was here that Jellett met painter and stained-glass artist Evie Hone (*qv*) for the first time. They were to become devoted friends, and both women would revolutionise Irish art in the twentieth century.

Jellett and Hone travelled to Paris in 1920 where they trained in André Lhote's studio. After a year the young women persuaded the abstract painter Albert Gleizes to take them on, and for the next ten years they went to France once or twice a year to work with him in a collaborative manner. With Gleizes they created a form of abstract art that was directly influenced by Cubism. It concentrated on creating rhythm and movement in each composition by means of the careful placing of shapes and colours throughout.

Despite the unfavourable reaction to *Decoration*, Jellett did not change styles and her consequent work, although it moved logically from phase to phase, remained grounded in cubism. She showed regularly with the Dublin Painters, the New Irish Salon and the Watercolour Society of Ireland, also exhibiting in London and Paris. Eager to promote an understanding of Modernism, Jellett also lectured and wrote on the topic.

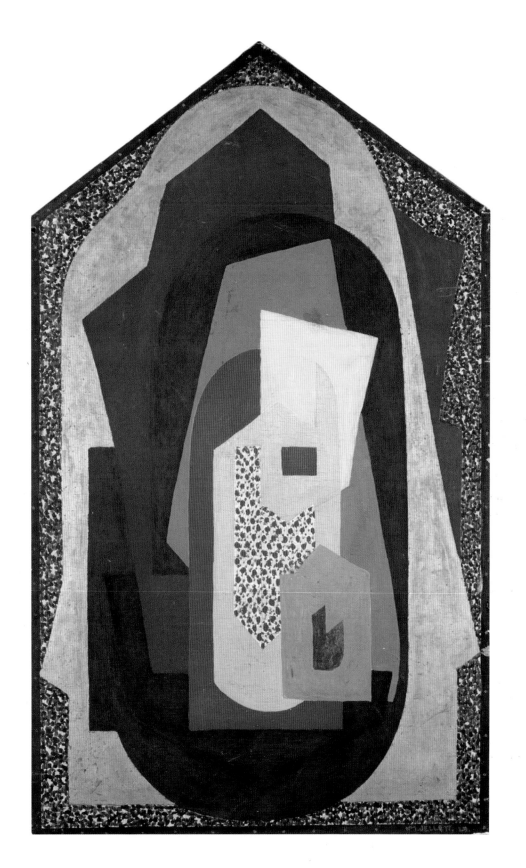

.35.
Honolulu Garden, 1924

Mary Swanzy (1882–1978) / Oil on canvas; 64 x 76 cm / Dublin City Gallery The Hugh Lane

Honolulu Garden is one of nineteen Pacific paintings depicted by artist Mary Swanzy while on a trip to Hawaii and Samoa. Arriving in Hawaii in 1923, she spent time with a relation of hers who was there as governor. This garden scene is a joyous, artistic response to the intense light and beauty of the tropics in this part of the world.

The exotic garden is strikingly different from those in Ireland or England. It is filled with palm and coconut groves, banana and papaya trees. The myriad greens in the large leaves, coupled with the dark and light trunks, contrast with the richly coloured shrubbery nearby. The brilliance of the light creates dark shaded areas, as if a pretty blue-mauve lace mat has been laid on the twisting sandy pathway. The blue sky peeping through the jagged leaves of the trees also creates its own delicate patterning.

Having spent time in Hawaii, Swanzy explored Samoa in the South Seas, producing equally vivid scenes. Like the French artist Paul Gauguin, who had lived in Tahiti to the east of Samoa, Swanzy fell in love with the sunshine, the simple life of the people and the luxuriant plants and shrubs that grew in abundance everywhere. Indeed, her tropical scenes have been compared to those of Gauguin. Both artists had a strong empathy with the local people and were inspired by the landscape. Unlike Gauguin, however, who wanted to escape from cosmopolitan Europe to what he perceived as a more innocent part of the world, Mary Swanzy's views are vignettes of the privileged life of colonial society, with their large villas and beautiful gardens.

Swanzy was one of the first champions of Modernism in the history of Irish art. She was born in Dublin and attended private art classes in May Manning's studio, also frequented by Mainie Jellett (*qv*). Strongly encouraged by portraitist John Butler Yeats who taught there occasionally, she studied in Paris from around 1905 attending Colarossi's studio. Swanzy was deeply interested in the latest artistic developments, such as Cubism and Fauvism; the former for the way in which objects are analysed, broken up and reassembled in an abstracted form on the painted surface, and the latter for its fore-fronting of painterly qualities and strong colour over a realistic approach. She was directly exposed to the work of Paul Cézanne, Pablo Picasso and other leading artists. By 1919 she was becoming recognised in Ireland as a leading Modernist, exhibiting with Paul Henry (*qv*), Grace Henry and Jack B. Yeats (*qv*).

The death of Swanzy's parents gave her financial security and enabled her to travel around Europe and further afield. She travelled to Yugoslavia and Czechoslovakia in 1919 and, by 1924, had reached California via the Pacific. Her sketchbooks are a marvellous contemporary record of the people and places she visited. Swanzy settled in London where she remained for the rest of her life. A major retrospective of her work was held at The Hugh Lane Gallery in 1968.

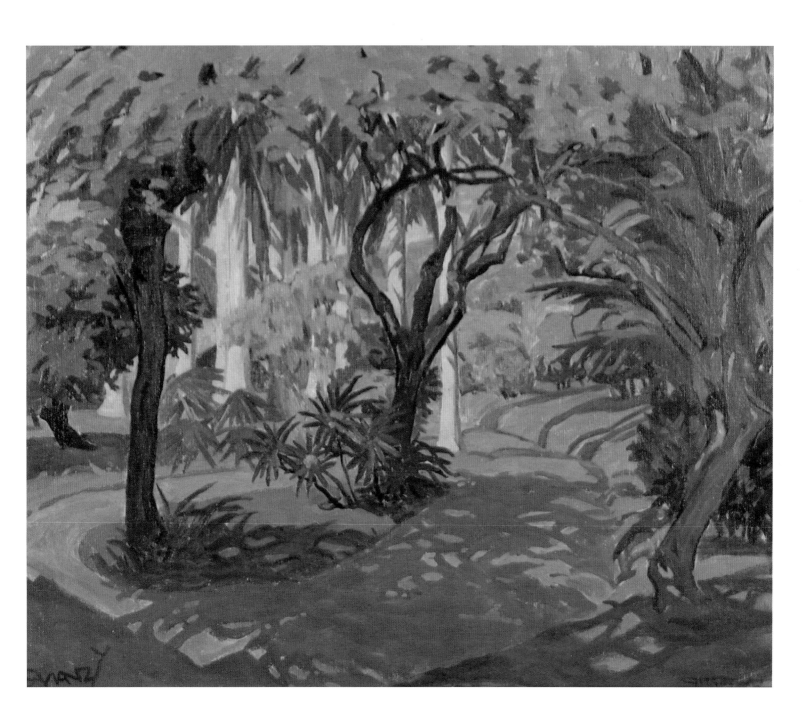

.36.

The Eve of St Agnes, 1924

Harry Clarke (1889–1931) / Stained glass; 157.5 x 105 cm / Dublin City Gallery The Hugh Lane

The Eve of St Agnes was commissioned by Harold Jacob, owner of Jacob's biscuit factory, for the landing of a house in Ailesbury Road, Dublin. Clarke suggested *The Eve of St Agnes* by the English poet, John Keats. Completed in 1924, the window was exhibited at the Irish Art Exhibition in Dublin where it won the gold medal for Arts and Crafts.

In the poem, Madeline's father has forbidden her to marry Porphyro but, despite this, Porphyro secretly enters the castle during a storm. With the help of her maid, they flee across the moors to freedom. Clarke tells the story in two large panels divided into fourteen scenes, separated by ornately decorated columns. Running along the bottom of both panels is a frieze depicting some of the characters from the poem.

The panels are surmounted by two lunettes. They are decorated with a wealth of marine creatures, shells, plant life, insects and flowers. The artist used blue glass and red glass attached to clear glass in the middle. The double-layered glass was etched by bathing it in acid to produce an imaginative assortment of colours. Aside from painting, Clarke also used a needle to scratch all the intricate details into the surface.

Read from left to right, the first three scenes show Madeline's servant praying for his mistress in a dark and cold gothic chapel. The central scene depicts revellers at a ball in the castle. The next scene shows Porphyro arriving in the cold, driving rain. He is dressed in brilliant blue clothes covered in jewels, with a magnificent plume on his headdress. He is there to take Madeline away with him. Below, Madeline's nurse Angela can be seen meeting Porphyro. Frightened for him, she hastens him through the corridor.

Next are two scenes in which the heroine, dressed in a silvery gown and holding aloft a long candle, is on her way to bed without having supper. This alludes to the tradition whereby young girls would fast on the eve of the Feast of St Agnes in the hope that they would dream of their future husbands. Scene seven depicts Madeline asleep, dreaming about Porphyro. The jewel-like stained glass windows in the room indicate Clarke's superb illustrative powers, as does the patterned coverlet on the bed. The right-hand panel continues the narrative: Porphyro gazing at his love through a curtain, then trying to wake her by playing the lute and, finally, Madeline slowly opening her eyes. The final scenes follow their swift exit from the castle and on to freedom.

Born in Dublin, Harry Clarke trained at the Dublin Metropolitan School where he studied stained glass. A scholarship enabled him to travel to France to inspect medieval windows in detail. He was particularly enchanted by the opulent hues of the windows in Chartres Cathedral, south-west of Paris. A superb draughtsman, Clarke excelled also as an illustrator of well-known poems and stories. Among his most popular work in this field are his illustrations for Hans Christian Andersen's *Fairy Tales* (1916, National Gallery of Ireland). His church windows can be found throughout Ireland and Great Britain.

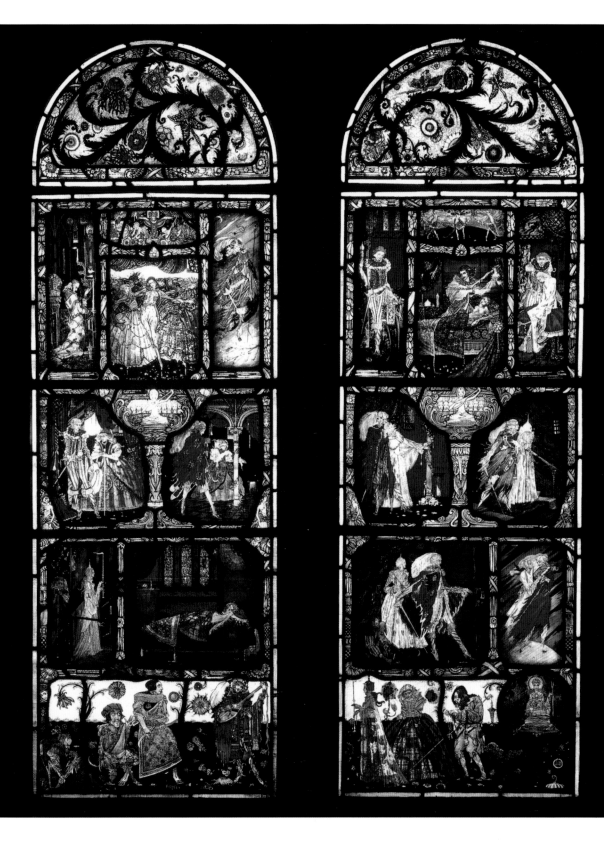

.37.

My Four Green Fields, 1938

Evie Hone (1894–1955) / Stained glass; height 640.08 cm / Government Buildings, Dublin

Evie Hone's career was overshadowed by illness. Struck down with polio as a child, she never fully recovered. The remainder of her life was one of constant pain and medical treatments, so much so that she always required a live-in companion. Yet she never let her ill health get in the way of her art. She is to the vanguard of Modernism in Ireland. She and her friend Mainie Jellett (*qv*) studied in Paris with cubist painter Albert Gleizes. His aim was to produce a pure abstract art, unfettered by representing the observable world. During their ten years working with him in the 1920s, Hone and Jellett eliminated realistic subject matter and explored in depth the relationship between form, colour and light.

By 1930 Hone had returned to a semi-abstracted figurative art. Two years later she turned to making stained glass and largely devoted the remainder of her career to producing windows with sacred themes, reflecting her own deep religious feelings. *My Four Green Fields* is regarded as her secular masterpiece (the East Window in Eaton College Chapel in England being its religious equivalent).

Commissioned by the Trade and Industries branch of the Department for Industry and Commerce, it was to be placed in a pavilion built by the Americans at the New York World's Fair of 1939. The oblong building was a sort of court of the nations, housing the history of Irish–American relations. The completed window was placed at the end wall. It was Hone's first major work in stained glass.

Made at *An Túr Gloine* where she was working at the time, Hone made various preparatory designs based on a choice of subjects: Irish life and Ireland; the Early Christian saints and scholars; and a heraldic design featuring the emblems of four of the ancient provinces in Ireland, namely Leinster, Munster, Ulster and Connaught. The new Constitution in 1937 had made claim to the 'four green fields' of Ireland, so this subject was deemed to be the most acceptable. The window was officially ordered in October 1938 for a fee of £600 sterling.

The emblems of the four provinces stand out clearly in the fusion of intense colours. At the top are the three crowns of the southern province of Munster. They are believed to be the crowns of three medieval lordships: the O'Briens (Thomand), the Butlers (Ormond) and the Fitzgeralds (Desmond). Below is the blood-red hand of the northern province of Ulster, which is the emblem of the O'Neills of Co. Tyrone. The arm, sword and eagle of the western province of Connaught are located one above the other to the left. The eagle's plumes, represented in deep rich tones of blue, purple and pink, provide a stark contrast to the cold stone colour of the arm and sword above it. A large golden medieval harp symbolises the eastern province of Leinster, as well as being the national symbol of Ireland since 1922. Below it a glowing shamrock completes the design.

My Four Green Fields was an instant success and won first prize for a work in stained glass at the World Fair. It is now located in the entrance hall of Government Buildings in Dublin.

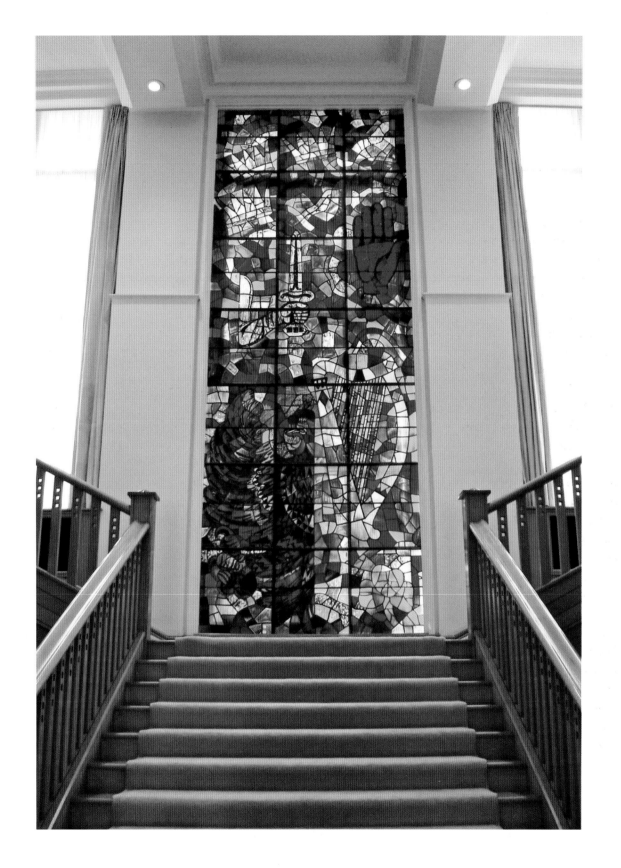

.38.

Island People, c.1950

Gerard Dillon (1916–1971) / Oil on board; 58.4 x 67.8 cm / Crawford Art Gallery, Cork

The west of Ireland represented an idyllic location for artist Gerard Dillon. Born in Catholic Belfast where sectarian conflict was never far from the surface, he portrayed aspects of life in Connemara and the Aran Islands in a decorative, idiosyncratic way. Like Seán Keating (*qv*) and Charles Lamb, he was interested in the life of the people of the west of Ireland, as well as its distinctive landscape.

He left school in 1930 wanting to be an artist. He attended some evening classes in the Belfast School of Art but left, afraid the lessons would interfere with his personal artistic vision. In order to make a decent living, he was obliged from time to time to work as a house painter. In 1942, with encouragement from Mainie Jellett (*qv*), he had his first solo show in Dublin. She had already persuaded him to join the Society of Dublin Painters. Dillon became an active member of the Irish Exhibition of Living Art and served on its committee for almost two decades.

Dillon spent time in London, sharing a house with his sister Molly. It became an important meeting place for Irish artists, writers, actors and musicians. He returned regularly to Ireland in the 1940s and 1950s. In 1958 Dillon represented Ireland at the Guggenheim International Exhibition in New York. He travelled widely in Europe and taught for short periods in some London art schools. In 1968 he designed sets and costumes for Seán O'Casey's play *Juno and the Paycock*.

Island People represents Gerard Dillon's vision of a distinct Irish utopia. The artist paints himself heading down a *bohereen* towards the sea, painted easel under his arm and holding a case containing his paints and brushes. Two islanders watch him from a discreet distance, possibly with some suspicion. Although artists had been going to the west of Ireland for many decades, their lives were radically different from the inhabitants whose lives were very enclosed.

Dillon was influenced by Early Christian high crosses, in which each scene is carved in a direct simple style and contained in its own compartmentalised space. As a child he had also enjoyed cutting out pictures from newspapers and magazines and rearranging them into decorative compositions. All of these influences come together in *Island People*, including the fresh naïve style, the bold bright colours and the manner in which each aspect of life in this part of Connemara is made to stand out clearly, with its typical dry-stone walls, rocks, fields and white-washed cottages. There are references to the working life of the inhabitants in the hayricks, the cattle in the fields, the donkey and geese. One of the islanders is holding an oar used to handle a currach. Two of these boats can be seen in the near distance, pulled high up on the beach. A nearby cart is a reminder that the inhabitants collected and sold seaweed to bring in some extra spending money.

The naïve spontaneity of Dillon's work earned him recognition in Ireland and London, evident in the number of his solo exhibitions. His pictures were also shown in exhibitions in Paris, Rome and the United States.

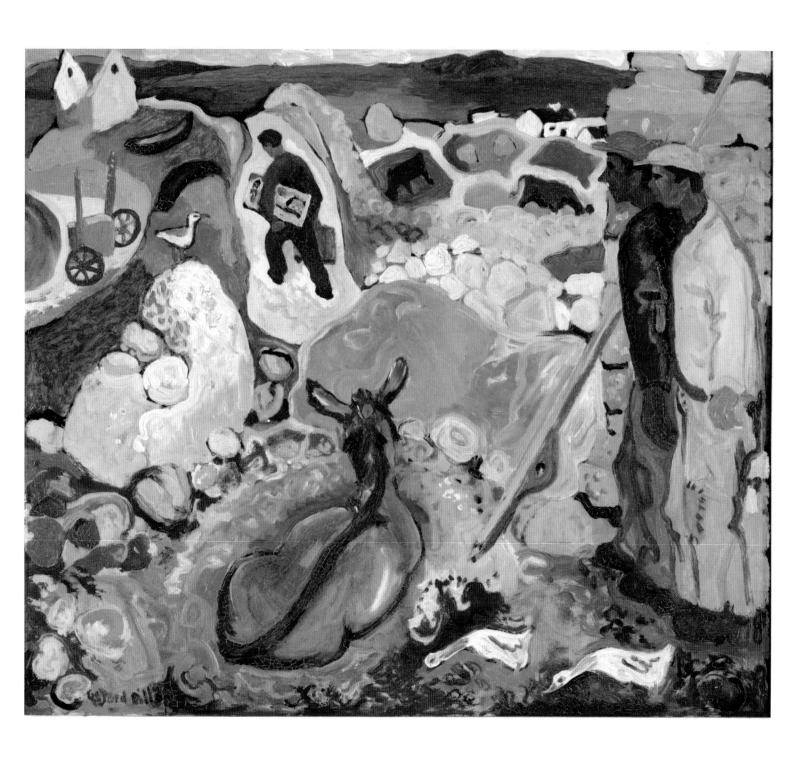

.39.

For the Road, 1951

Jack B. Yeats (1871–1957) / Oil on canvas; 61 x 92 cm / National Gallery of Ireland

For the Road is one of Jack B. Yeats' evocative paintings of his later career. Conjuring up a mood of *joie de vivre*, it depicts a horse – ears pricked up, eyes alert – galloping towards the youth calling to him from a sunlit clearing in an avenue of trees. The delight of the horse, who knows that he will be reunited with his beloved rider, is brilliantly expressed in the exuberant colours that flesh out its form. Equally, the sheer energy of the brushwork conveys the speed at which the animal travels. Every muscle seems to strain forward, the tail and mane flying behind.

Jack B. Yeats, considered by his peers to be *the* painter of Irish life, was born into an impressive artistic family. His father, John, was a portrait painter, while his brother, William Butler, was a foremost figure of twentieth-century literature. His sisters, Susan and Elizabeth, established the Dun Emer Guild, a focus for the Irish Arts and Craft movement, and his niece, Anne, was a painter and stage designer.

Although born in London, Yeats spent much of his childhood in Sligo in the care of his maternal grandparents. The hustle and bustle of life in the town in the late nineteenth century, with its fairs, markets and entertainments of all kinds, affected the direction of his career. His later affectionate portrayals of Irish people across the social scale are rooted in memories of this happy time.

Having briefly attended art schools in London, he began a successful career as an illustrator. He would later contribute cartoons to *Punch* under the pseudonym W. Bird from 1910 to 1948. Following his marriage in 1894 to fellow art student Mary Cottenham, he began painting watercolours of the English countryside. He then turned his attention to Irish life and landscape. His range of subjects was to be wide-ranging, from street scenes to circuses, travelling entertainers, boxing matches, races and funerals. In 1910 he and his wife returned to live in Ireland.

The West held a particular appeal and his travels to Galway and Mayo with playwright John Millington Synge deepened his understanding and affection for those he depicted. Yeats believed that an artist and his art must be rooted in a love of country. Intensely patriotic, some of his paintings were inspired by major political events before and after Independence. *Bachelor's Walk, In Memory* (1915, National Gallery of Ireland) poignantly remembers those shot and injured after the discovery by British forces of German guns in Howth Harbour. *Communicating with Prisoners* (1924, The Model and Niland Collection, Sligo) focuses on the aftermath of the Civil War.

In the 1920s Yeats' style changed radically. He began to apply paint more loosely and colour was used in a richer and more luminous way. He moved away from realistic themes and increasingly relied on his own earlier memories and experiences as well as sketches. Forms in the new style were defined by brushstrokes rather than by drawing, and colours were juxtaposed to create an expressive impact. *For the Road* does not tell a story, but rather evokes a nostalgia for a life free from emotional pain. His wife's death two years earlier is believed to have influenced his choice of subject matter.

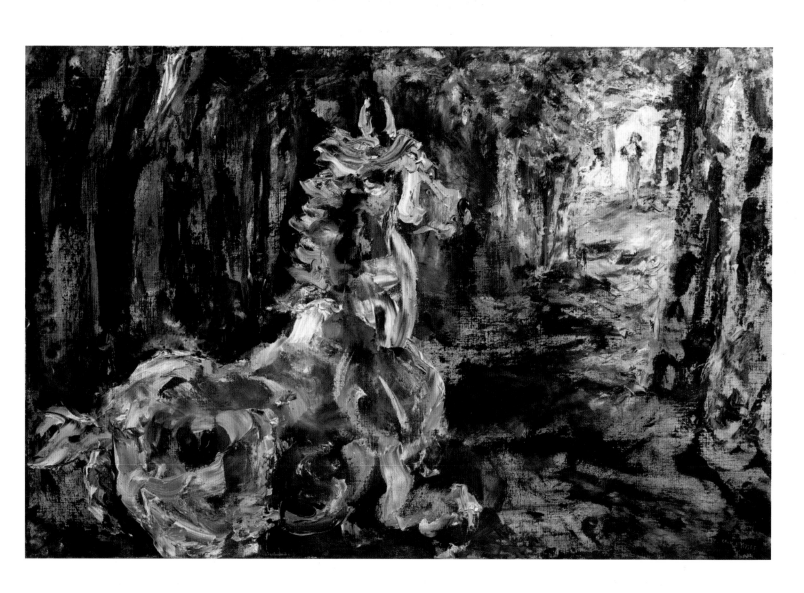

.40.

A Family, 1951

Louis le Brocquy (1916–2012) / Oil on canvas; 147 x 185 cm / National Gallery of Ireland

A Family belongs to a series (the Grey period), painted between *c.*1951 and 1954. Le Brocquy's earlier relatively colourful work was now supplanted by a predominantly grey and white palette. In the years following the Second World War, the artist explored a number of themes, including family life. This bleak, sombre representation of a family was first exhibited in a one-man show at the prestigious Gimpel Fils gallery in London in June 1951. It elicited much praise from some eminent critics.

Almost two metres wide, le Brocquy's unusual painting was inspired by the cataclysmic turmoil in Europe after the Second World War and the ensuing Cold War. Millions of displaced people, uprooted by the war, were still desperately trying to get back to their own countries. Families had been split with members missing or dead. Refugees were still trying to find places to settle. In addition a primal fear gripped European society in the aftermath of the Atom Bomb.

This anonymous family group inhabits a grey, sterile enclosed space, somewhat reminiscent of an operating theatre. The mother, leaning on one arm, stares broodingly at the spectator. The family cat peers menacingly out from beneath a drawn sheet, a drop of blood visible under its paws. In the background, the father sits in a thoroughly dejected pose. He seems to be oblivious to the small child holding a bunch of colourful flowers, the single symbol of hope in the picture. This is a traumatised family, psychologically and physically isolated from each other. Unlike the iconic imagery of the Holy Family, this painting offers no comfort, but rather shocks and unsettles.

Le Brocquy's composition is based on a long tradition of reclining nudes in the history of European painting. In fact, it is a homage to a painting by Édouard Manet, *Olympia* (1865), which created shock and astonishment – instead of portraying a passive, voluptuous figure to be ogled by an implied male viewer, Olympia disconcertingly meets the viewer's gaze. From other details in the picture, the Parisian viewers would have recognised that this nude represented the Parisian prostitutes of the day. Equally, le Brocquy, like Manet, turns the tradition of nude painting on its head to alarm and disturb.

At its Dublin showing, conservative viewers were deterred by its lack of academic realism. It was regarded as repellent by some art critics. However, there were others who were excited by it. A small group of interested art lovers were prepared to present the painting to the Art Advisory Committee in charge of acquisitions for the permanent collection of modern art at The Hugh Lane Gallery. But the work was refused.

Even so, the future of *A Family* was destined to be a successful one, both internationally and nationally. In 1956 le Brocquy and sculptor Hilary Heron represented Ireland at the Venice Biennale, where *A Family* was awarded the Premio Aquisitato. This award greatly enhanced the reputation of the artist in Ireland and assured him a long successful career.

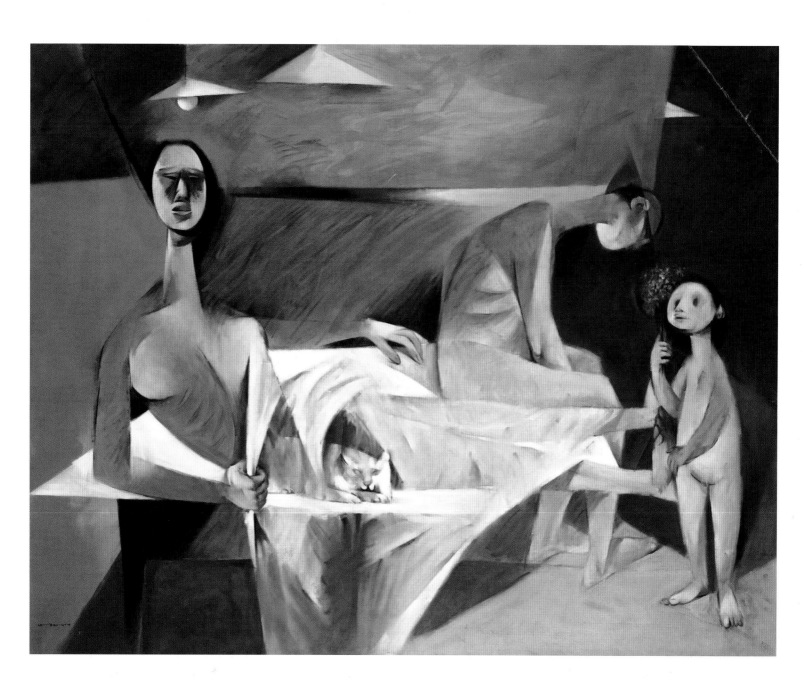

.41.

Hy Brasil, 1963

Patrick Collins (1911–1994) / Oil on board; 76.2 x 91.5 cm / Dublin City Gallery The Hugh Lane

Born in Sligo in 1911, Patrick Collins did not begin to paint until 1945. Instead he earned a living by working for the Irish Life Insurance Company in Dublin for twenty years. During that time, however, he attended evening classes in the National College of Art and read voraciously. *Ulysses* by James Joyce was his bible. He believed that there should be a visual equivalent to the poetic lyricism of W. B. Yeats and the stream of consciousness of James Joyce. The artist aspired to achieve these literary features in his own art.

Collins began to exhibit in 1950 at the Irish Exhibition of Living Art. His first show was held at the Hendriks Gallery in 1956 and was highly commended. Two years later he was awarded first prize at the Guggenheim International Exhibition for *Liffey Quaysides* (1957–8, National Gallery of Ireland). It is an unusual and atmospheric depiction of Dublin city. The river and its quayside buildings seem to emerge out of a misty haze, transforming the busy urban scene into a romantic dreamlike location. Painted a decade later, *Hy Brasil* is similar in style.

The title refers to a mythical island, north-west of Ireland in the Atlantic Ocean. It is said to be mysteriously shrouded in mist except for one day every seven years, when it can be seen but not reached. Collins depicts the island as an indistinct rocky outcrop, peaking just above the distant horizon. Its blurred form is framed within a transparent mist adding to a sense of distance between the island and the viewer. There is not a breath of wind, the sea is still and the magical location casts a long shadow on the water. The dominant colours chosen are blue-grey tones and the composition is slowly built up from layered expanses of these muted colours, with some perfectly judged use of *impasto* (thickly applied paint).

From his early childhood in Sligo, Collins developed an affinity with nature and this experience formed the foundation of his painting. To this end, in 1968 he spent almost a year digging ditches in Connemara, which in turn led to a series of works inspired by bog landscapes. His pictures have been described as the product of a rare imagination. While taking up the mantle of Paul Henry (*qv*), his way of seeing is as equally unique as that of the earlier artist. This is a landscapist more concerned and in touch with the hidden depths of nature than with the observable world.

In 1971 Collins moved to Paris and a year later exhibited a small number of works painted in France, in which he combines mythology and autobiography. Recognised as an outstanding artist, Collins was elected an honorary member of the Royal Hibernian Academy in 1980 and received a bursary from the Arts Council. The following year he was elected a member of Aosdána (affiliation of creative artists in Ireland).

.42.

The Children of Lir, 1970

Oisín Kelly (1915–1981) / Bronze; height 7.3 m / Garden of Remembrance, Parnell Square, Dublin

The Children of Lir sculpture dominates the small Garden of Remembrance in Dublin's Parnell Square. It is dedicated to all the men and women who died in pursuit of Irish freedom from the 1798 rebellion to the Easter Rising in 1916 and the Irish War of Independence between 1919 and 1921. Other conflicts, such as the Land War of the later nineteenth century, are also remembered. The location itself marks the spot where the leaders of the Easter Rising were held overnight before being taken to Kilmainham Gaol to be executed.

As early as 1946, a competition had been held to decide on the layout of the garden. The brief was that the design would symbolise the sacrifice and endeavour of those who inspired Ireland's struggle for political freedom. The winner, architect Daithi Hanly, planned a garden that is strikingly specific to Celtic Ireland. It includes a wealth of abstract and religious motifs. On the entrance gate there is a replica of the processional Cross of Clogher. The railings are designed with motifs dating from the Iron Age to medieval Ireland: the ancient trumpet of Loughnashade, the sword of Ballinderry and the so-called Brian Boru harp. The central pool is cruciform in shape with a series of motifs on its mosaic floor, which recall the tradition of Celtic warriors throwing their weapons into lakes and rivers after battle.

The bronze group of the Children of Lir is the central feature of the park. This favourite old Irish tale tells of the four children of King Lir, who were transformed by their jealous stepmother into swans for 900 years. She decreed that only the sound of a church bell would break the spell. Nine hundred years later, the swans finally heard the ringing of a bell in Inis Glora, off the coast of Mayo. A local monk came upon them and was amazed to hear swans talking so he listened to their tale of woe. He then went into the church, brought out some holy water and sprinkled it on them while he prayed. As soon as the water touched them the swans began to change into very old people. Their bodies almost immediately turned to ashes and the remains were buried on the spot.

Oisín Kelly wanted to make a memorial that would continue the Celtic and religious symbolism of the garden design and touch on Irish popular imagination. He chose the moment when Aodh, Fionnuala, Fiachra and Con were turned into swans. Their lifeless bodies fall to earth while their swan-like forms fly upwards. A symbol of rebirth that emerges out of tragedy, the swan seemed to Kelly and architect Daithi Hanly to be the most appropriate image. The sculpture also evokes W. B. Yeats' poem *Easter 1916*, in which he declares that everything changed after that event and 'a terrible beauty' was born. Below the bronze statue, a plaque entreats that the dead whose sacrifice led to freedom be remembered.

The sculptor, noted for his ability to work in stone, bronze, copper, wood and even cement, created his first mature works in the mid-1940s. He was a regular exhibitor at the Irish Exhibition of Living Art and the Royal Hibernian Academy.

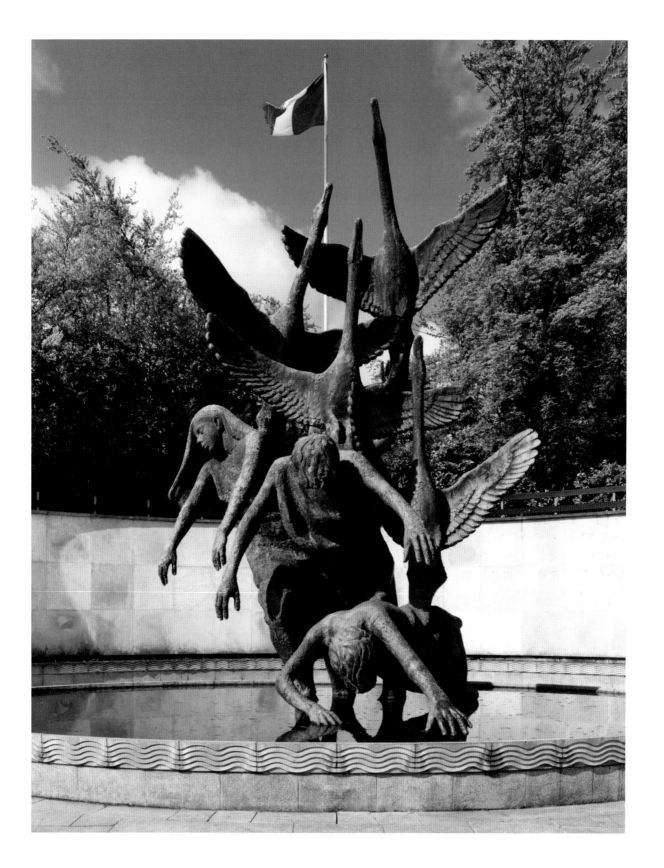

Habitation 1, 1970

Maria Simonds-Gooding (b.1939) / Plaster, collage and oil; 106.7 x 147.3 cm / Irish Museum of Modern Art

Maria Simonds-Gooding was born in Quetta, now Pakistan, into an Anglo-Irish family. They returned to Ireland in 1947 and settled near Kenmare, Co. Kerry. She studied at the National College of Art and Design for one year in 1962, followed by a year in Brussels. Dissatisfied with the art training she had received up to that point, she took the advice of Dublin gallery owner David Hendriks and artist Cecil King, who suggested she apply for a place at the Bath Academy of Art in England. Her two years there, beginning in 1966, proved to be enormously fruitful. Her anti-academic inclinations were encouraged and she was urged to use her imagination spontaneously.

It was at the Academy in Bath that she began to use plaster as a medium of expression on large wooden-framed boards, stripping her compositions down to a few incised lines, abstract shapes and muted hues. *Habitation 1* is the first of many pictures that use a plastered surface in this way. It conjures up a minimalist vision of the primeval wilderness of the Dingle Peninsula. The artist would go on to embrace print-making, tapestry, oil on paper and aluminium.

Attending a drawing class by the inspirational painting tutor Adrian Heath in her final year in Bath, the students were asked to sketch an outline of the model in the studio. Rather than focusing on working the sketch up into a three-dimensional figure, Heath proposed they use the model simply as a reference point from where the drawing line started and to freely extend that line within the pictorial space.

Having outlined the hip and leg, Simonds-Gooding found herself extending the line in the plaster to instinctively create a picture of a Kerry landscape that was always in her thoughts. The result was her personal response to the primitive vastness of this westerly tip of the Dingle Peninsula, its wild terrain arbitrarily marked by water-holes and bogs, tiny round-shaped shelters (*botháns*) and ring forts.

Its evocative, simple shapes are present in the double *botháns* that seem to shelter in the outline shape of the model. Nearby a ring fort is nestled, set within an irregular triangular-shaped surround. On the lower left there appears to be a large waterhole, or perhaps some bogland from which a narrow stream trickles. The viewpoint is a bird's eye one. This adds to the sense of being immersed in an immense space. Altogether, this spare but haunting view captures the essence of the terrain by virtue of the choice of material, colour and form.

While her relationship with Kerry is a profound one, Simonds-Gooding has always been attracted to remote places and has travelled far and wide, including Greece, Lanzarote, India, New Mexico and Mali. In recognition of her unique interpretation of the Irish landscape, she was elected to Aosdána (affiliation of creative artists in Ireland) in 1981. Her work can be seen not only in Ireland, but also in public collections in Washington, New York and Mexico.

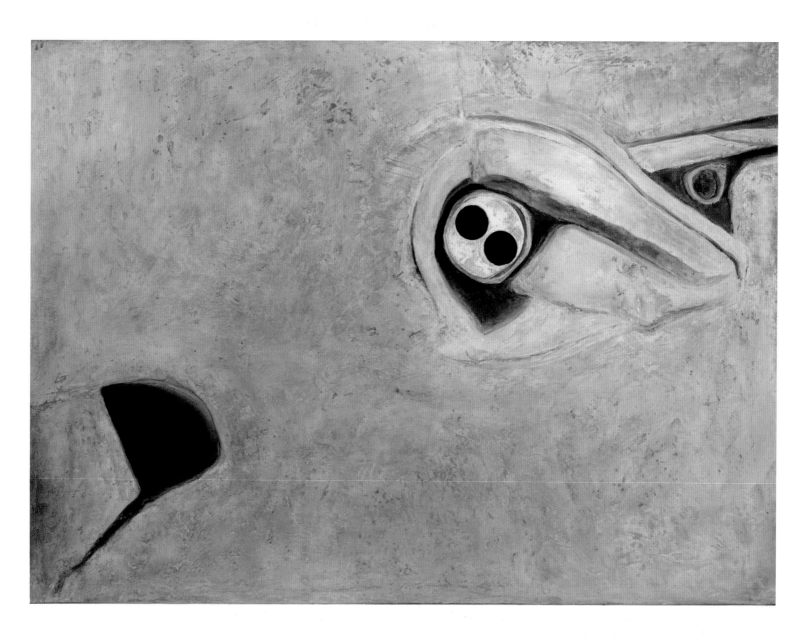

.44.

Portrait of Noël Browne (1915–1997), Politician, 1985

Robert Ballagh (b.1943) / Oil on canvas; 183 x 137 cm / National Gallery of Ireland

Dr Noël Browne remains one of the most controversial figures in twentieth-century Irish politics. He qualified as a doctor in 1942 and, having contracted tuberculosis as a child, he became a leading campaigner for its eradication. It had killed his parents as well as several of his siblings. In 1948 he became a Clann na Poblachta TD for Dublin South-East and was made Minister for Health in the first coalition government. His campaign against tuberculosis led to its virtual eradication.

In 1951 he attempted to implement a Mother and Child scheme, which proposed that all mothers and children aged under sixteen be provided with free state-funded healthcare. Significantly, this would be without a means test. It met with strong opposition from the Roman Catholic hierarchy and the Irish Medical Association. The hierarchy opposed the establishment of socialised medicine in Ireland, fearing that the introduction of non-religious medical advice to mothers would lead to birth control, which was contrary to Catholic teaching. The Irish Medical Association objected to the lack of a means test because their income largely depended on a fee system. The scheme did not proceed and Browne resigned. He continued in politics until 1973 and later became a senator.

In view of Browne's stance, it could be presumed that Robert Ballagh deliberately portrayed him in a cruciform-shaped canvas. However, the canvas on which the seventy-year-old was to be painted was originally a rectangular shape. The artist's first idea was to pose the figure against a background of stones, but he soon realised that this would entail painting acres of stones so he removed the sides to emphasise the tall figure.

Next he looked at the top corners filled with empty sky. He decided that these areas also needed to be eliminated. Only then did he realise that he had ended up with an image in the shape of a cross. The uncompromising and unflinching gaze of Browne seems to serve as a reminder of a politician whose own beliefs often went against the grain in his years in politics.

Ballagh chose to leave the work on the drawing board for a couple of months before deciding to continue the portrait. The finished work includes real stones spilling onto the floor. Two of the books on the floor are by Karl Marx and Samuel Beckett, who influenced Browne in his political thinking. The third book carries the embossed signature of the artist.

Dublin-born Robert Ballagh initially studied architectural drawing, but in 1967 he was represented at the Irish Exhibition of Living Art with two metal constructions, *Pin Ball* and *Torso*. Both objects ignored the fashion of the time, which was for works either in the academic style of Seán Keating (*qv*) or the Cubist-influenced Modernist styles of Michael Farrell and Cecil King. Ballagh's lack of academic training presented no barrier to his successful career as a painter. He was equally successful as a designer, especially those he did for the hugely popular *Riverdance*.

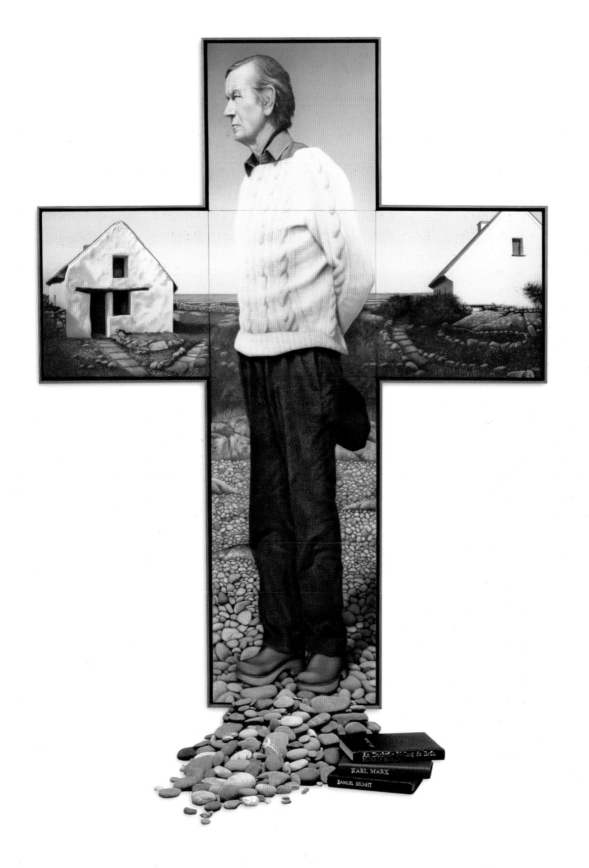

.45.

Chinese Landscape, 1986

Patrick Scott (1921–2014) / Gold leaf and tempera on linen; 122 x 218.5 cm / Dublin City Gallery The Hugh Lane

Patrick Scott began his series of Gold Paintings in 1964. The technique involved the application of gold leaf (sometimes silver) and the use of tempera (pigment mixed with egg yolk) on unprimed linen canvases. Immediately striking is their simple abstract forms. These recall the Far East and Zen philosophy in the use of a restrained colour range and the foregrounding of rich gold-leaf motifs. Unlike the more expressive and colourful work by some of his contemporaries, Scott's flat and clear abstract minimalist style induces a mood of mindful stillness.

This picture captures the distinctive mountain range of the Guilin region in China. In the winter of 1984–5, the artist travelled to the Far East. He was enchanted by the beauty of the terrain, Zen Buddhism and the features of Japanese aesthetics. This painting on linen is a stylised representation of that landscape. The unusual yet familiar shapes of the peaks are delineated in triple linear form across the canvas and, together with the soft shadowy shapes, they create the illusion of mountains appearing to fade away as though shrouded in mist. The semi-circular sun, composed of squares of gold leaf, appears to move majestically up and out of the picture space.

During the war years, Scott was involved with the White Stag Group and first exhibited in 1944, but only decided to become a full-time artist in 1960, the year he won the Venice Biennale. He had worked for fifteen years with the Irish architect Michael Scott assisting in the design of Busáras, the central bus station in Dublin city. His work included designing the building's mosaics. Scott also designed tapestries and carpets for the interiors of large, corporate Modernist buildings. The distinctive motif chosen for the ROSC exhibitions are by him, and he is credited with the design of the first ROSC hang in 1967.

Influenced by his interest in Zen and Japanese art, he went on to make a series of screens in the late 1970s and stylish folding tables in the early 1990s. The rationale behind these works was to connect art and meditation in a tangible way to people's daily lives.

In 1992 Scott was conferred with an honorary LLD in Civil and Canon Law in University College Dublin. He was the first living Irish artist to have a work bought by the Museum of Modern Art in New York. A founding member of Aosdána (affiliation of creative artists in Ireland), he was conferred with the office of Saoi in 2007, a special title for outstanding achievement in the arts. No more than seven current members may be so honoured at one time. The title of Saoi is conferred by the President of Ireland and is held for life. A major exhibition of Scott's work was held in The Hugh Lane Gallery in 2002.

.46.

Berry Dress, 1994

Alice Maher (b.1956) / Rosehips, cotton, paint, sewing pins; 25 x 32 x 24 cm
Irish Museum of Modern Art

On first sight, this small dress with its plain top, sleeves and heavily decorated skirt looks appealing. The dress is perched daintily on a Perspex shelf high up on the wall, and what initially draws the attention of the viewer are its vivid red hues and tones. However, a closer inspection begins to reveal that the pretty garment is not what it seems. While the material used is, unsurprisingly, cotton, it is decorated with real rosehip berries. These are attached to the painted cloth with sharp sewing pins that protrude into the dress, thus transforming it into a dangerous and menacing object. All the usual connotations associated with children's clothes have been challenged in a most disquieting way.

Like much of Alice Maher's works, things are not always what they appear to be. For Maher, the irrational array of materials that make up the dress, plus the height at which it is on view, are deliberate. These combined encourage the spectator to think beyond the usual expectations for such a familiar item. On the one hand, the berries signify the rural countryside in which the artist grew up. They are linked with food and drink but, conversely, if eaten raw the hair inside the berries can be an irritant and cause pain. Dresses usually conjure up notions of warmth and comfort but this one is unwearable.

Berry Dress is about childhood, its innocence and cruelty and, as such, has multiple meanings. On one level the colourful dress represents a common pleasurable memory from early life, but the inclusion of sharp pins conjure up the stuff of childish nightmares. They glisten in the light when seen from a high angle, yet when viewed underneath the transparent ledge, they recall the paraphernalia of medieval torture. On another level the garment draws on folk tales that recall the dual nature of childhood, such as the stories of Little Red Riding Hood, Snow White and Sleeping Beauty.

Maher's work is a perfect example of surreal art, drawing on the irrational and fantastical. It is deliberately subversive and destabilising. Importantly, her art is situated within the context of the rising status of women in the last decades of the twentieth century. The work constantly undermines conventional notions of female identity, especially in her use of non-conventional art materials (berries, bees, nettles, hair, etc.). She and other artists such as Dorothy Cross, Kathy Prendergast and Pauline Cummins were to the forefront of changing the bias against women in the art world and of questioning commonplace assumptions of women in Irish society.

Alice Maher attended the Crawford School of Art between 1981 and 1985. This was followed by an MA at the University of Ulster and a Fulbright Scholarship to the San Francisco Art Institute. She was elected to Aosdána (affiliation of creative artists in Ireland) in 1996 and has exhibited widely, both nationally and internationally.

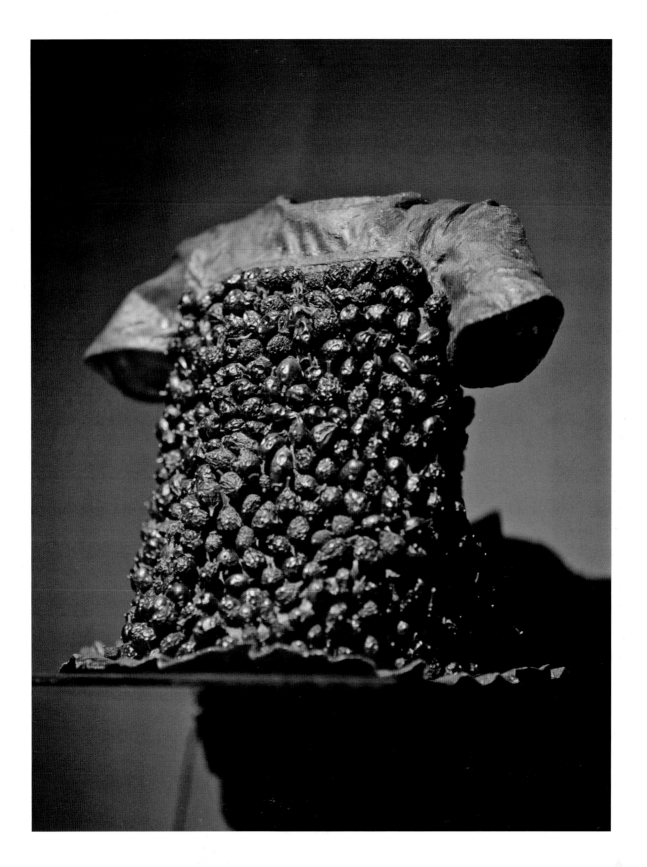

.47.

National Famine Memorial / Ghost Ship, 1997

John Behan (b.1938) / Bronze; height 7.5 m / Murrisk, Co. Mayo

The Great Famine of the 1840s, also known as the Irish Potato Famine, was a watershed in Ireland's history. Over two-fifths of the population relied solely on the potato crop, so when it failed there was mass starvation, disease and emigration. Within a decade, one million people had died and two million had emigrated. While there was famine all over Europe in this decade, the impact on Ireland was disproportionate. Because of the conservative *laissez-faire* political and economic policies of the British government, free market principles dominated and the level of state help was totally inadequate. The result for Ireland was calamitous.

In 1996 the Irish government invited nominations for a suitable location for a memorial to the Famine. Co. Mayo was chosen as it had been one of the worst affected regions. The Office of Public Works commissioned the well-known sculptor John Behan to create a memorial that would encompass the terrible loss and suffering of the famine victims. The sculptor was already interested in the subject, having previously adapted engravings of the event from contemporary illustrations in the *Illustrated London News* into small private sculptures.

The monument is located near Murrisk, at the foot of Croagh Patrick overlooking Clew Bay. Behan created what is colloquially known as a coffin ship but what he termed a ghost ship. Conditions on board these ships for the emigrants who escaped Ireland were atrocious. Most of the passengers were starving or diseased and the loss of life on the ships was horrendous. With its weathered surface and chain of contorted skeletal figures twisting together like some macabre rigging, Behan's roughly modelled ship has the look of a ship of death rather than one transporting its passengers to a hopeful future.

Following the success of the memorial, Behan was invited to create a companion piece, *Arrival*. It was presented in 2000 to the United Nations, New York, and is installed in the sculpture plaza outside the building. This smaller bronze ship shows 115 passengers disembarking on arrival in New York.

As a child John Behan enjoyed drawing. He began his career with an apprenticeship in metalwork and in turn attended night classes at the National College of Art and Design in Dublin, the Art College Ealing in London and the Royal Academy School in Oslo. In 1960 he exhibited with the Irish Exhibition of Living Art. Unlike some of his fellow artists, he was not interested in Modernist styles, but rather in producing a figurative art. This art is not in a realistic vein, where smoothness of material dominates. Instead, it is characterised by a rough, expressive execution.

Behan was a founder member of the New Artists' Group in 1962 and co-founded the Dublin Art Foundry with Peter O'Brien in 1970. He is a member of the Royal Hibernian Academy and of Aosdána (affiliation of creative artists in Ireland). In 2000 he was conferred a Doctor of Literature by National University of Ireland in Galway.

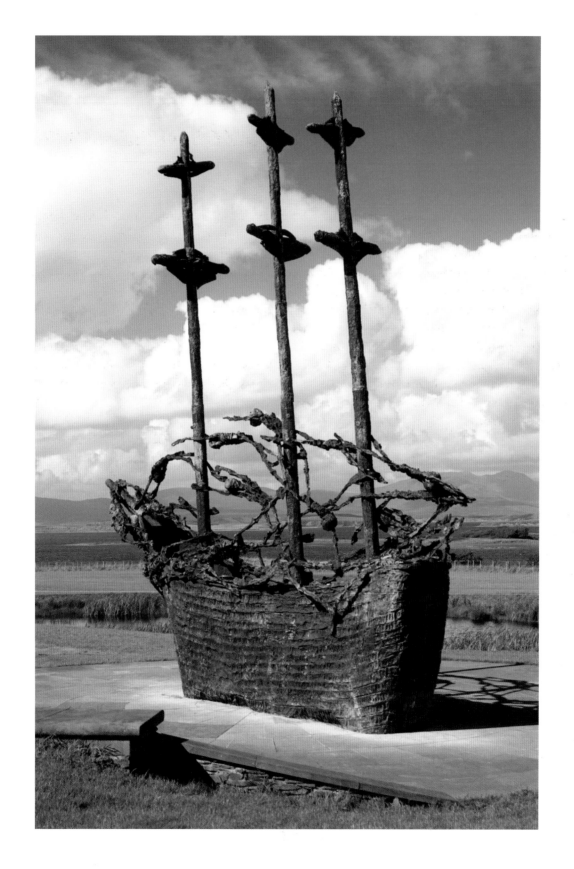

.48.

Portrait of Ronnie Delany (b.1935), Sportsman, 2000

James Hanley (b.1965) / Oil on linen; 206 x 155 cm / National Gallery of Ireland

Ronnie Delany is a former Irish athlete. He won a gold medal in the 1,500 metre event in the 1956 Summer Olympics in Melbourne and later earned a bronze medal at the 1958 European Athletics Championships in Stockholm. Before the run in Melbourne, he was the youngest and only the seventh man in history to complete a mile in under four minutes. He set three consecutive world records for the indoor mile and won forty successive indoor races between 1955 and 1959. He retired from competitive athletics in 1962.

Dublin-based artist James Hanley is primarily a portrait painter. He studied History of Art at University College Dublin before going on to train as an artist at the National College of Art and Design, graduating in 1991. His talent lies in his ability to capture a strong likeness, yet his portraits are never merely descriptive. He likes to build up a layered image, placing the sitter in a context and framework. Among his many renowned portraits are those of former Taoiseach Bertie Ahern and former President of Ireland Mary McAleese.

This vivid, colourful portrait of Ronnie Delany was commissioned for the National Gallery of Ireland as part of the Irish Life & Permanent Portrait Series. The artist depicts the former sportsman as a person who has lost little of his physical strength. Facing fully to the front, his legs are animated as if ready to run should a whistle be blown. The hands are strong, the gaze steady and focused. The lapel pin on his jacket refers to the gold medal he won all those years ago.

The wall behind him is intended to suggest a locker room and was chosen by the artist as a place on which to hang some significant references to the sportsman's career. These defining images enable the viewer to get the full picture of Delany's ultimate sporting success, rather than just a casual view of the sitter. Clockwise from the bottom left is the 1956 Olympics poster, weathered with time, and the classic photo of the runner breaking the tape, but reduced to a small blurred photograph. Next are references to his running of the indoor mile at Madison Square Gardens, followed by his image on the cover of *Sports Illustrated* and a Polaroid of the winning jersey taken by Hanley himself as reference material for the portrait. Finally comes Delany's favourite image of himself crossing the winning line in Melbourne, his rivals out of sight as he runs into sporting history. The almost hyper-realistic representation of the figure, the meticulous detailing throughout and the use of very vibrant colours all add up to a mesmerising iconic image.

Aside from his portrait practice, James Hanley has had other interesting commissions. In 2006 he designed a coin to mark the 175th anniversary of the Irish Office of Public Works. He has also been commissioned by the national postal service to design stamps.

Hanley is a full member of the Royal Hibernian Academy and Aosdána (affiliation of creative artists in Ireland). He was recently elected to the Board of Governors of the National Gallery.

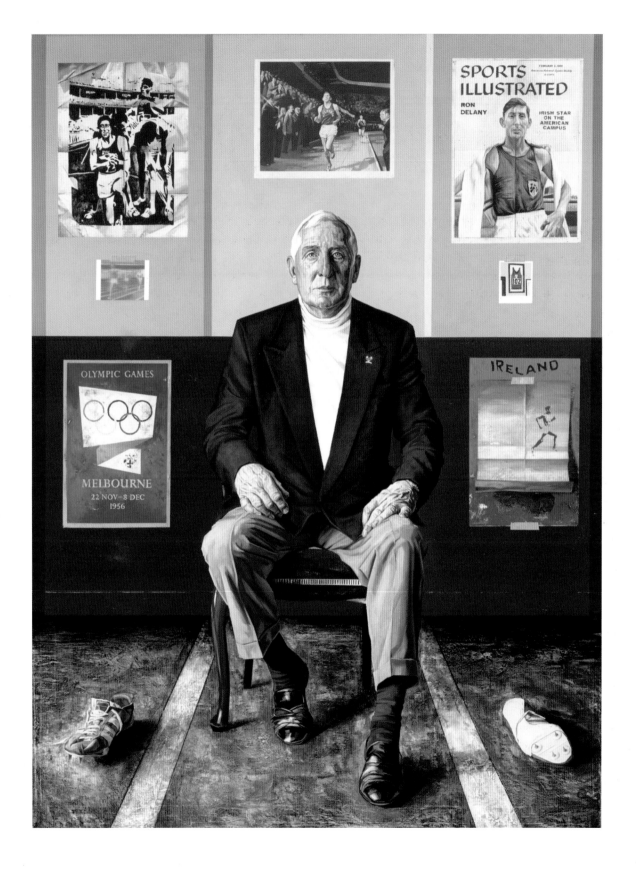

.49.

Wall of Light Sky, 2000

Sean Scully (b.1945) / Oil on linen; 243.8 x 365.8 cm / Dublin City Gallery The Hugh Lane

In the new wing of The Hugh Lane Gallery, located off gallery 12, is a room dedicated to works by Sean Scully. The paintings easily dominate the great space. The overwhelming impression for the first-time visitor is that of the scale and rich colour of the various striped images hanging on the unadorned walls. There is little to distract the viewer from engaging directly with these large abstract works. There are no stories to connect to, no recognisable landscapes to gaze at, no familiar horizon to act as a personal compass point. Each painting, by virtue of laying thick coloured stripes on linen, simply offers a new way of seeing the world as a spiritual domain in which beauty and tranquillity are foremost and everyday conflicts temporarily cease to exist.

Wall of Light Sky is one of a series of paintings the artist started in the 1990s. His earlier travels to Morocco brought him into contact with the striped design of local textiles and the particular quality of southern light. In Mexico, he was enamoured by the ancient Mayan walls and how the light played on them. Taking inspiration from these visits, Scully began to replace the precise stripes of his earlier abstract pictures with blocks of colour. Using a house-painter's brush, he built up the blocks with increasingly loose brushstrokes into irregular structures or 'walls'.

Some of this series of *Walls* record how light transforms them at different times of the day, month or season. Others depict the light associated with specific places, such as the Red Sea, the Mediterranean, the Burren or

Nevada. Yet more are concerned with the light effects when different colours are painted side by side.

Wall of Light Sky is built up of vertical and horizontal blocks of soft diffused colours: black, several shades of grey, brown, creamy yellow and pink on grey. Each block has been painted with enormous freedom and energy. The brushstrokes are clearly visible and it is evident that the artist expended a great deal of energy in producing them. That feeling of immediacy and personal expression by the artist offers one point of departure for the viewer. Another way of connecting with the work is in the painterly way in which the blocked colours are built up. Looking closely, it can be seen that there are other colours coming through from underneath and around the edges of the blocks. There are no defined lines, no closed spaces, but rather light seems to filter through the wall enveloping the whole picture space in a composed, atmospheric way.

Internationally, Sean Scully is one of Ireland's best-known artists. Regarded as an important exponent of Abstract Expressionism, he is represented in all the major museums in the United States and Europe. Born in Dublin, he was raised in South London. He studied at Croyden College of Art and Newcastle University. He received a graduate fellowship at Harvard in the early 1970s and subsequently settled in New York. He became an American citizen in 1983. Nowadays, Scully lives and works in New York City, Barcelona and Munich. He is also a skilled photographer and printmaker.

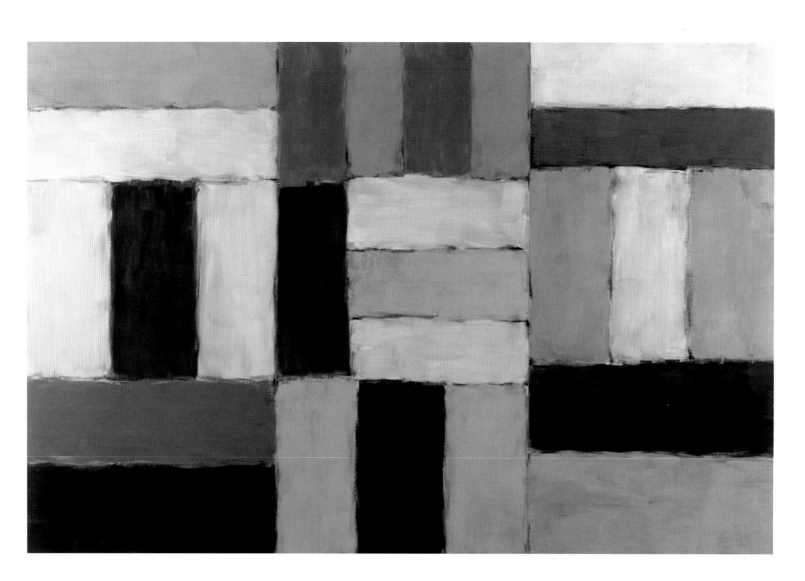

.50.

7 Reece Mews Francis Bacon Studio, 2001

Francis Bacon (1909–1992) / Studio; diameter 3.6 x 7.3 m / Dublin City Gallery The Hugh Lane

On 23 May 2001 the reconstructed studio of internationally renowned painter Francis Bacon was opened at The Hugh Lane Gallery. The artist's heir, John Edwards, had donated the studio in 1998, six years after Bacon's death. The original studio was located at 7 Reece Mews in South Kensington, where the artist had a flat. From 1998 every stick and stone from Bacon's home was transferred to Dublin, including the walls, doors and staircase leading up to the studio, plus thousands of accumulated items littering the artist's workplace. This event was seen as an important step in recognising the artist as a key twentieth-century painter from Ireland. Although he had lived almost all of his life in London, much of his creative imagination can be traced to his childhood and adolescence in Ireland and his love of literature. The bleakness of his outlook mirrored that of his contemporary, the Irish dramatist Samuel Beckett, who lived in Paris for much of his life.

The team involved in the transfer comprised of archaeologists, who made the survey and elevation drawings of the small studio. They mapped out the spaces and locations of the objects. Conservators and curators labelled and packed each item, even the dust! Over 7,000 items were found and these were catalogued on a unique database in the Dublin gallery.

The studio is faithful to the original. The door and stairway leading up to his flat can be viewed next to the re-constructed studio, beneath floor level. Inside the room are a bewildering array of artistic materials, books, photographic material, slashed canvases, drawings, his easel and the mirror which hung on the wall behind it. Each item has been relocated to the exact spot in which it was discovered in the studio in London. These items revealed Bacon's sources for inspiration, his method of work and personal interests.

It is clear that the walls of the studio and the entrance door were used to mix and test paints. Three towelling dressing gowns were found, as were several pairs of thick corduroy trousers, cashmere sweaters, ribbed socks and cotton. Many of these were cut up into pieces and Bacon apparently used them to pattern his paintings. Among the more surprising items are cut-out arrows with thick deposits of paint on them. Bacon employed these to imprint the shape of an arrow directly onto the canvas. The photographic material includes images of victims of world oppression or natural disasters. These informed his nihilistic view of the world, which is central to an understanding of his art.

It seems incredible that an artist who produced many of his finest paintings in this place could work in such a totally chaotic environment. Yet he was happy there. While the rest of the flat was neat and tidy, he believed that the total disarray in his studio actually helped him to create his pictures and find his own technique. Although Francis Bacon had a reputation as a bohemian and roué, he kept his social life separate from his work life. An extremely hard worker, he was self-critical of his work and over his lifetime destroyed many canvases, some of which are in the studio reconstruction in Dublin.

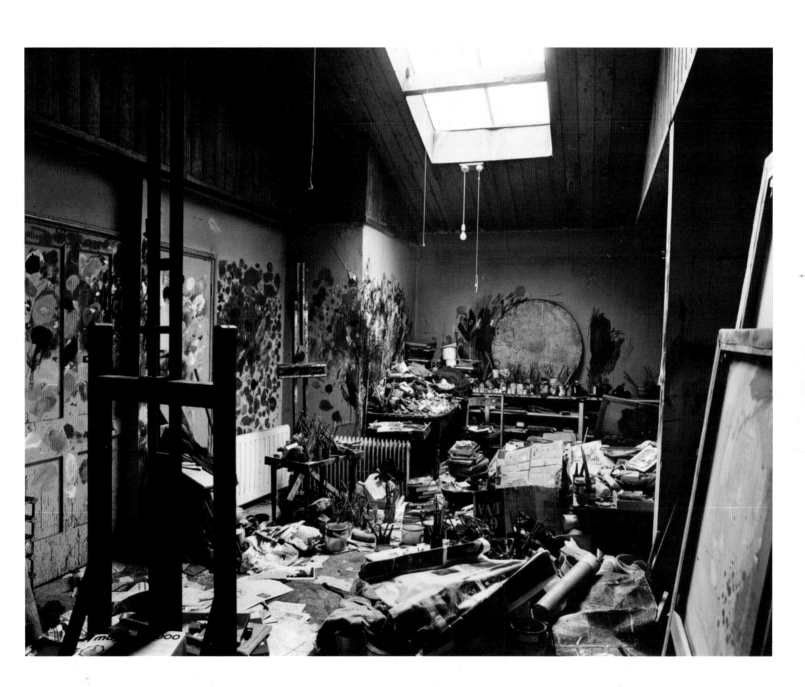

Picture Credits

Page 37 / © Martin Norris Travel Photography / Alamy

Page 39 / Gold Collar, *c.*700 BC / Courtesy the National Museum of Ireland / IA:1934.85

Page 41 / The Petrie Crown, 2nd century AD / Bronze / Courtesy the National Museum of Ireland / IA:P869, IA:P870

Page 43 / Silver chalice (The Ardagh Chalice), 8th century AD / Courtesy the National Museum of Ireland / NMI 1874:99

Page 45 / MS 58 fol.34r Chi-rho, from the Gospel of St Matthew, chapter 1 verse 18, from the Book of Kells, c.800 / Vellum / © The Board of Trinity College, Dublin, Ireland / Bridgeman Images

Page 47 / © Christophe Boisvieux / Corbis

Page 49 / BELUM.U1652 *East Prospect of the Giant's Causeway* (c.1739) / Susanna Drury fl.1733-1770 / © National Museums Northern Ireland / Collection Ulster Museum

Page 51 / George Barret (Irish, 1728/1732–1784) / *View of Powerscourt Waterfall*, *c.*1760 / Oil on canvas / 101.5 x 127.5 cm / Photo © National Gallery of Ireland NGI.174

Page 53 / Patrick Cunningham / *Jonathan Swift, c.*1766 / Marble / Height 0.64 cm St Patrick's Cathedral, Dublin / © Imagoinsulae / Dreamstime.com

Page 55 / James Barry (Irish, 1741–1806) / *The Temptation of Adam*, 1767–1770 / Oil on canvas / 199.8 x 152.9 cm / Photo © National Gallery of Ireland / NGI.762

Page 57 / Thomas Roberts (Irish, 1748–1777) / *A Landscape*, c.1770 / Oil on canvas 112 x 153 cm / Photo © National Gallery of Ireland / NGI.4052

Page 59 / Nathaniel Hone I (Irish, 1718–1784) / *The Conjurer*, 1775 / Oil on canvas 145 x 173 cm / Photo © National Gallery of Ireland / NGI.1790

Page 61 / Thomas Hickey (Irish, 1741–1824) / *An Indian Lady, perhaps 'Jemdanee', Bibi of William Hickey*, 1787 / Oil on canvas / 102 x 127 cm / Photo © National Gallery of Ireland / NGI.1390

Page 63 / Hugh Douglas Hamilton (Irish, 1740–1808) / *Frederick Hervey, Bishop of Derry and 4th Earl of Bristol (1730-1803), with his Granddaughter Lady Caroline Crichton (1779–1856), in the Gardens of the Villa Borghese, Rome*, c.1790 / Oil on canvas 224.4 x 199.5 cm / Photo © National Gallery of Ireland / NGI.4350

Page 65 / John Hogan / *Dead Christ* (1829) / Carrara marble / St Teresa's Church, Dublin / Photo by JC Murphy

Page 67 / George Petrie (Irish, 1790–1866) / *The Last Circuit of Pilgrims at Clonmacnoise, County Offaly*, c.1828 / Graphite and watercolour on paper / 67.2 x 98 cm / Photo © National Gallery of Ireland / NGI.2230

Page 69 / Joseph Patrick Haverty (Irish, 1794–1864) / *The 1843 Monster Meeting at Clifden*, 1844 / Oil on canvas / 110 x 183 cm / Photo © National Gallery of Ireland / NGI.1183

Page 71 / Daniel Maclise (Irish, 1806–1870) / *The Marriage of Strongbow and Aoife*, c.1854 / Oil on canvas / 315 x 513 cm / Photo © National Gallery of Ireland NGI.205

Page 73 / Frederic William Burton (Irish, 1816–1900) / *Hellelil and Hildebrand, The Meeting on the Turret Stairs*, 1864 / Watercolour and gouache on paper / 95.5 x 60.8 cm / Photo © National Gallery of Ireland / NGI.2358

Page 75 / Harry Jones Thaddeus (Irish, 1860–1929) / *Market Day, Finistère*, 1882 / Oil on canvas / 201 x 132 cm / Photo © National Gallery of Ireland / NGI.4513

Page 77 / Sarah Henrietta Purser (Irish, 1848–1943) / *A Lady Holding a Doll's Rattle*, 1885 / Oil on canvas / 41 x 31 cm / Photo © National Gallery of Ireland / NGI.4131

Page 79 / Edith Œnone Somerville / *The Goose Girl*, 1888 / Irish School / Oil on canvas / 95.5 x 132cm / Crawford Art Gallery, Cork (395-P)

Page 81 / Walter Frederick Osborne (Irish, 1859–1903) / *The Dublin Streets – A Vendor of Books*, 1889 / Oil on canvas / 80 x 90 cm / Photo © National Gallery of Ireland / NGI.4736

Page 83 / Aloysius O'Kelly (Irish, 1853–1936) / *Mass in a Connemara Cabin*, 1883 Oil on canvas / Framed: 171 x 217 x 13 cm / On loan from the people of St Patrick's, Edinburgh and the Trustees of the Archdiocese of St Andrew's and Edinburgh / Photo © National Gallery of Ireland / L. 14780

Page 85 / James Brenan / *Patchwork*, 1892 / Oil on canvas / 25.0 x 30.5cm Crawford Art Gallery, Cork (868-P)

Page 87 / Nathaniel Hone II (Irish, 1831–1917) / *Pastures at Malahide*, c.1894–1896 Oil on canvas / 82 x 124 cm / Photo © National Gallery of Ireland / NGI.588

Page 89 / Roderic O'Conor (Irish, 1860–1940) / *Still Life with Apples and Breton Pots*, c.1896–1897 / Oil on board / 49.5 x 55.5 cm / Photo © National Gallery of Ireland / NGI.4721

Page 91 / John Lavery (Irish, 1856–1941) / *The Artist's Studio: Lady Hazel Lavery with her Daughter Alice and Stepdaughter Eileen*, 1909–1913 / Oil on canvas / 344 x 274 cm Photo © National Gallery of Ireland / NGI.1644

Page 93 / Oliver Sheppard / *The Death of Cuchulainn* (1911–12) / Bronze / Height, 150cm / The General Post Office, Dublin / © Design Pics Inc / Alamy

Page 95 / William Leech (1881–1968) / *A Convent Garden, Brittany, c.*1913 / Oil on canvas / 132 x 106 cm / National Gallery of Ireland Collection / © Artist's Estate Photo © National Gallery of Ireland / NGI.1245

Page 97 / BELUM.U301 / *Dawn, Killary Harbour* (1921) / Paul Henry 1876–1958 © Estate of Paul Henry/IVARO Dublin 2015 / Collection Ulster Museum

Page 99 / Seán Keating / *Men of the South*, 1921–22 / Oil on canvas / 127 x 203.4 cm / © Estate of Seán Keating/IVARO Dublin 2015 / Crawford Art Gallery, Cork (75-P)

Page 101 / William Orpen (Irish, 1878–1931) / *Portrait of Count John McCormack (1884–1945), Singer*, 1923 / Oil on canvas / 104 x 86.4 cm / Purchased, 2009 Photo © National Gallery of Ireland / NGI.2009.11

Page 103 / Mainie Jellett (Irish, 1897–1944) / *Decoration*, 1923 / Tempera on wood panel / 89 x 53 cm / Photo © National Gallery of Ireland / NGI.1326

Page 105 / Mary Swanzy / *Honolulu Garden* (1924) / Oil on canvas / 64 x 76 cm Purchased, 1976 / © Artist's Estate / Dublin City Gallery The Hugh Lane, Reg. 1491

Page 107 / Harry Clarke / *The Eve of St Agnes* (1924) / Stained glass / 157.5 x 105 cm / Dublin City Gallery The Hugh Lane, Reg. 1442

Page 109 / Evie Hone / *My Four Green Fields*, 1938 / Stained glass / Height, 640.08cm / Government Buildings, Dublin / Courtesy of MerrionStreet.ie, the Irish Government News Service

Page 111 / Gerard Dillon / *Island People, c.*1950 / Irish School / Oil on board 58.4 x 67.8cm / Crawford Art Gallery, Cork (150-P)

Page 113 / Jack B. Yeats (Irish, 1871–1957) / *For the Road*, 1951 / Oil on canvas / 61 x 92 cm / © Estate of Jack B. Yeats. All rights reserved, DACS 2015 / Photo © National Gallery of Ireland / NGI.4309

Page 115 / Louis le Brocquy (Irish, 1916–2012) / *A Family*, 1951 / Oil on canvas, 147 x 185 cm / Heritage Gift, Lochlann and Brenda Quinn, 2002 / National Gallery of Ireland / NGI.4709 / © Estate of Louis le Brocquy

Page 117 / Patrick Collins / *Hy Brasil* (1963) / Oil on board / 76.2 x 91.5 cm © Estate of Patrick Collins/IVARO Dublin 2015 / Dublin City Gallery The Hugh Lane, Reg. 1210

Page 119/ Oisín Kelly / *The Children of Lir*, 1970 / Bronze / Height, 7.3 metres Garden of Remembrance, Parnell Square, Dublin / Photo © Donal Murphy Photography/Alamy

Page 121 / Maria Simonds-Gooding / *Habitation 1*, 1970 / Plaster, collage and oil 106.7 x 147.3 cm / Collection Irish Museum of Modern Art / © Maria Simonds-Gooding / Heritage Gift, P.J. Carroll & Co. Ltd. Art Collection, 2005

Page 123 / Robert Ballagh (Irish, b.1943) / *Portrait of Noël Browne (1915–1997), Politician*, 1985 / Oil on canvas / 183 x 137 cm / © Robert Ballagh/IVARO Dublin 2015 / National Gallery of Ireland / NGI.4573

Page 125 / Patrick Scott / *Chinese Landscape* (1986) / Gold leaf and tempera on linen 122 x 218.5 cm / © Estate of Patrick Scott/IVARO Dublin 2015 / Dublin City Gallery The Hugh Lane, Reg. 1698

Page 127 / Alice Maher / *Berry Dress*, 1994 / Rosehips, cotton, paint, sewing pins 25 x 32 x 24 cm / Collection Irish Museum of Modern Art / © Alice Maher / Purchase, assisted by funding from Maire and Maurice Foley, 1995

Page 129 / John Behan / *National Famine Memorial/Ghost Ship*, 1997 / Bronze / Height, 7.5 metres / Murrisk, Co. Mayo / Photo © Vincent MacNamara / Alamy

Page 131 / James Hanley (Irish, b.1965) / *Portrait of Ronnie Delany (b.1935), Sportsman*, 2000 / Oil on linen / 206 x 155 cm / © National Gallery of Ireland / Photo © National Gallery of Ireland / NGI.4684

Page 133 / Sean Scully / *Wall of Light Sky*, 2000 / Oil on linen / 96 x 144 in. (243.8 x 365.8 cm) / Public Collection: Dublin City Gallery The Hugh Lane, Dublin, Ireland / © Sean Scully

Page 135 / *7 Reece Mews Francis Bacon Studio* / Photograph: Perry Ogden / Collection: Dublin City Gallery The Hugh Lane / © The Estate of Francis Bacon. All rights reserved. DACS 2015

Selected Reading

Early Irish Art

Harbison, Peter, Potterton, Homan and Sheehy, Jeanne, *Irish Art and Architecture: From Prehistory to the Present*, Thames & Hudson, 1993.

Moss, Rachel, ed., *Art and Architecture of Ireland, Volume 1: Medieval c.400–c.1600,* Royal Irish Academy, 2014.

O'Brien, Jacqueline and Harbison, Peter, *Ancient Ireland: From Prehistory to the Middle Ages,* Weidenfeld & Nicolson, 1996.

Painting

Arnold, Bruce, *A Concise History of Irish Art,* Thames & Hudson, 1977.

Barber, Fionna, *Art in Ireland since 1910*, Reaktion Books, 2013.

Bourke, Marie and Bhreathnach-Lynch, Síghle, *Discover Irish Art at the National Gallery of Ireland*, National Gallery of Ireland, 1999.

Butler, Patricia A., *Three Hundred Years of Irish Watercolours and Drawings*, Phoenix Illustrated, 1990.

Crookshank, Anne and The Knight of Glin, *Ireland's Painters 1600–1940*, Yale University Press, 2002.

Fallon, Brian, *Irish Art 1830–1990*, Appletree Press, 1994.

Figgis, Nicola, ed., *Art and Architecture of Ireland, Volume 2: Painting 1600–1900*, Royal Irish Academy, 2014.

Figgis, Nicola and Rooney, Brendan, *Irish Paintings in the National Gallery of Ireland, Volume 1*, National Gallery of Ireland, 2001.

Kennedy, S.B., *Irish Art and Modernism 1880–1950*, Hugh Lane Municipal Gallery of Modern Art, 1991.

Marshall, Catherine and Murray, Peter, eds., *Art and Architecture of Ireland, Volume 5: Twentieth Century*, Royal Irish Academy, 2014.

McConkey, Kenneth, *A Free Spirit Irish Art 1860–1960*, Antique Collectors' Club, 1990.

Sheehy, Jeanne, *The Rediscovery of Ireland's Past: The Celtic Revival 1830–1930*, Thames & Hudson, 1980.

Walker, Dorothy, *Modern Art in Ireland,* Lilliput Press, 1997.

Sculpture

Hill, Judith, *Irish Public Sculpture: A History,* Four Courts Press, 1998.

Crookshank, Anne, *Irish Sculpture from 1600 to the Present Day,* Department of Foreign Affairs, 1984.

Murphy, Paula, ed., *Art and Architecture of Ireland, Volume 3: Sculpture 1600-2000,* Royal Irish Academy, 2014.

Stained Glass

Gordon Bowe, Nicola, *Irish Stained Glass,* Arts Councils in Ireland, 1983.

Gordon Bowe, Nicola, Caron, David and Wynne, Michael, *Gazetteer of Irish Stained Glass: The Works of Harry Clark and the Artists of An Túr Gloine 1903–1963,* Irish Academic Press, 1988.